india

PHOTOGRAPHS LAURENCE MOUTON AND SERGIO RAMAZZOTTI
TEXT CATHERINE BOURZAT

india

A CULTURAL JOURNEY

© PUTUMAYO WORLD CULTURE

www.putumayo.com

Putumayo World Culture • 1924 Magazine Street • New Orleans, LA 70130

CONTENTS

INDIAN PINK
& SAFFRON YELLOW

Arun and Moti are brothers, and dyers by trade. They live in Kutch, on the edge of the desert. On the pages of a school notebook, they have stapled samples of thread, the colourful notes for their textile compositions: *zangal*, the bluish-green colour that comes from copper acetate, opens the section of greens; these are followed by blues, introduced by *nil*, or indigo; the reds hover between *al*, madder, and *hinglu*, the luminous vermilion made from the stone called *hingol*. Almost all the yellows are made from minerals, except the intense, acidic one to which Arun draws attention: 'This is the yellow of India, which is prepared with urine from cows fed only with mango leaves; French marigolds are also used to make a softer shade . . .'

A handful of colourists' secrets are revealed, in a country where colour is not only found in clothing but marks every human activity. It is as if it were conjured up by nature – nature which, apart from the Himalayas and the tropical lakes of the Malabar Coast, presents an austere landscape of dusty, monochrome aridity, except when it is starred with flowers after the monsoon rains. In days gone by, princes spent fortunes in combating the greyness of the desert, painting whole towns azure blue and salmon pink. At the edge of a village, a house painted pale crème-de-menthe green stands next to a stall covered with red distemper, which offers a whole range of powdered colours, neatly presented in cones, to be used to draw cheerful messages and religious symbols on walls and streets. In the next shop, painted mauve, colour is sold in the form of flowers and scents. Threaded into wreaths, the saffron yellow marigolds will become festival decorations or welcoming garlands, the scented white jasmine will be wrapped round ebony chignons, and rose petals will be scattered on the surface of a pool. Three shops further on, under an orange canopy, sky-blue melamine plates receive great spoonfuls of whatever is the meal of the day. Colour becomes flavour: vegetable curries are coloured gold with turmeric, and sparkle with the brilliant red of peppers, the purple of raw onion and the green

> **For the sadhus – holy men or ascetics – saffron has always been the colour of wisdom and renunciation . . ."**

of lime. At the shop next door, fabrics in dazzling Technicolor are displayed on an immaculate white mattress – muslins to be knotted into turbans, and yards of cotton, silk and nylon to be draped as saris. Next to them are colourful ready-to-wear clothes: *kurta* tunics, to be worn over the *churidar* that narrows at the ankles, great *ganghara* skirts, and floating *kamis* worn with loose trousers. Three divinities, lit by a red electric bulb, oversee the transactions: Lakshmi painted gold, Krishna with blue cheeks, and Ganesh with a pink elephant's trunk. Colours are for the gods of India too. From the back of the shop comes the rhythmic drumming of a *tabla*, to which a flute responds with a shower of notes. These are the colours of the modes or *ragas* of classical music, which, as in a chromatic scale, combine to produce new sounds and infinite variations.

Colours lie at the heart of Indian society: the Sanskrit word *varna*, colour, is used in the designation of the four castes. Traditionally, moving from the top downward in this hierarchy, white is the colour associated with Brahmins, the intellectual guardians of knowledge; red that of the Kshatriya, or warriors; green that of the Vaishya, or merchants; and blue that of the Shudra, the farmers, artisans and weavers at the bottom of the social pyramid. For the *sadhus* – holy men or ascetics, independent of this hierarchy – saffron has always been the colour of wisdom and renunciation. Of all these hues, red is the colour of life, and the ornament of women: it is present in the vermilion of *kumkum* powder, placed in the hair at the central parting, or as a spot marked with the fingertip in the middle of the forehead; in the henna traced by expert hands in arabesques over the faces of young brides; and in the carmine of the wedding sari, edged with gold. And red rules again at the spring equinox, where, symbolizing the new blood of the year, it introduces Holi, the festival of colours, when people throughout India throw coloured powders and coloured water at one another.

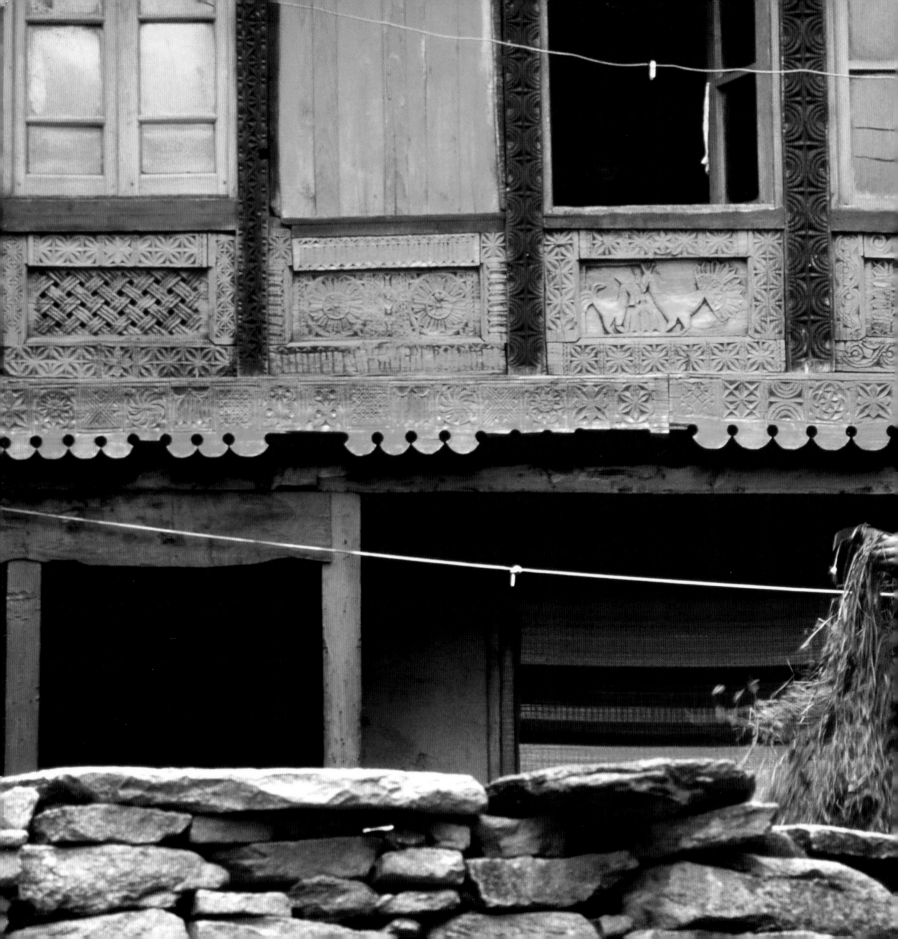

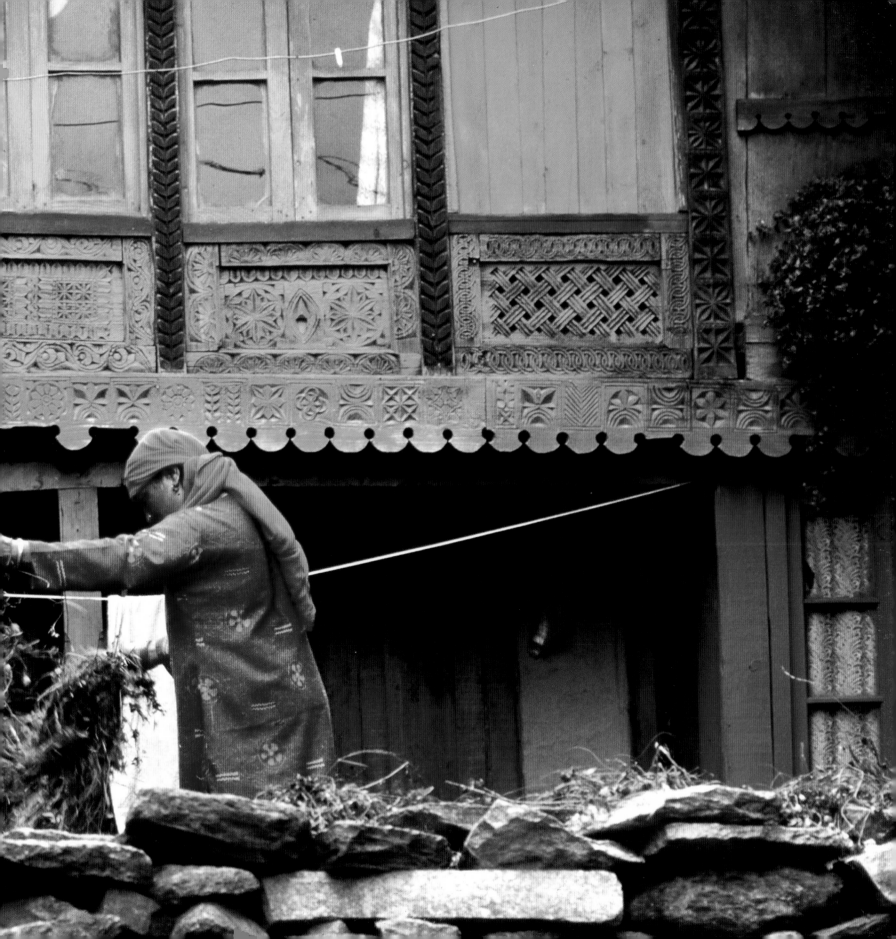

India loves pink, and pink suits India perfectly. It tints the early morning skies, and colours the villages in the moments before sunrise. In the form of garlands of flowers it hangs at the doorways of houses to indicate festivities within. In coloured powder, it creates drawings and messages to flatter the gods and attract their good will. Clasping the waists of young girls, it becomes the pink that the fashion writer Diana Freeland called the navy blue of India.

PRECEDING PAGES
Painted wooden façade in the upper Kulu Valley.
LEFT
Flowers threaded into garlands, sold in the Howrah Bridge market in Kolkata (Calcutta).
RIGHT
Earthenware dishes used as palettes for pigments to draw good-luck signs on the walls and doorsteps of houses • Year-end festival in a girls' school in Tamil Nadu.

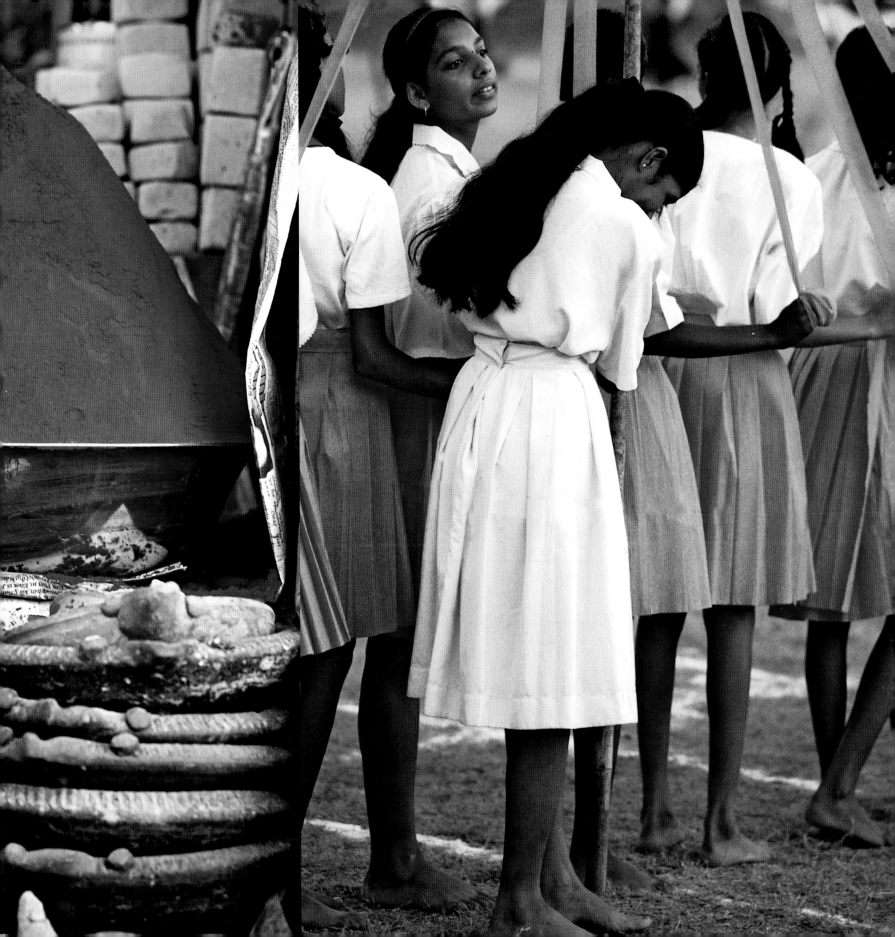

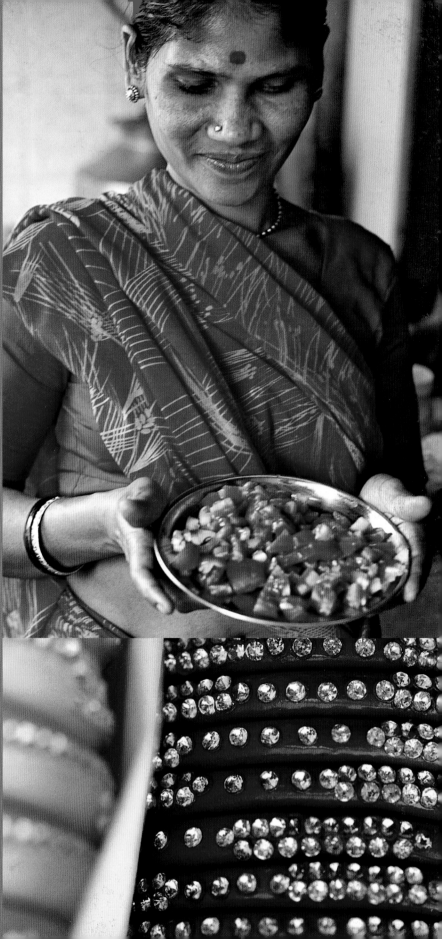

India hesitates between pink and saffron; indeed, they might be combined in a flag to celebrate the country's favourite colours – pink for a life of tender happiness, and saffron for renunciation, or on the contrary for the fragrant, infinitely warm aromatic richness of the spice that comes from the stamens of crocuses.

LEFT
Pink in the market, wrapping a parcel. • Pink for a packet of cigarettes or *bidis*. • Pink or saffron – which to choose for a garland of flowers to hang round the neck of your guest as a sign of hospitality?

RIGHT
Saffron in a plate of sweets. • Pink in glittering bangles to slip on the wrist.

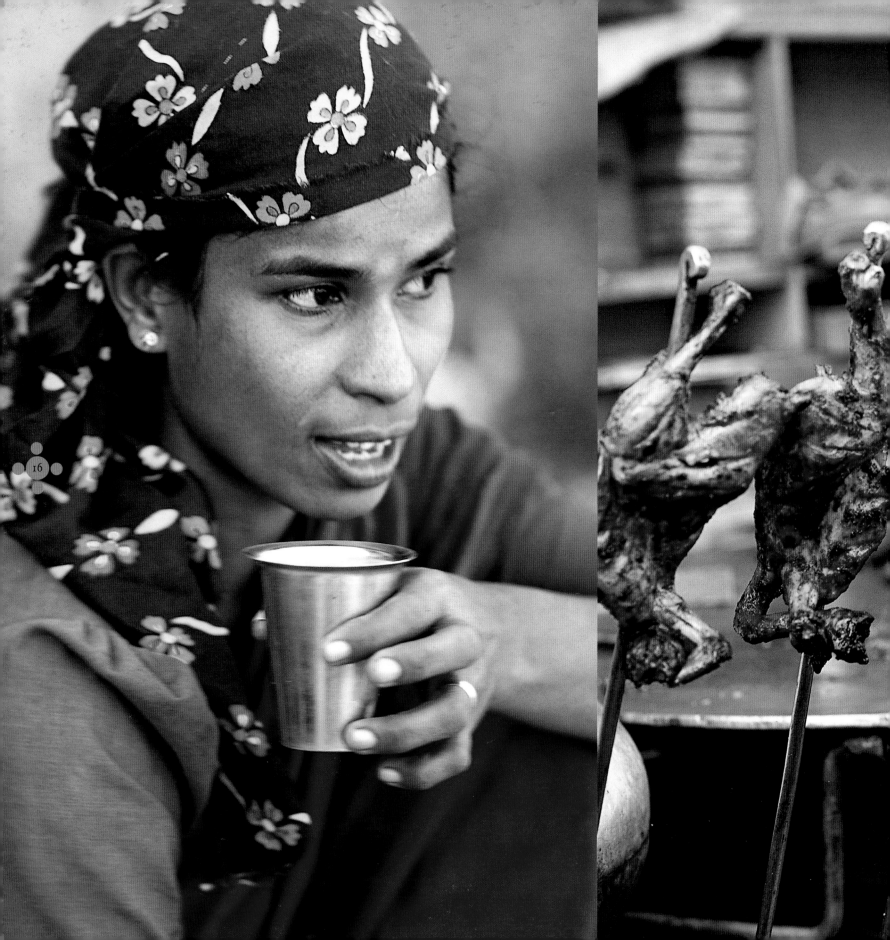

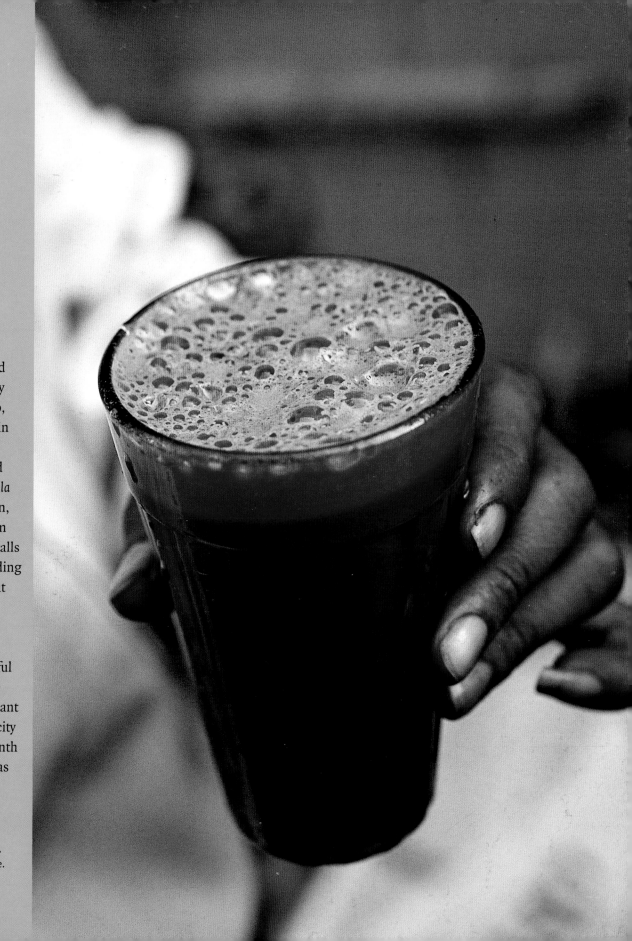

Jaipur is a pink city, created in the eighteenth century by Jai Singh, a maharajah who, with the help of his Brahmin astrologer, was a devoted student of the stars. He laid out his ideal city as a *mandala* of the planets round the sun, with avenues radiating from the palace. On the palace walls nature was depicted, including the rain-swollen clouds that bring the monsoon in summer. Jaipur astonished European visitors, who declared it the most beautiful city in Rajasthan. To amaze them even more, a descendant of Jai Singh had the whole city painted pink in the nineteenth century. Since then, pink has been the colour associated with Jaipur.

LEFT
A woman dressed in lilac and violet. ·
Turmeric-coated chickens on parade.
RIGHT
The Tyrian pink of a glass of fresh
beetroot juice.

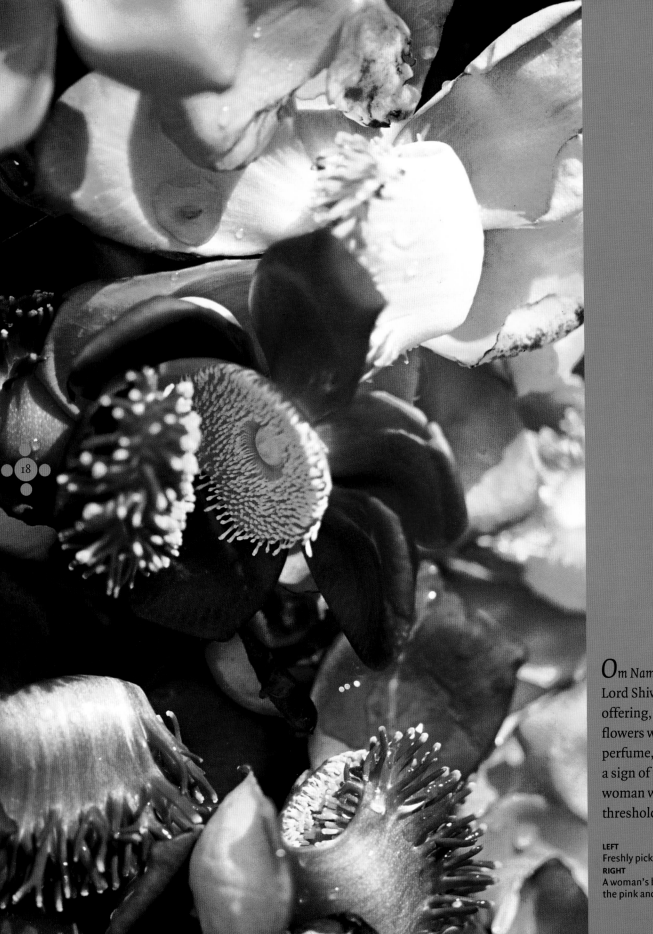

Om *Nama Shiva* – glory to you, Lord Shiva! For you, as an offering, an armful of *champa* flowers with their heady perfume, and bare feet as a sign of the humility of a woman who has crossed the threshold of your temple.

LEFT
Freshly picked *champa* flowers.
RIGHT
A woman's bare foot, glimpsed below the pink and brown border of her sari.

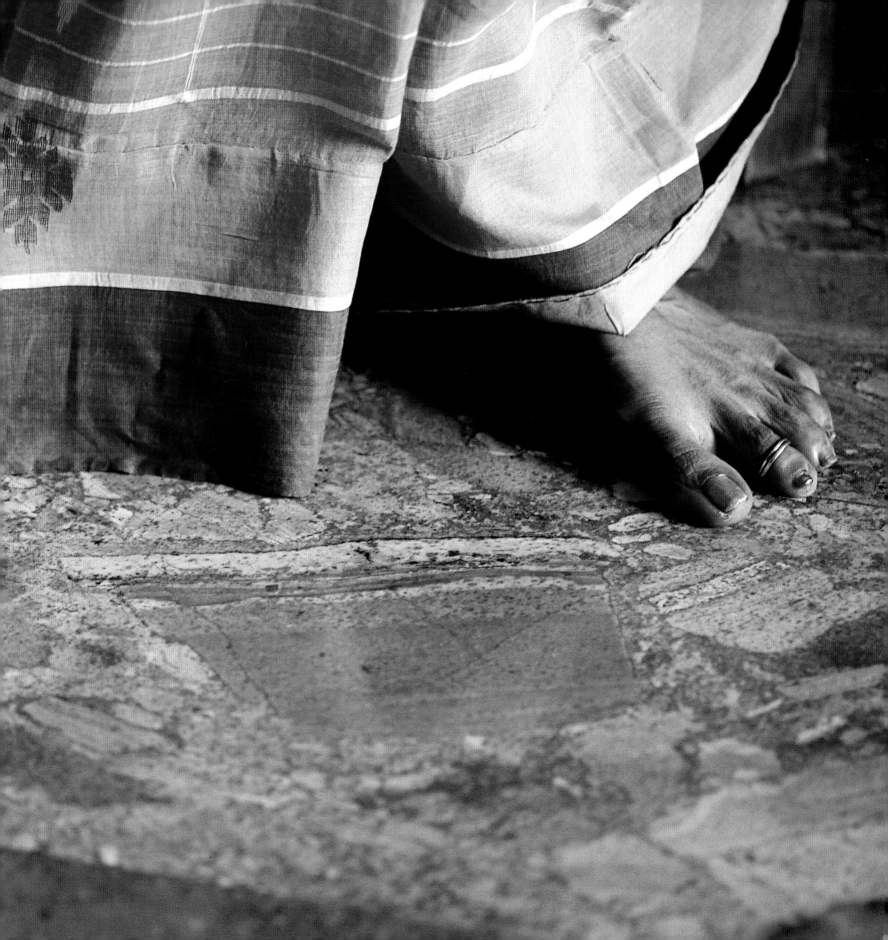

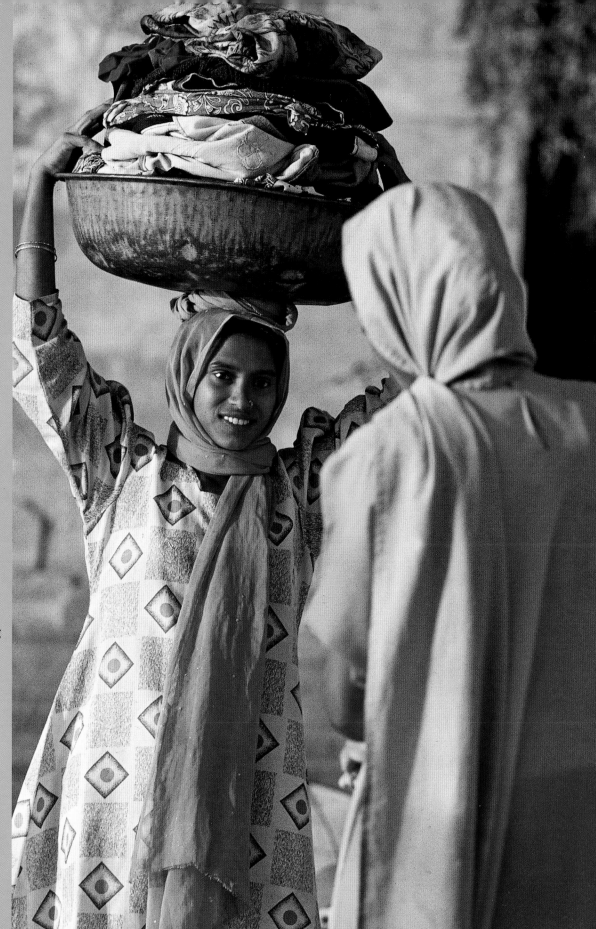

Along the ghats – the stone steps leading down to rivers and tanks – the hour of bathing is also the hour of laundry, and of the great display of coloured fabrics that drape the men and women of India. In villages, it is a time for women to gossip. In towns, the ghats are the realm of the *dhobiwallas*, the laundrymen who spread out the community's washing like banners.

LEFT
Arpeggios of textiles.
RIGHT
Carrying laundry, in rural Gujarat.

City of colours! It is as if people wanted to take their revenge for the uniform colour imposed by the tyrant by displaying between these pink walls all the brightest colours – men, women, princes and beggars, dressed in rags or in silks, percales or velvets. In these streets there is an incessant stream of colours which would be impossible under European skies, but which blend together under this sun, in this setting, to create a discordant harmony that is a joy to the eyes: sulphur yellow, ochre, red, carmine, purple, green mixed with white lead, willow green, light blue, turquoise.

Guido Gozzano, *Verso la cuna del mondo; Lettere dall'India*
(Journey to the Cradle of Mankind: Letters from India)

RIGHT
Coloured washing hung out to dry by the *dhobis* of Hyderabad on the banks of the River Musi.

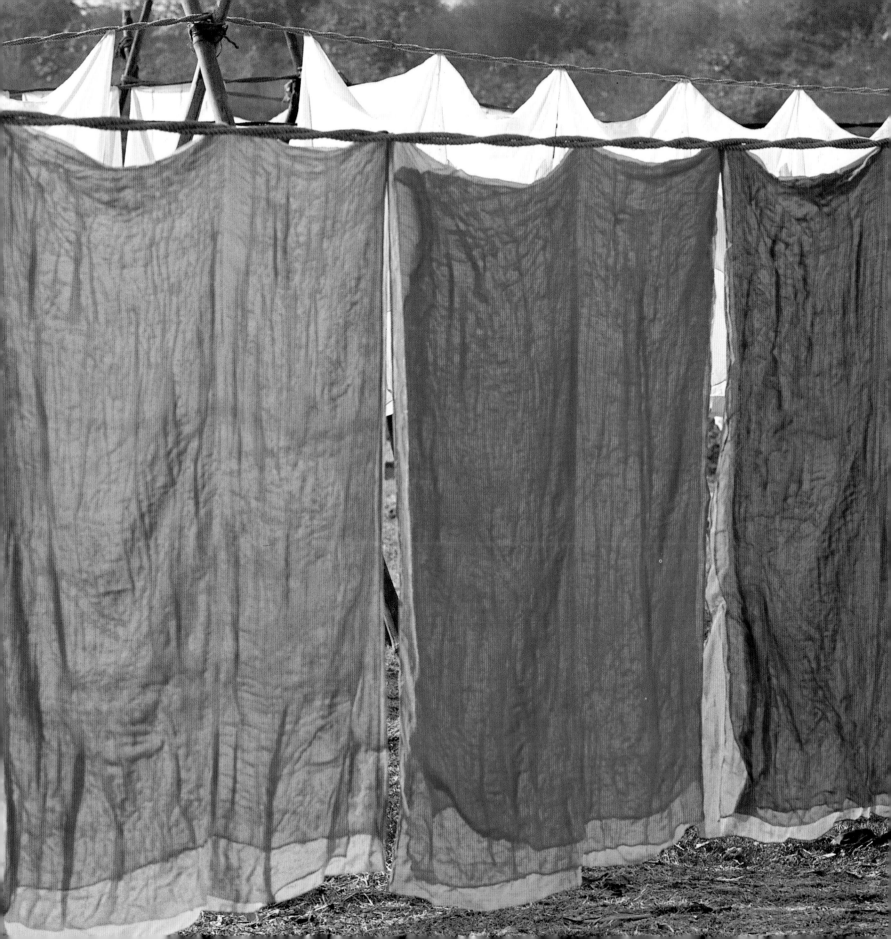

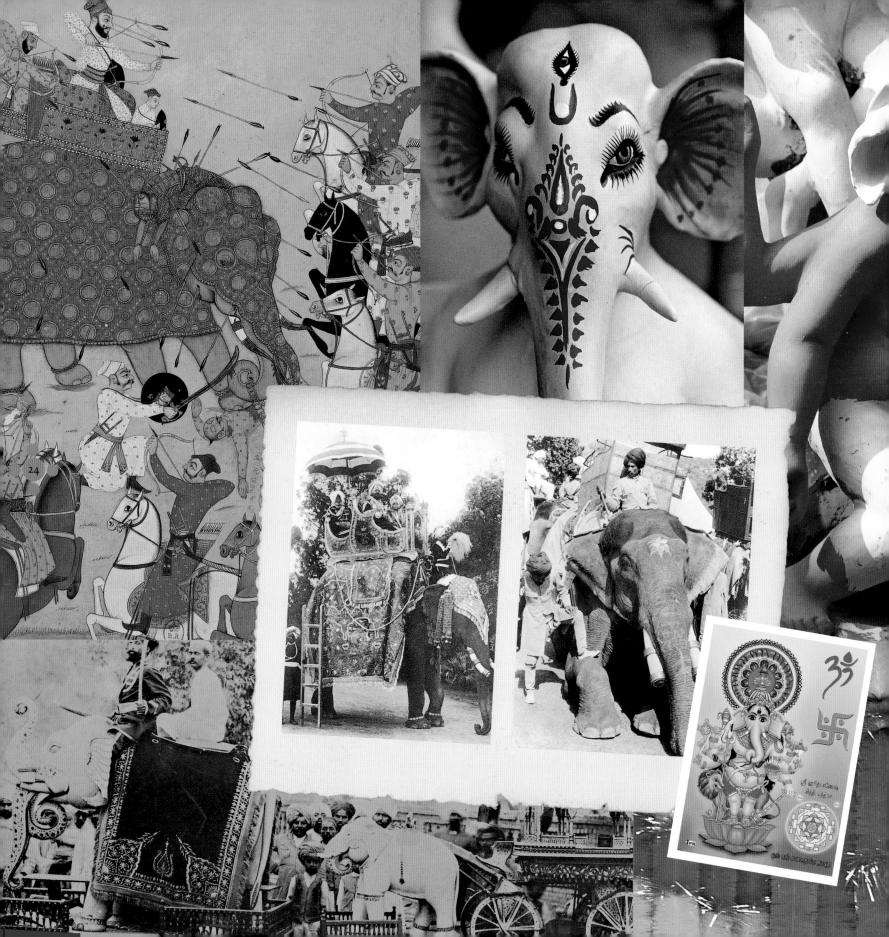

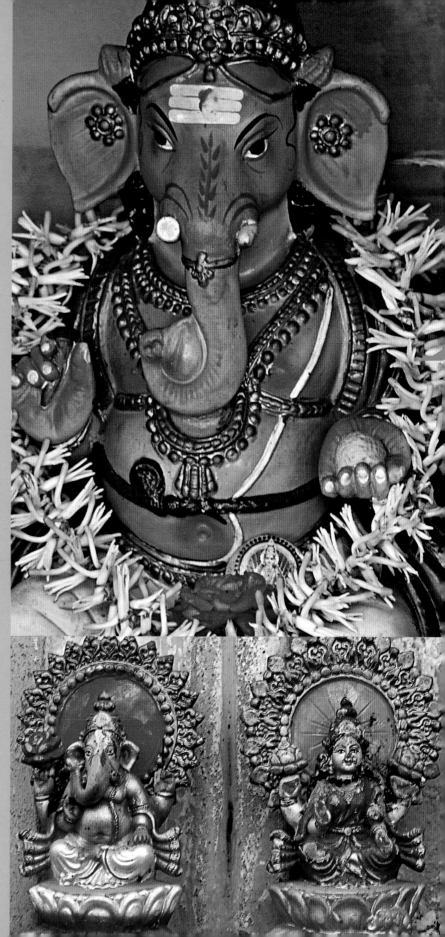

For Ganesh, the greedy elephant god, candy pink is the obvious colour. Of all the divinities of India, he is the fondest of sweets. One day when he had gorged himself even more than usual, he tripped on a snake and fell over head first. His belly burst, and all the cakes and multi-coloured sweets tumbled out. He sewed up his stomach as best he could, with the help of the snake. The moon had witnessed the scene, however, and mocked him. Furious, Ganesh broke off one of his tusks and hurled it at the moon. Ever since, he has had one short tusk, while the other shines as a crescent every month when the moon is absent from the night sky.

LEFT
A charge on elephant-back, from an Indian manuscript. • Two effigies of Ganesh in painted earthenware, which will be consigned to the sea on the beach in Mumbai (Bombay) at the end of the festival of the god, in September. • Festival garlands. • Astrological image of the elephant god. • Effigies of two elephants paraded on chariots at a Hindu festival.
The old photographs show the Maharajah of Kapurthala with the crown prince on a caparisoned elephant, from a postcard of 1909, and a laden elephant with its mahouts.
RIGHT
Ganesh in majesty, a sweetmeat in his left hand, and in his right the broken end of his tusk. • Ganesh and his consort keep watch on the doorstep of a house.

When the monsoon rains are past and the cool winter mists arrive, the vast, dusty plain of the Ganges is dotted with colourful flowers. Mustard, with its fresh yellow blossoms, is the gold of this land: its grains provide a popular spice for vegetables dishes, and an oil with many uses; its fresh leaves have a taste of rocket; and its stems, dried, contribute fuel for the little hearths on which the morning bread is turned to gold.

LEFT
Garlands of marigolds.
RIGHT
Picking mustard in the province of Uttar Pradesh.

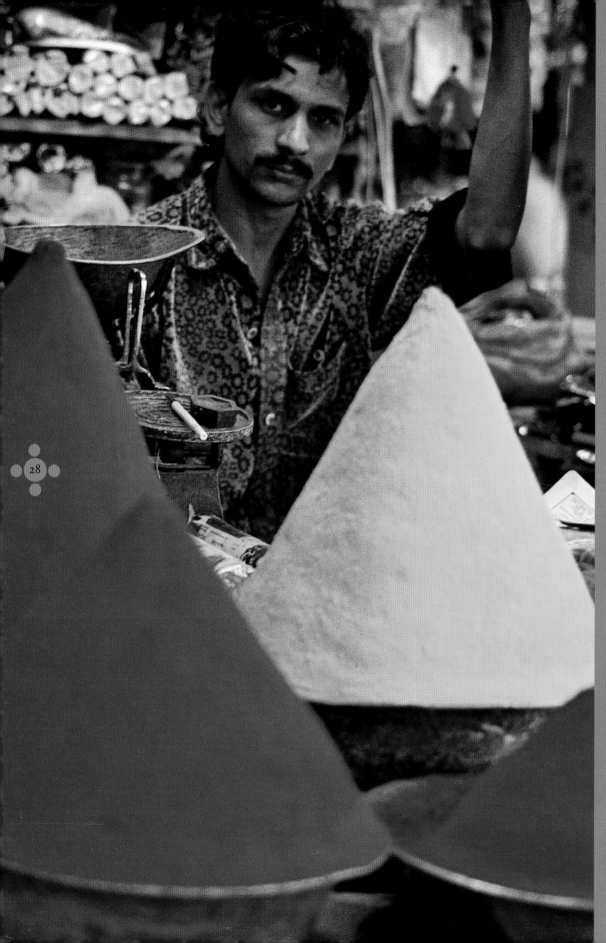

Colours and scents create the magic of Indian bazaars, where they form both the goods and the setting. A stall is made from a few planks, sometimes with the addition of a piece of cloth to serve as a canopy. In this informal showcase, the merchant's skill consists in catching the shopper's eye by the care with which he has arranged his coloured merchandise. Fresh flowers are stripped of leaves and stems and concentrated into a colourful and aromatic note. In the dimly lit markets, fruit and vegetables are sorted and displayed in appetizing pyramids, while pearly rice, spices and pigments are arranged in perfect cones.

LEFT
A pigment merchant displays colours in cones.
RIGHT
Lemon yellow or saffron yellow marigolds, threaded into garlands, are symbols of hospitality. • Shades of ochre colour the *dupatta* or scarf, decorated with tie-and-die lozenges, wound over her black hair by this young woman.

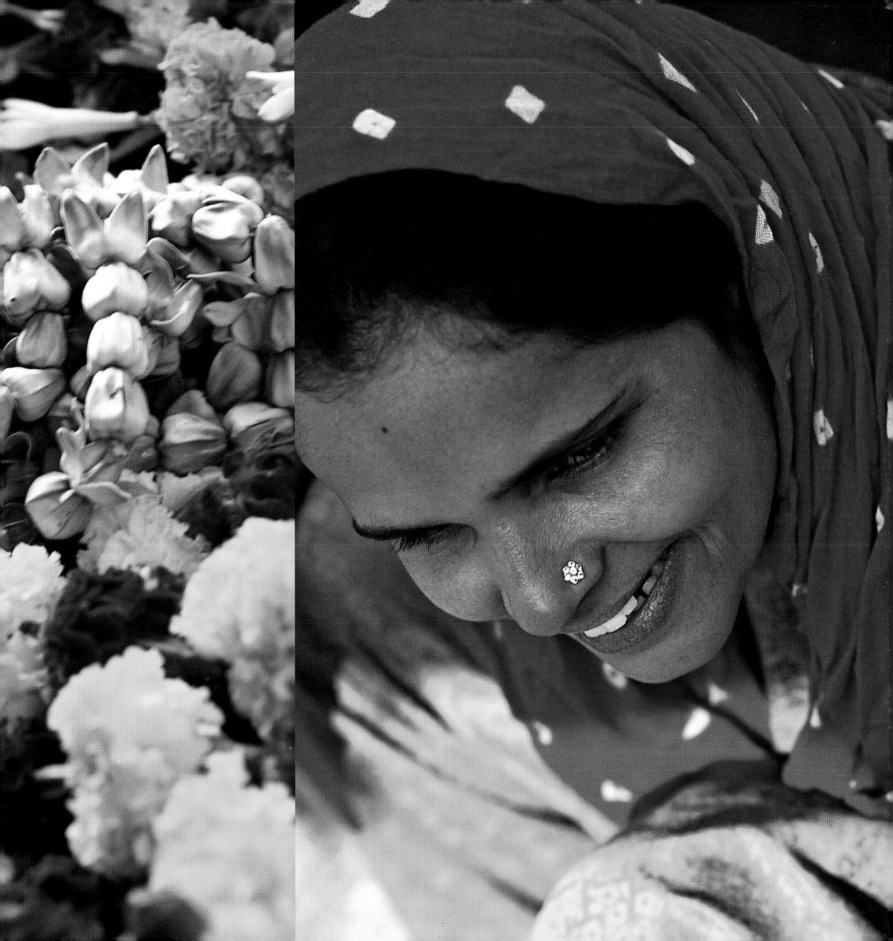

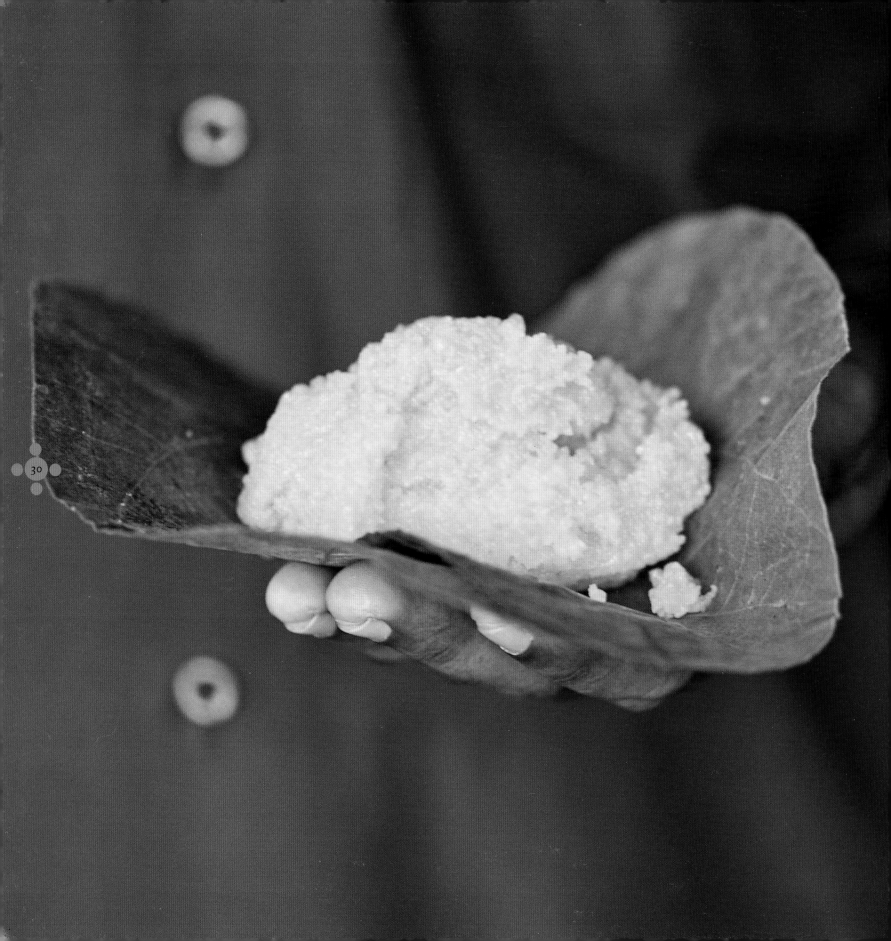

The colours mattered too. In fact, as I grew older the colour of the food mattered to me as much as the taste. I disliked vegetables that were cooked into a grey-brown mash. I liked shining green bhindi, sparkling yellow masur dal, burnished copper pumpkin, sliced red watermelons, diced orange papayas, unsliced red apples, leaf-green guavas, snow-white curd.

Tarun J. Tejpal, *The Alchemy of Desire*

Even for the most destitute, whose home is on the street when night falls, and whose wardrobe consists of a single garment, in India colour is life.

LEFT
A girl in a canary yellow sari in front of a spice stall. · The flowered green of the *ganghara* skirt of a Rajasthani peasant woman doing her shopping is set off by the sunny fabric of her long scarf or *odhni*.

RIGHT
In the dry plains of the North-West, Rabari herdsmen with their brilliant white garments and colourful turbans can be spotted from far off.

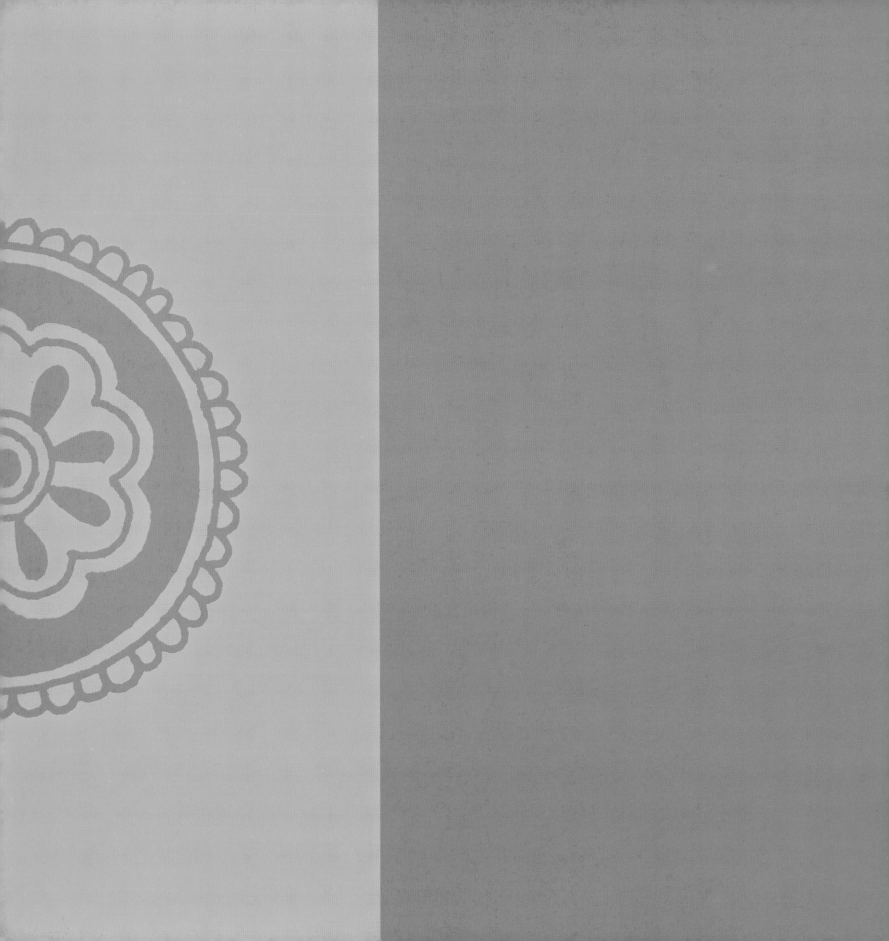

THE TUMULT OF
THE TOWNS

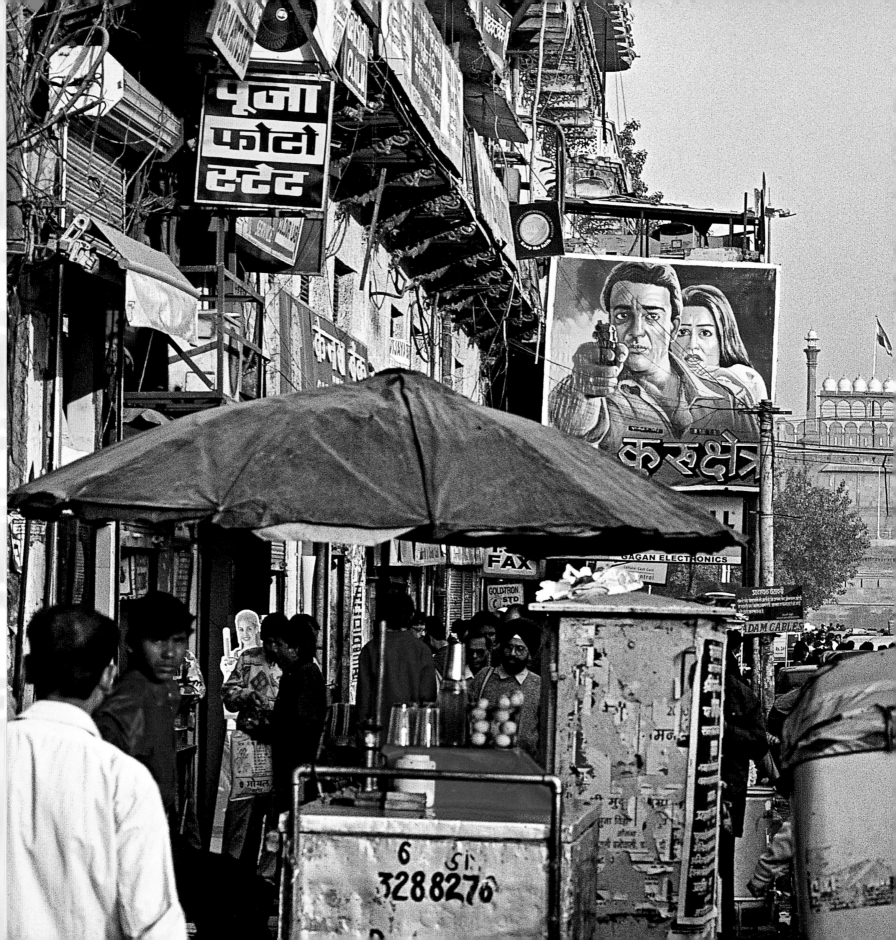

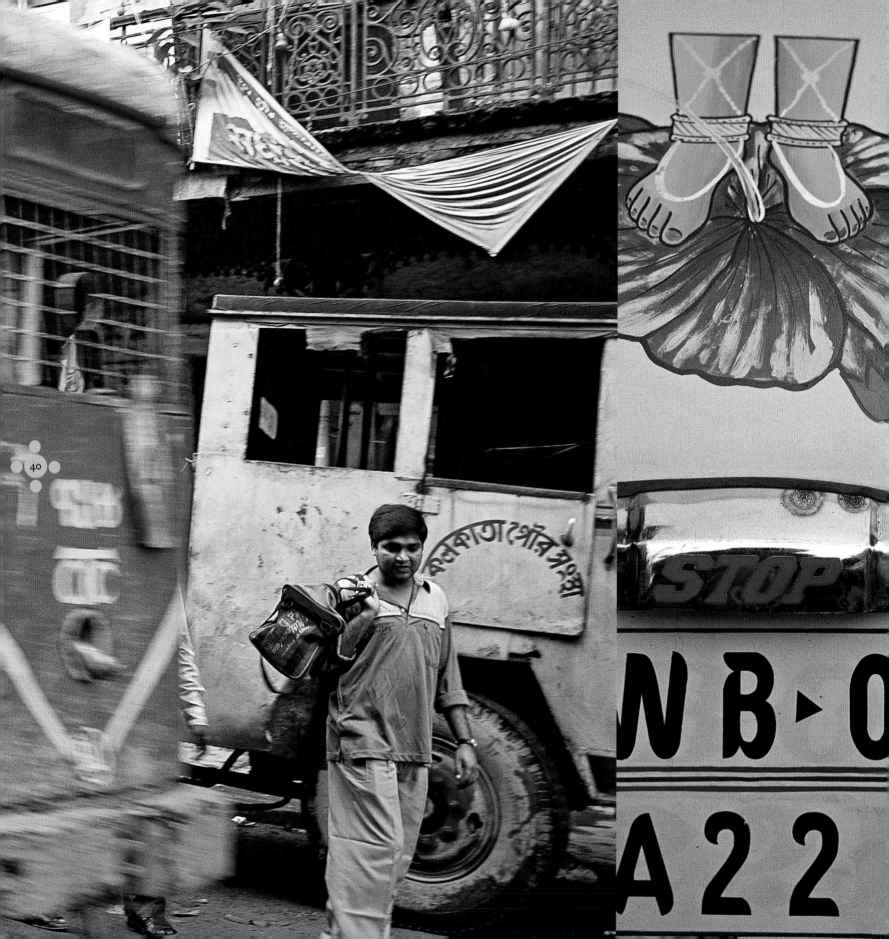

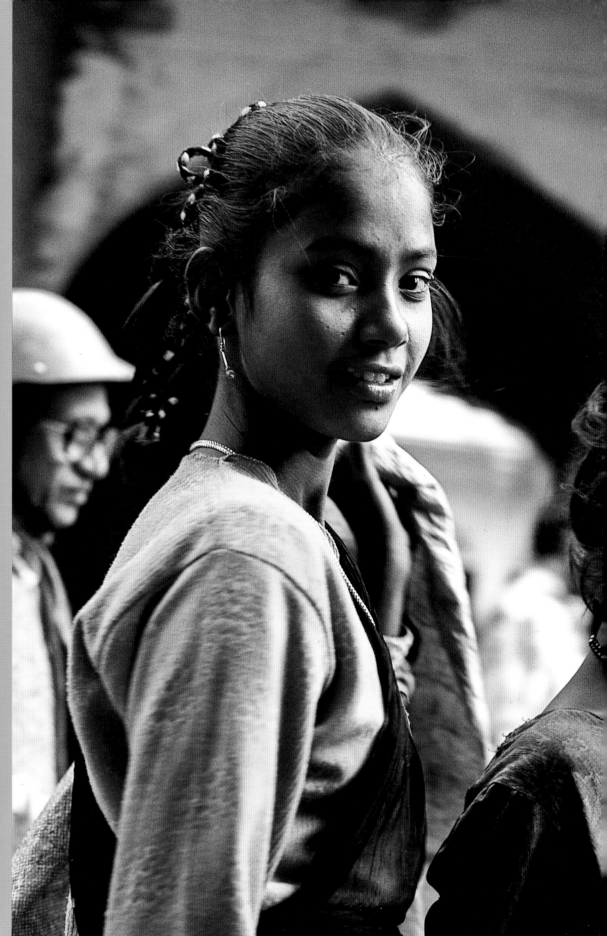

Yellow and black are the colours of the auto rickshaw. This motorized version of the cycle rickshaw is the essential Indian taxi, and auto rickshaws are everywhere: tens of thousands criss-cross every great city, and in the most remote parts of town, at the latest hours, they spring up as you turn a corner and plunge ahead of you, their rickety framework swaying as it goes. No door protects the passenger on the seat behind the driver, who, for a handful of rupees, leads you with a gesture of the handlebars into the urban dance, and with his engine at full throttle weaves his way through traffic jams. Scarcely bigger than an insect, the auto rickshaw is to the urban street what the Tata truck is to the highway; it rules the road with its horn, as loud as that of an American 38-ton truck.

PRECEDING PAGES
A Delhi street is a sea of yellow and black auto rickshaws.
LEFT
The yellow and black livery of the Indian auto rickshaw.
RIGHT
An alert pedestrian.

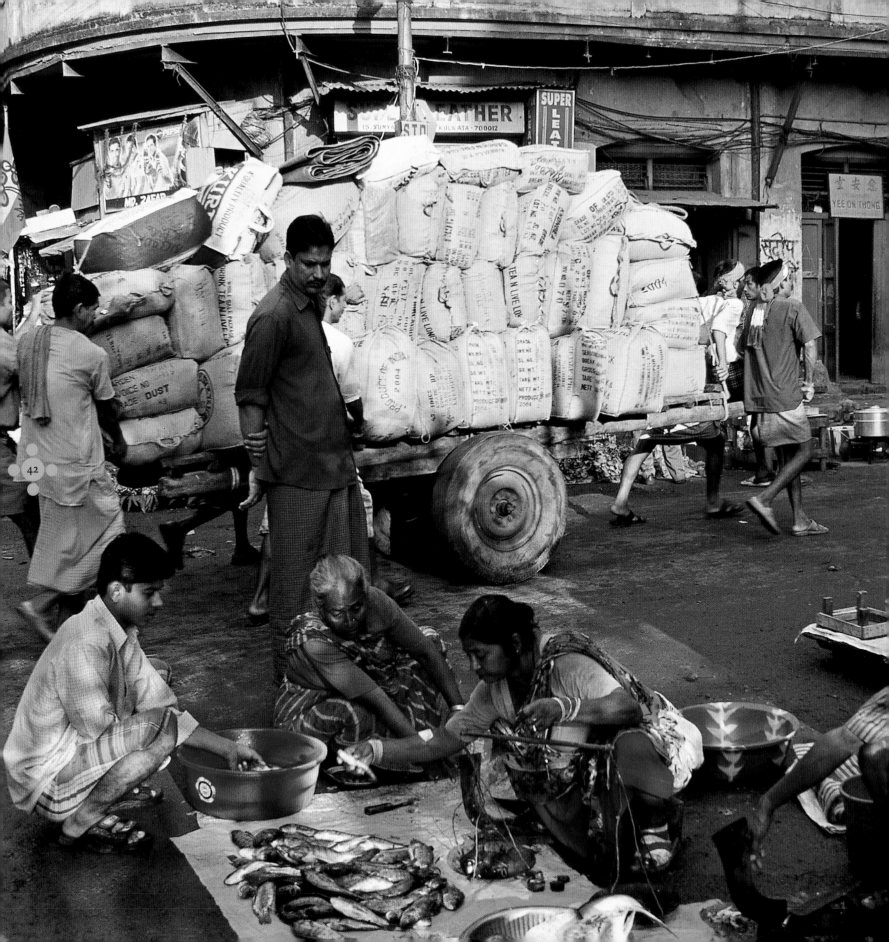

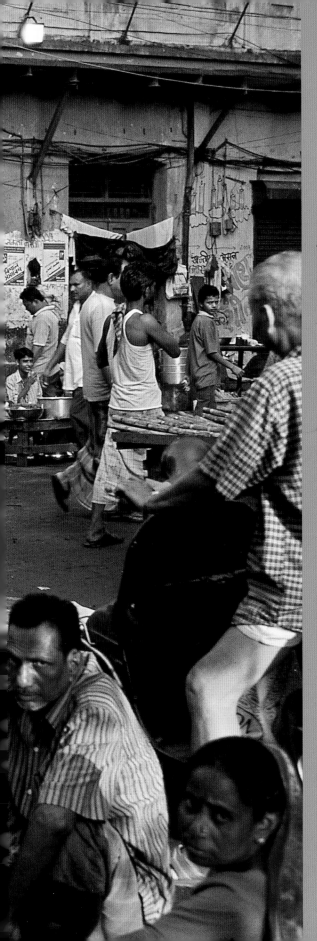

With their brand names of Hercules or Atlas, Indian bicycles evoke the heroes of ancient Greece rather than the gods of India. Brands change, but the bicycles remain more or less the same – with a robust frame that weighs as much as a dead donkey (they can only be ridden on the flat); black or bronze in colour; puncture-proof tyres that can cope with the most decayed road surfaces; a saddle so hard you can't ride seated for more than half-an-hour without injury; no gears; and, like everything that moves on the Indian road except pedestrians and carts drawn by animals, a horn. As with all the means of transport on the roads of India, their uses are many and varied: you may see, balancing precariously on the bicycle's frame, a cluster of milk cans, a string of coconuts, or much of the harvest from a market garden.

LEFT
Kolkata comes to life in the morning.
RIGHT
A Rajasthani shepherd has come to town on his bicycle.

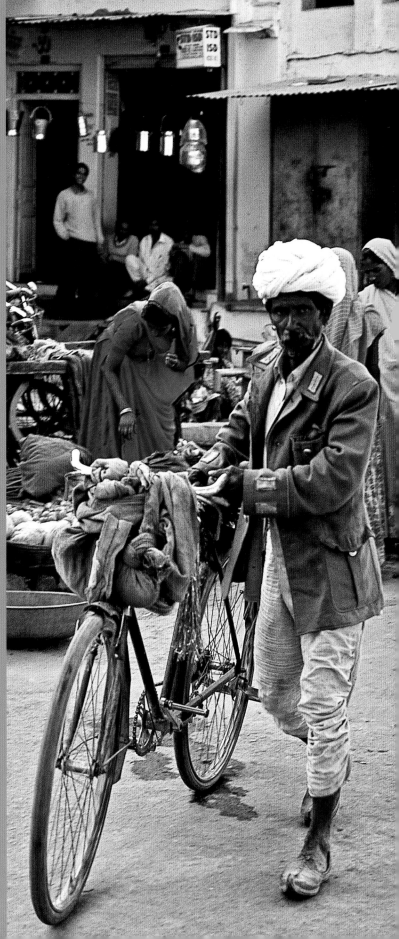

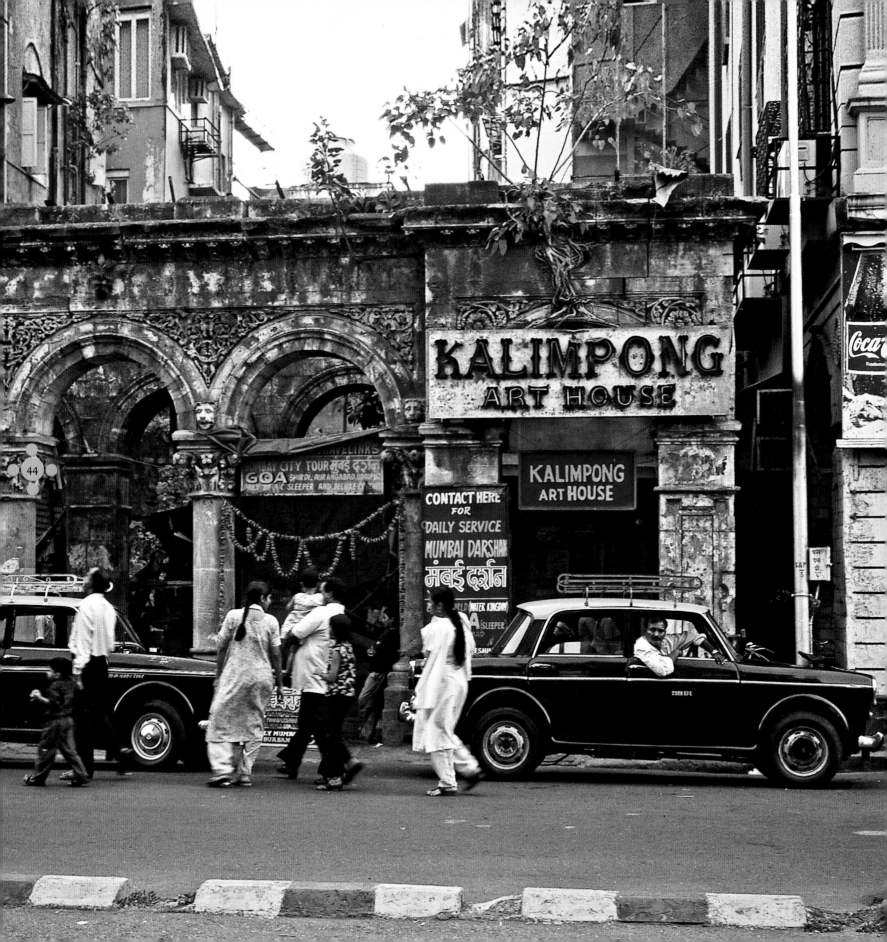

Walking up Central Avenue – the sudden crash of Trams on rails, hoot of auto horns in the early evening dark, buses roaring from exploding motors, clank of rikshaw bells, cries of brakes of cars, voices in the rush hour streets . . .

Allen Ginsberg, *Indian Journals*

LEFT
In Mumbai taxis supplant auto rickshaws, but their colours are the same: yellow and black.

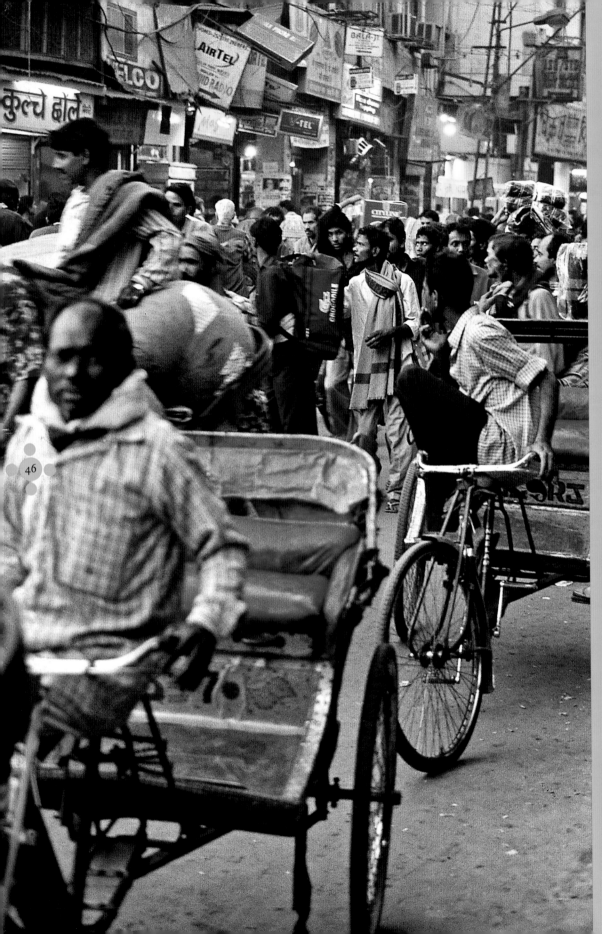

46

The rickshaw, created in Japan in 1871, where it was called the *jin riki shaw* or 'vehicle pulled by hand', was introduced to Kolkata (then Calcutta) in 1900. The city was then the capital of British India, and the first rickshaws were pulled by coolies from China. Now as the capital of West Bengal Kolkata has hardly any Chinese residents, but it is unquestionably the last city in the world where the hand-drawn rickshaw of colonial times still operates: some ten thousand rickshaw-pullers earn a miserable living through the energy of their calves, competing with cycle rickshaws (non-motorized versions of the auto rickshaw) and the pink tramways to ferry passengers through the proud and decaying city.

LEFT AND RIGHT
Traffic in Kolkata, under the impassive gaze of the goddess Durga.

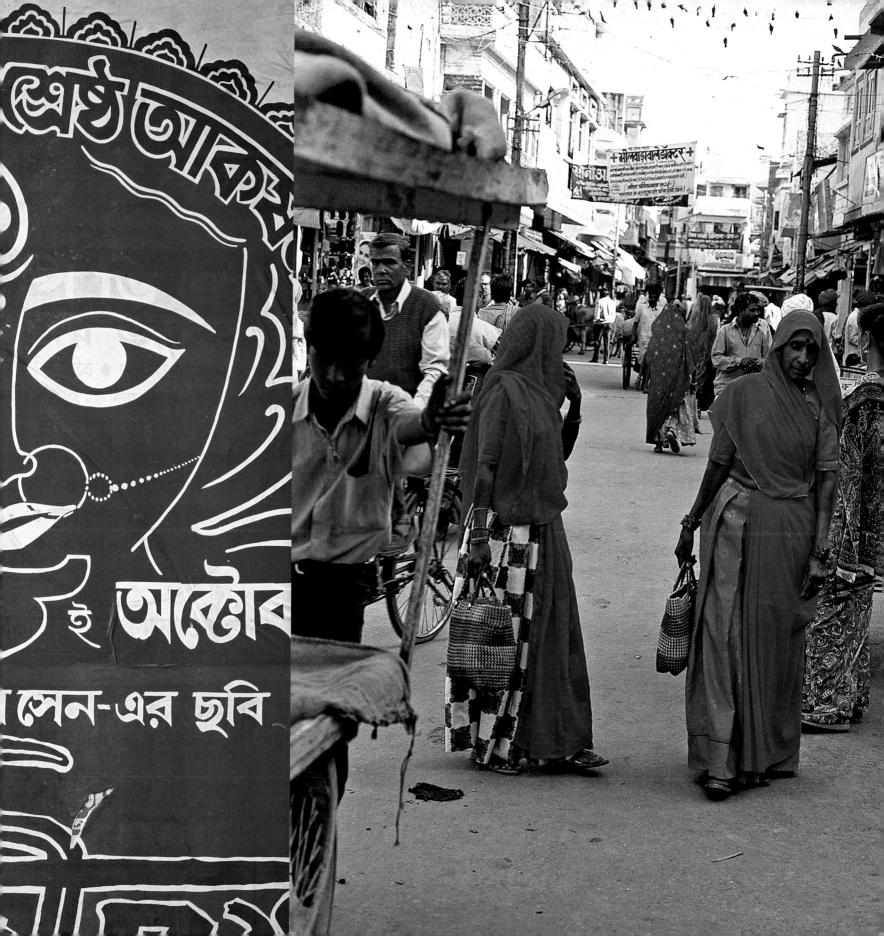

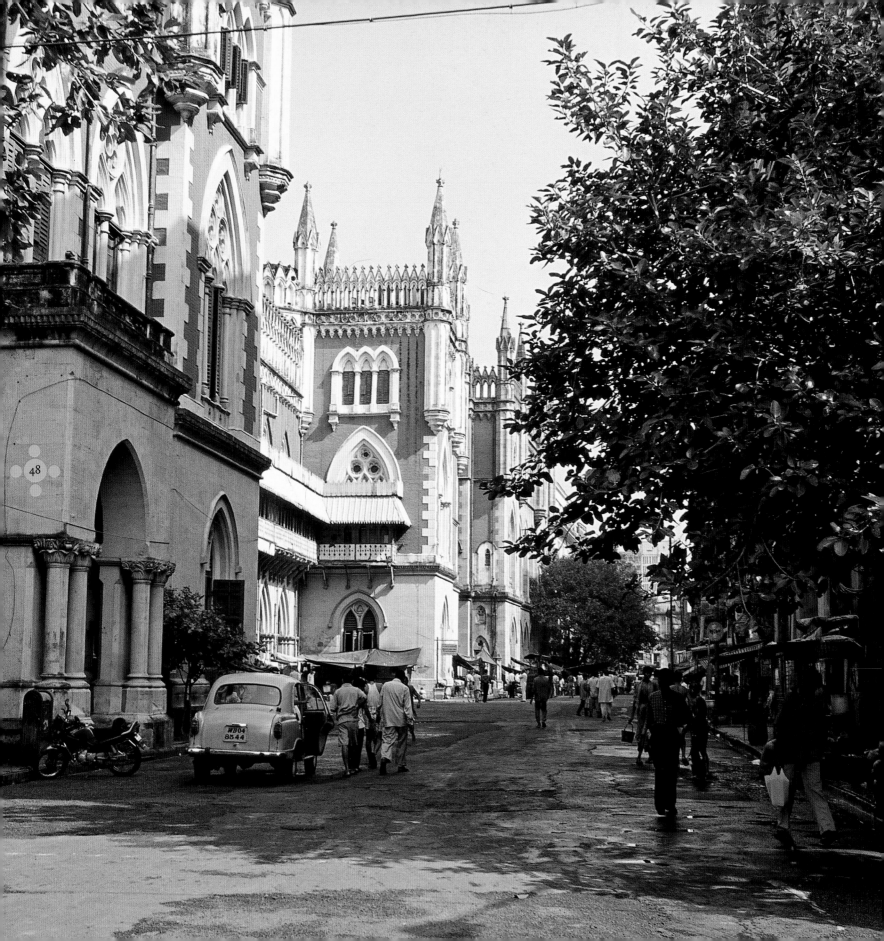

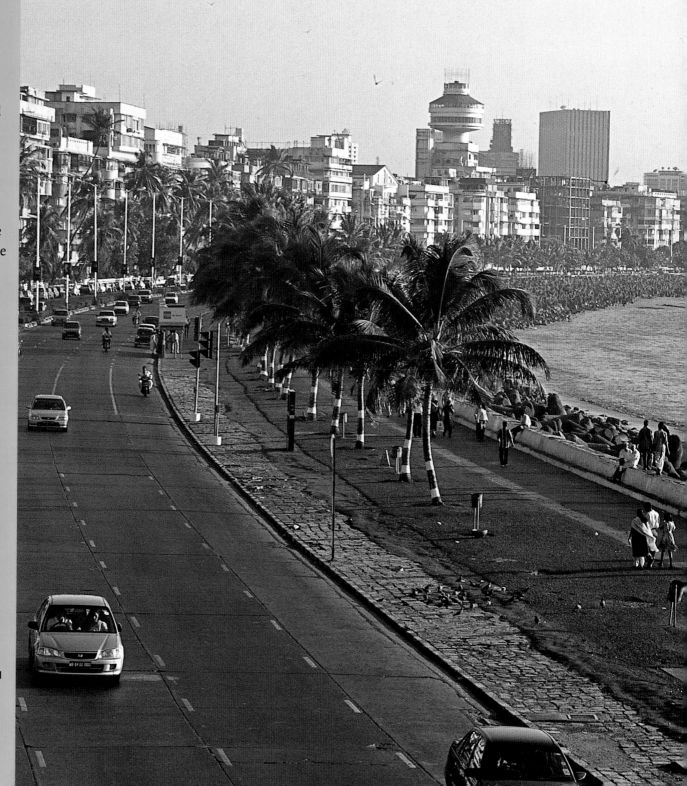

If Calcutta (Kolkata) and then Delhi were the political capitals of the British Raj – the empire that Britain carved out in India in the eighteenth and nineteenth centuries – Bombay (now Mumbai) was its port, the gateway of India, opening to the Arabian Sea. Thanks to its cotton mills, the city enjoyed a golden age at the end of the nineteenth century. Its old fort was demolished and Bombay became another London – coloured, however, by stones hewn from the quarries of India: grey basalt from the Deccan Traps, bluish basalt from Kurla, red sandstone from Bassein, and yellow sandstone from Porbandar. The façades, bathed in the damp air of the sea, still display the fashionable architecture of Victorian England, with neo-Gothic pinnacles and Neoclassical porticoes, frequented by seagulls, jackdaws and crows.

LEFT
Neo-Gothic buildings near the Taj Mahal Palace Hotel in Mumbai.
RIGHT
In the days of the Raj, Marine Drive, along the seafront of what was then Bombay, was nicknamed 'the Queen's necklace'.

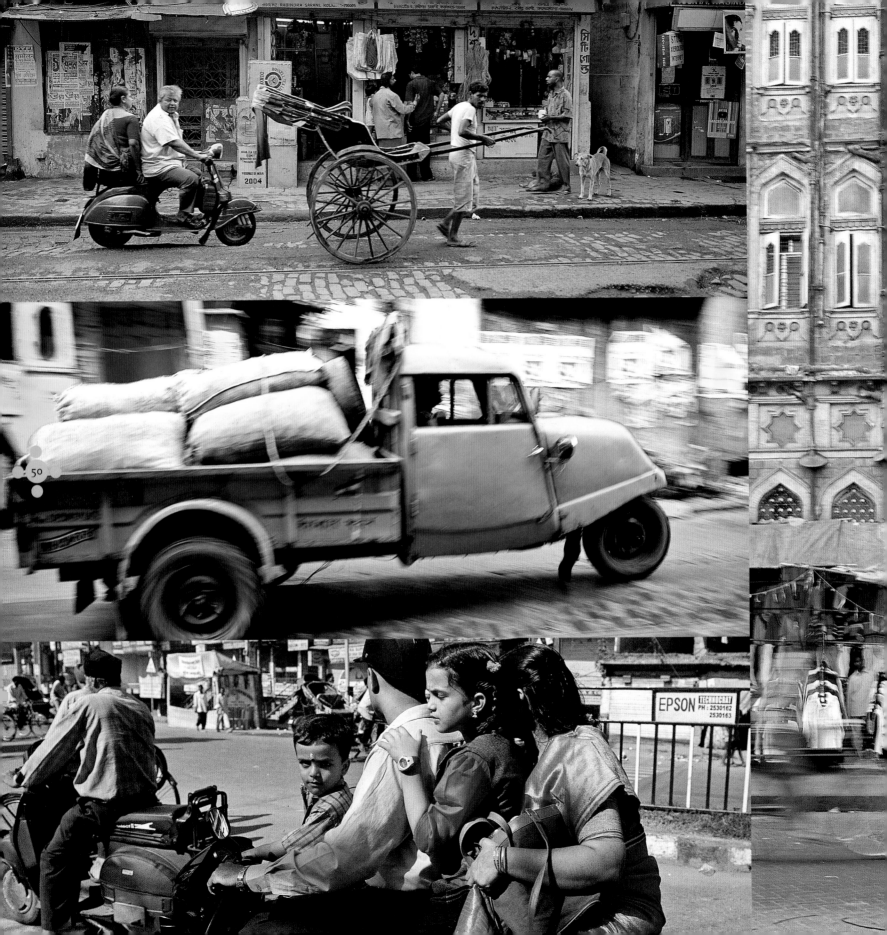

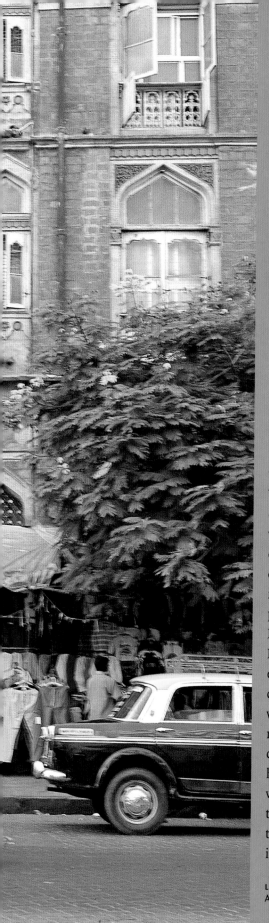

An equation governs street traffic in India. A litre of petrol costs much the same as it does in the West; but the average income is infinitely less. This has two consequences. The first is that use is made of any creatures, human or animal, that provide transportation without requiring petrol. The second is that internal combustion engines are fed with cocktails of fuel of doubtful but pragmatic character, with more interest in saving money than in protecting the environment. In the matter of pollution Indian roads beat all records, engulfed in a permanent cloud of exhaust fumes, fuel vapour and dust. This is the result of the equation. In some cities, enterprising individuals have opened 'oxygen parlours' where the better-off can pay to breathe oxygen, just as tanning sessions are available in the West.

LEFT AND RIGHT
An anthology of forms of transport.

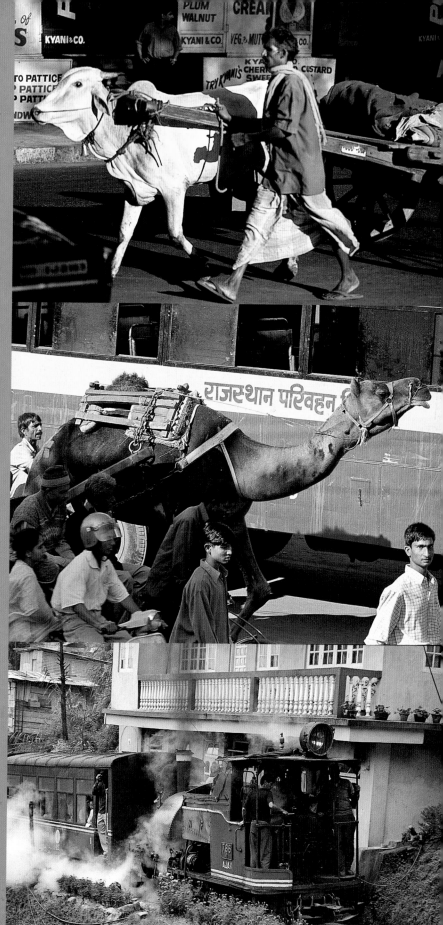

With metropolitan populations of some fourteen million each in Delhi and Kolkata, and nineteen million in Mumbai, the great Indian cities are a dizzying sprawl with endless suburbs, and the countryside round the suburbs is itself becoming urbanized. Mumbai, the 'golden city', is the maddest of them all. It grew up on a string of islands and land reclaimed from the sea, and it is like the end of a funnel into which trains pour six million passengers every day. It is the home of the two extremes of Indian society: a handful of millionaires, who live luxuriously in villas on some of the most expensive real estate in the world, and hundreds of thousands of the poor, most of them rural migrants. Between the two, the difference is so immense that it seems hopelessly unbridgeable. For the poorest, the first step towards integration is to have a roof over your head, even if it is only a shack made of corrugated iron and canvas in one of the *basti*, the slums of Mumbai, which are demolished and then as quickly form again.

LEFT
Home, on a corner of the pavement.
RIGHT
A young seller of shelled coconut.

52

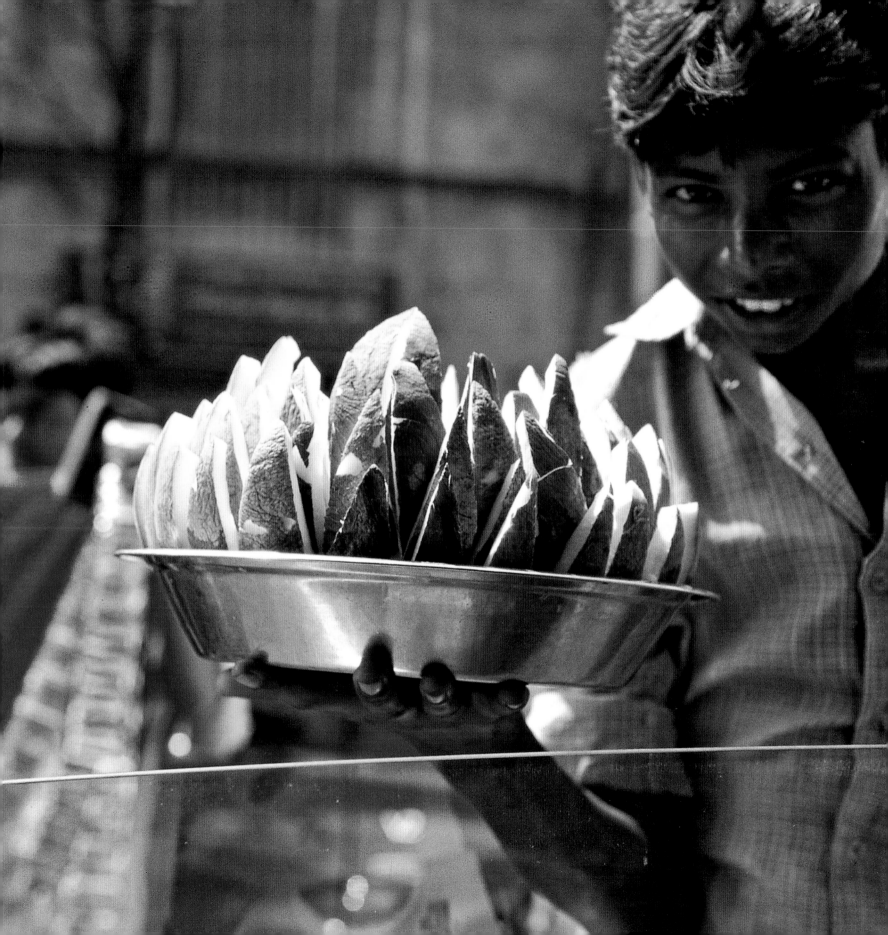

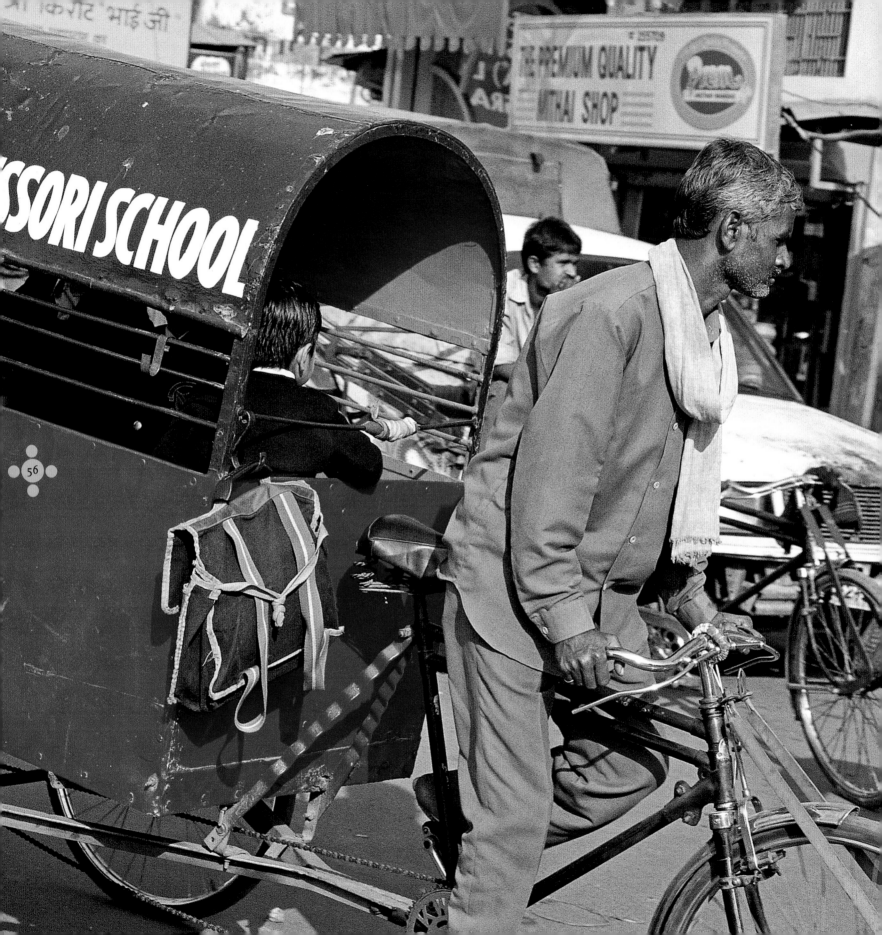

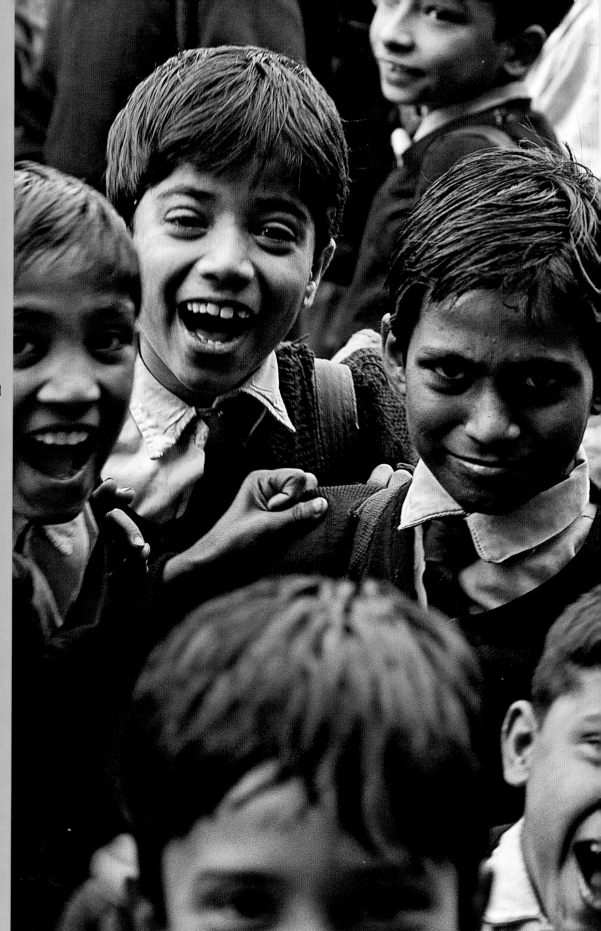

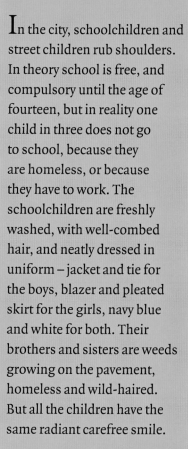

In the city, schoolchildren and street children rub shoulders. In theory school is free, and compulsory until the age of fourteen, but in reality one child in three does not go to school, because they are homeless, or because they have to work. The schoolchildren are freshly washed, with well-combed hair, and neatly dressed in uniform – jacket and tie for the boys, blazer and pleated skirt for the girls, navy blue and white for both. Their brothers and sisters are weeds growing on the pavement, homeless and wild-haired. But all the children have the same radiant carefree smile.

PRECEDING PAGES
Police and passers-by.
LEFT
A rickshaw serves as a school bus.
RIGHT
A group of boys coming away from school in Delhi.

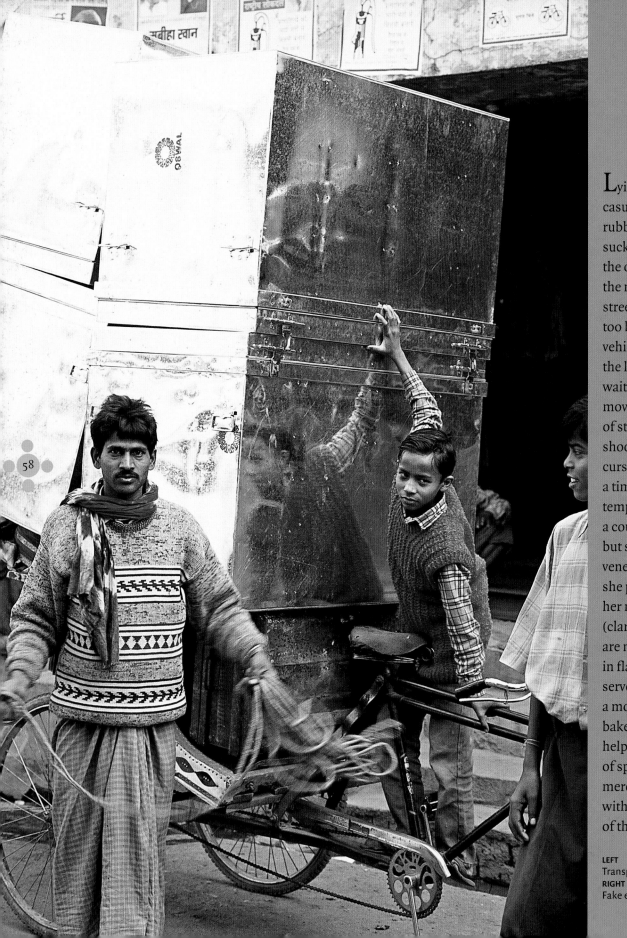

Lying calmly in the road, casually rooting through the rubbish in a gutter or busy suckling her calf, the cow is the only obstacle that can stop the mad flow of traffic in the street. If she blocks the way, too bad: only the smallest vehicles can get round, and the larger ones will have to wait until she chooses to move. There is no question of startling her, still less of shooing her away: you cannot curse a sacred animal. This is a timeless custom. There is no temple dedicated to the cow in a country of 330 million gods, but she is held in great veneration, because everything she provides is useful: from her milk yoghurt, butter, *ghee* (clarified butter) and sweets are made, and her dung, dried in flat cakes on sunlit walls, serves as fuel. If she devours a mountain of cakes freshly baked by the pastry cook, or helps herself to a whole basket of spinach from the vegetable merchant, they must put up with the self-indulgent habits of the queen of the road.

LEFT
Transporting tin trunks.
RIGHT
Fake elephant and real cow.

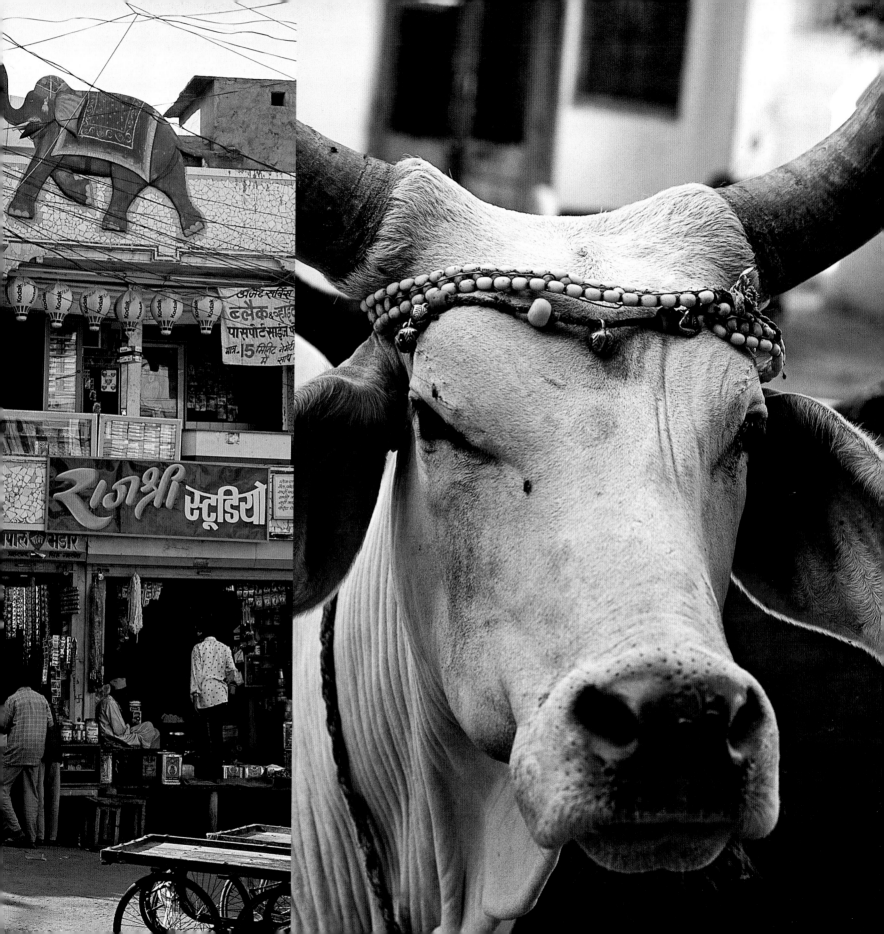

Signboards, posters, plaques, advertisements and graffiti, in a many-layered fresco, line the streets in commercial districts. In the North, English coexists with words whose letters hang from horizontal bars – Hindi – and in the South it mingles with garlands of loops – Tamil. India is a linguistic whirlpool with 1,600 dialects and languages, of which 18, including Hindi, are official languages. Hence all Indians are born polyglot, and in the course of a single conversation they will, depending on the subject, move from the dialect of their village to the language of their State, or to one of the official languages – highlighted with English words, because, despite all attempts to impose one of the country's own languages, and though only a small fraction of people speak English fluently, the old colonial tongue is the only universal key to the Babel of India.

LEFT AND RIGHT
Scenes of everyday life in town.
The old photographs, most of them taken in the early twentieth century, show, clockwise from top left, a gateway in Madurai; a street scene in Bombay (now Mumbai); snake charmers in Benares (now Varanasi) about 1900; and another Bombay street scene.

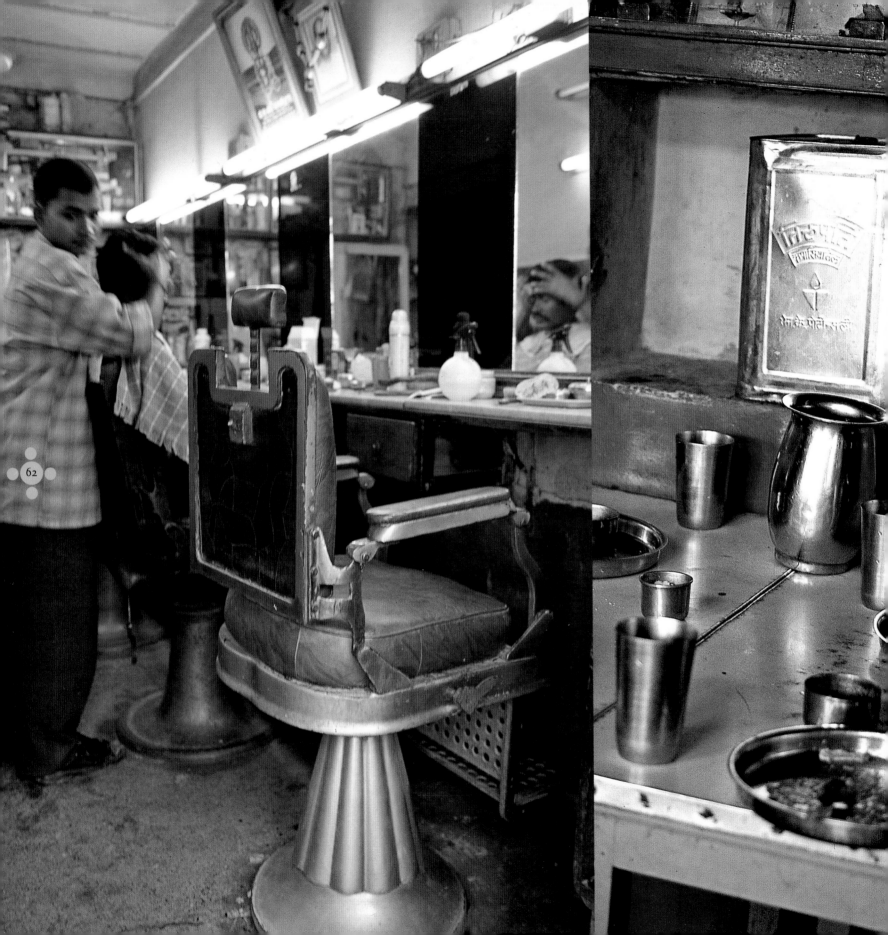

Hairdressers, barbers, masseurs, people who clean the wax out of your ears, shoe shiners, water carriers, knife grinders, key cutters, padlock sellers, cobblers, collectors of old paper, glaziers, *dhobis* gathering laundry to wash, sellers of flowers for offerings, water carriers, porters, sweepers, photographers, weeders of flowerbeds, garland makers, street entertainers, hucksters, sellers of balloons and postcards, *paanwallas* selling betel, *chaiwallas* selling tea, *chaatwallas* cooking food, *dabbawallas* carrying hot meals prepared by wives in the suburbs for their husbands working in Mumbai. . . The list of the minor professions of the city is infinite. New ones appear every day, catering to new needs with a vitality that is in inverse proportion to the inertia and incompetence of the public services. Without them, the cities would be paralysed.

LEFT
The best chair in a barbershop opening off the street. • Two tables pushed together support a *dabba*, or snack.
RIGHT
Sorters of chilli peppers.

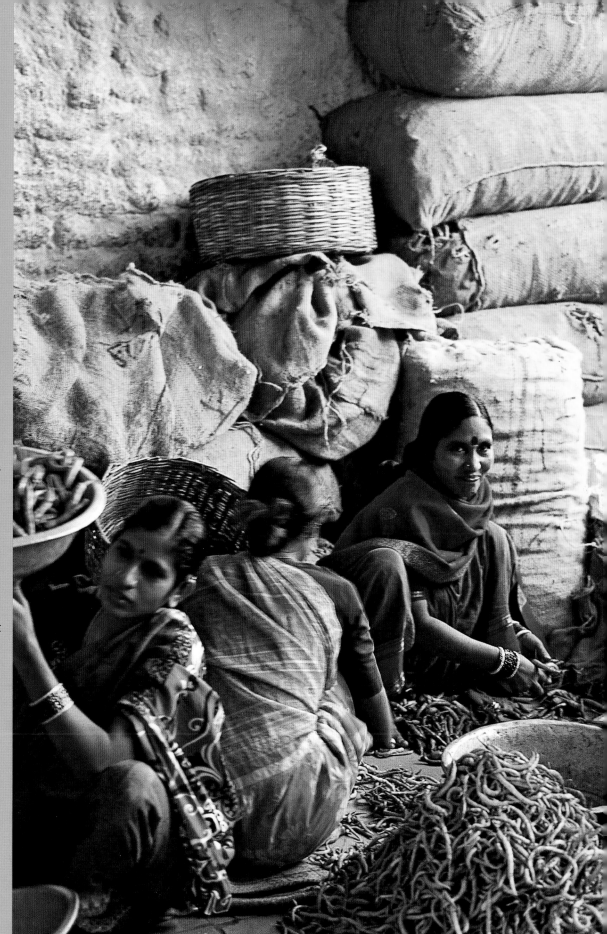

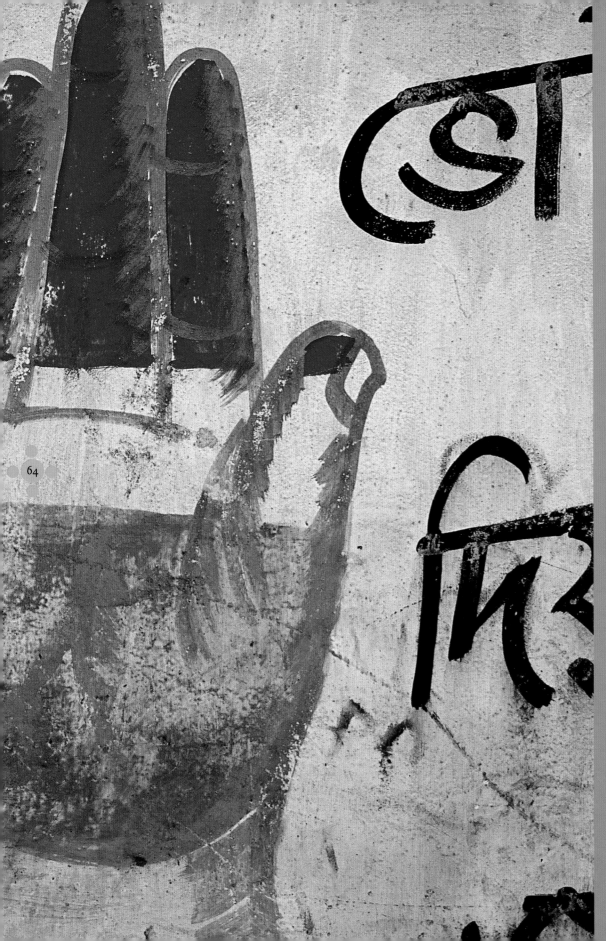

A leaf, a flower, a tool, a house, a hand, sometimes painted, sometimes applied with a stencil, on the corner of a street or a house or the side of a shop – what do these signs mean? They are the emblems of the countless political parties of the greatest democracy in the world. Why images rather than names? Because when India votes, of the 670 million called to the polls a quarter are illiterate. Hence all the parties of India have chosen logos to express their identity. In cities, towns and villages Indians have a passion for politics, to the extent, it is said, that if there were only two people in a village, there would be two parties. Everyone wants to know everything about interconnections and inner workings. Everyone votes together, everyone argues, and everyone is wedded to one cause or another. People think a government is bad? It can easily be got rid of.

LEFT
This hand on a wall symbolizes the Congress party, the party of India since independence.
RIGHT
Close-up of a pile of slingshots waiting to be sold. • A uniformed hotel porter.

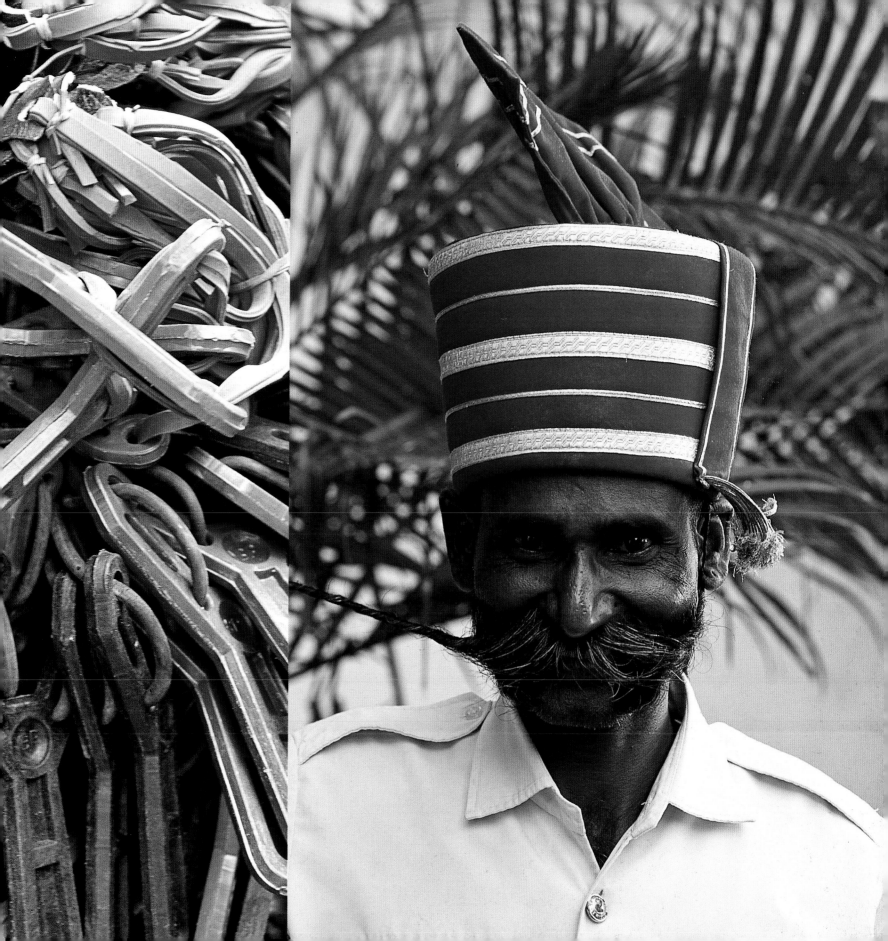

PRIVATE LIVES

Meenakshi puts a disk of Lata Mangeshkar on the CD player. She could never tire of listening to her, or to her sister Asha Boshle – the true queens of Bollywood, to whose voices generations of actresses had mimed since the 1960s. Jagdish, her husband, has left for work on his Penjaj scooter, and the street door, protected by a grille, is closed. Everything is quiet. '*Chori Chori Koi Aye*' sings Lata with her high-pitched voice. In the courtyard the servant, who has come back from the *dhobighat* with the household's clean laundry, is sweeping up leaves and dust, as she does every day. Meenakshi's mother-in-law has gone upstairs to rest in her room. You can hardly hear any noise from outside. Suddenly there is the ringing of a horse's hooves. Through the window, Meenakshi sees the rider, dressed like a prince and wearing a turban: it is Chandra, her neighbours' son, who is setting out thus arrayed to meet his bride. February is the great month for weddings. It is an arranged marriage. The bride has an excellent dowry, and her parents'

presents have been on show for almost a week – a complete bedroom suite, a set of drawing-room furniture, and up-to-the-minute kitchen equipment, including frying pans, a bucket, an iron, a pressure cooker and even a yoghurt maker. On the CD, Lata Mangeshkar has moved on to '*Bheegi Bheegi Raaton Mein*'. This reminds Meenakshi of the film *Mother India*. Eternal Mother India, with her adventures, melodramas, comedies, and the two sons irrevocably opposed to each other – the good one and the one who has turned out badly – and the mother, courageous, admirable, exemplary Radha, ready to do anything for her children. Meenakshi herself has two children – a boy, and a girl, Jaya, who is her favourite. Meenakshi sighs. In India some women achieve great things, but far too many lead miserable lives. So many families think that 'raising a daughter is like watering a garden for a neighbour'. Such is *karma*: you are born a girl or a boy, a Brahmin or an Untouchable, and that conditions the whole of your existence.

> ## " Raising a daughter is like watering a garden for a neighbour"

You have no choice. Even in the city, attitudes only change very slowly. You may read in the papers that caste no longer means very much, but it exerts its full power where marriage is concerned: you need only see how prominently it features in newspaper announcements of weddings. And what with the costs of the ceremony and the festivities and those of the dowry, marriage has become a major financial worry for the families of young couples. In her mother's day, and even in her own, things were simpler because one owned much less. A young bride's entire possessions fitted into the padlocked chest that she brought with her to the house of her in-laws: her saris, her jewels, keepsakes, books, and sometimes a diary. Meenakshi remembers her own wedding. How could she forget it?

In India, marriage is not just the union of a man and a woman, but a formal alliance between two families. The young bride, adorned with flowers, jewels and henna like a goddess, is the instrument. She is taught shyness, respect, modesty, and ceaseless devotion to her in-laws. Her fate depends not only on her husband, but on her relationship with another woman, whose position is assured because she has already given birth to a male child – the bride's husband: this is her mother-in-law. (Meenakshi is lucky: her mother-in-law is of another generation, granted, but she has always given Meenakshi considerable freedom, as she herself concentrates on her devotions.) Then one day the wife becomes a mother herself, and, no longer a mere instrument, she becomes the bond between the two families, and the source of a new prosperity. Such is the fate of an Indian woman in a society entirely run by men. Will it still be the same for her daughter, Jaya? In the street, an auto rickshaw slows down by the front door: the children are coming back from school for lunch. Meenakshi has not noticed that the CD of Lata Mangeshkar is no longer playing.

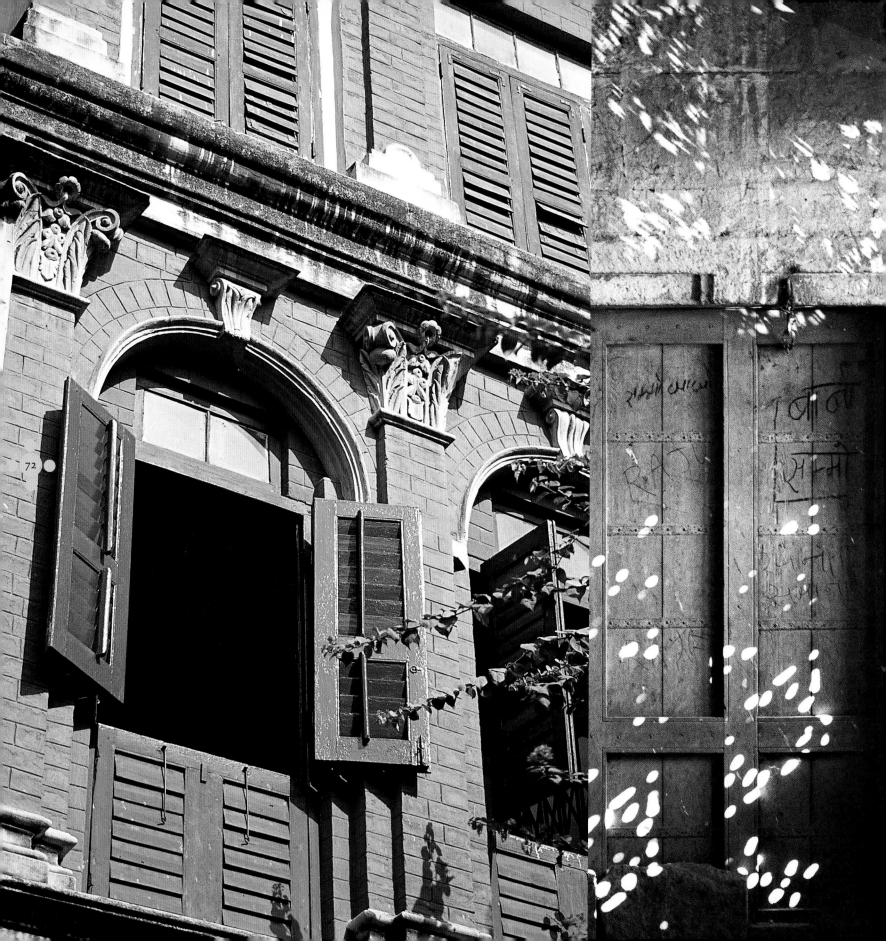

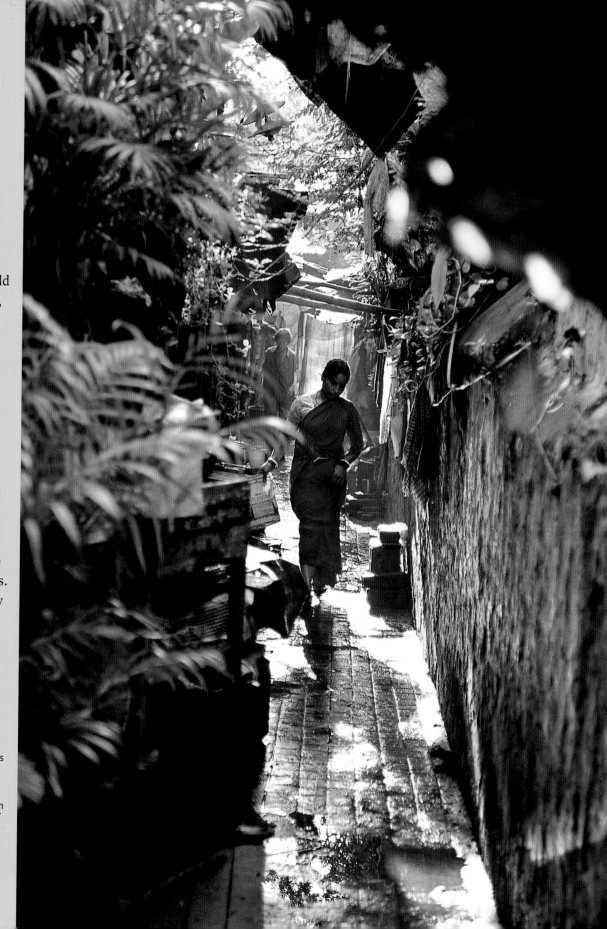

The ideal Indian house would include a central living room, where visitors could be entertained at any time; a kitchen that spilled out into the rest of the house when preparations for a party were under way, or overflowed outdoors when the weather allowed; and a bedroom for each member of the household. This is very rare, however, since three generations often live under the same roof, and well-to-do Indians have resident servants. The average dwelling has only two rooms, and in the course of a day these are the setting for complex territorial claims between the varied activities of men and women.

PRECEDING PAGES
From Goa to Kerala, the luxuriant tropical vegetation is ordered in gardens and verandas laden with plants.
LEFT
Corinthian capitals and a moulded cornice take the sun on a street façade in Kolkata – as Calcutta, the first capital of British India. • Elsewhere, there is cool, shadowy light.
RIGHT
Escaping from their small homes, families take over or share spaces outdoors, in alleyways and courtyards.

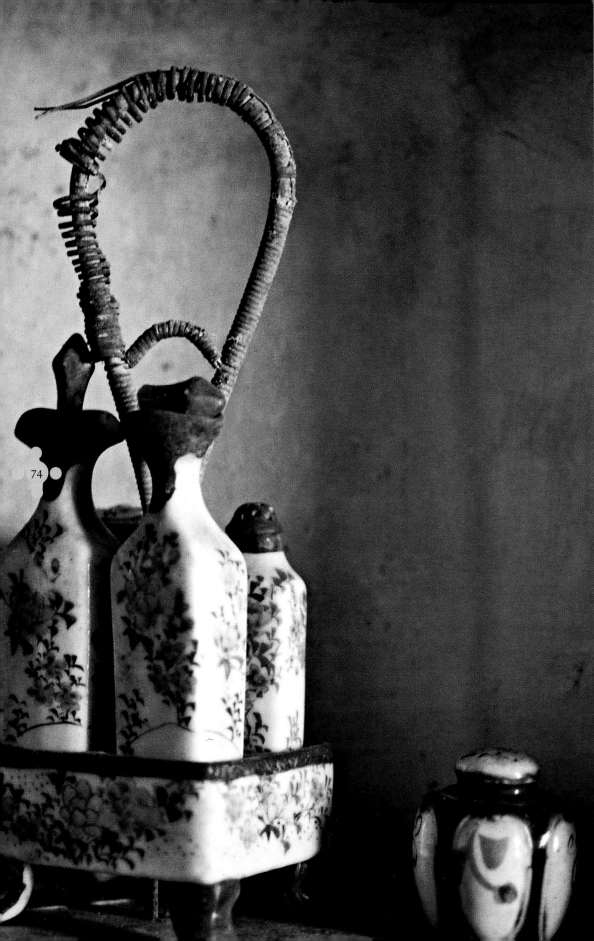

Traditional Indian dwellings have little or no furniture, apart from what is strictly necessary for sleeping, eating, and storage. It was Western influence – first that of the Portuguese trading posts in the sixteenth century, and then, more significantly, that of two and a half centuries of British colonization – that led the rich to want furniture and china. The skill of Indian craftsmen was harnessed for these hybrid interiors, where indigenous hardwoods, mother-of-pearl and ivory came together with Chinese porcelain and Venetian glass.

LEFT
A memory of international trade in the days of the Portuguese in Goa: Chinese porcelain painted with delicate flowers.
RIGHT
Carved panelling in an eighteenth-century Indo-Portuguese house in Goa.
• Goa still retains some buildings from Portuguese times, but few interiors. The Solar dos Colaços, in the village of Ribandar, looks out to the River Mandovi; it was built in 1730 for a local family ennobled by the king of Portugal, and their descendants still piously watch over the collections of Far Eastern porcelain displayed in glass-fronted cabinets made of Macassar ebony.

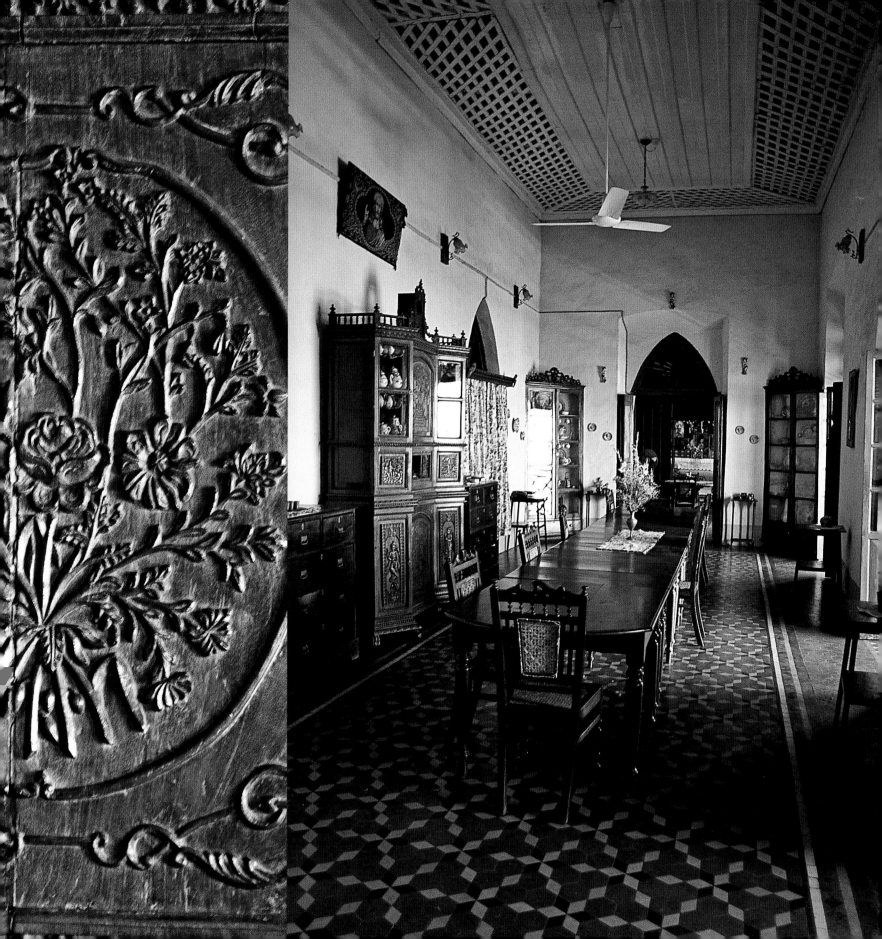

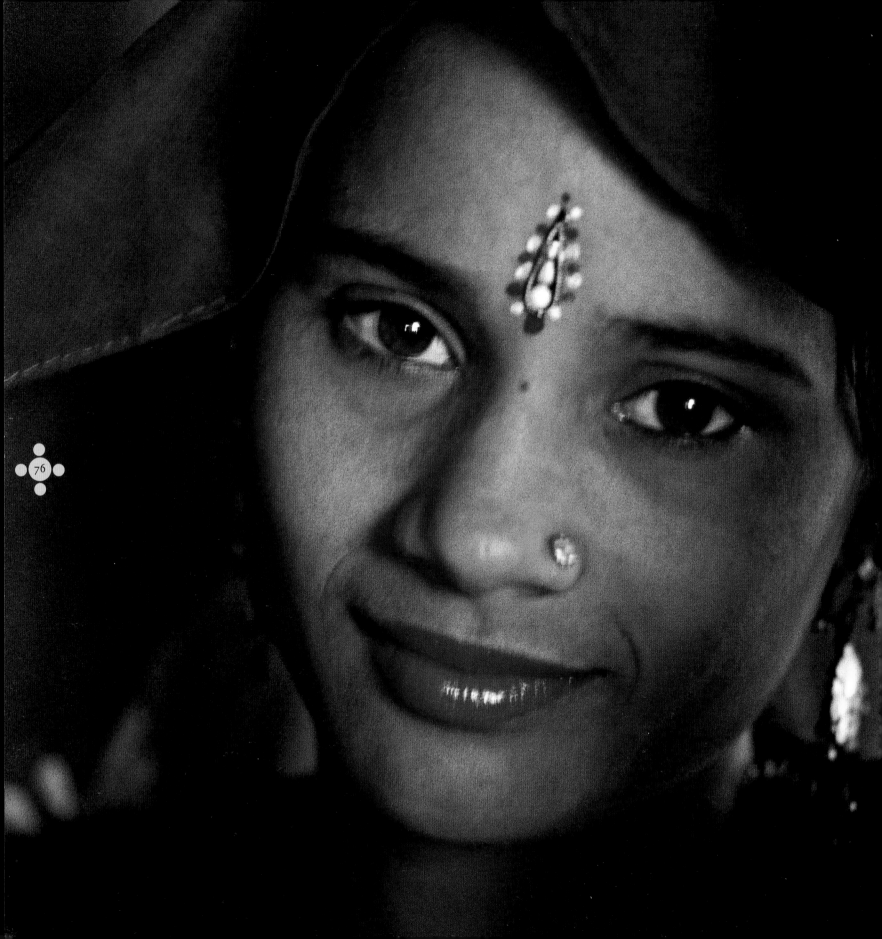

There are many women – beauties from Sind, clothed in silk pyjamas and white veils; from Kathiawar, with laughing faces, wearing short velvet tunics embroidered with silver; from Central India, small, tanned by the sun, laden with heavy gold bracelets on their wrists and silver bracelets like shackles round their ankles; or women of Bengal, with honey-sweet smiles half-hidden in the shade of a veil, wearing blue saris drawn up over their hair, intoxicated with the incense-like perfume of oils and essences.

Mircea Eliade, *India*

LEFT
Except on their wedding day, Indian women wear hardly any make-up, apart from the *bindi* in the centre of their forehead, which may be a jewel, matching a fine nose ring.

78

In both town and country the kitchen is the woman's realm. An all-purpose board, something to cook on, a pan and a skillet are all that is needed to make wonderful dishes. The flavours of India depend on skill and subtlety, and the practical equipment can be contained in a pocket handkerchief, a stairway landing, or the corner of a courtyard. But even when the kitchen is nomadic, it is always extremely clean, swept every day and washed down thoroughly at least once a week. Unlike the living room, which is open to all and sundry, only a few people are allowed into the cooking area – and that always barefoot, out of respect for the goddess who lives there on the corner of a shelf.

LEFT
A stainless steel pan and wooden rolling pin to make *chapatis*, the unleavened flat breads that accompany curries.
RIGHT
Squatting by the wooden board that serves as a work surface, a young woman kneads the daily bread.

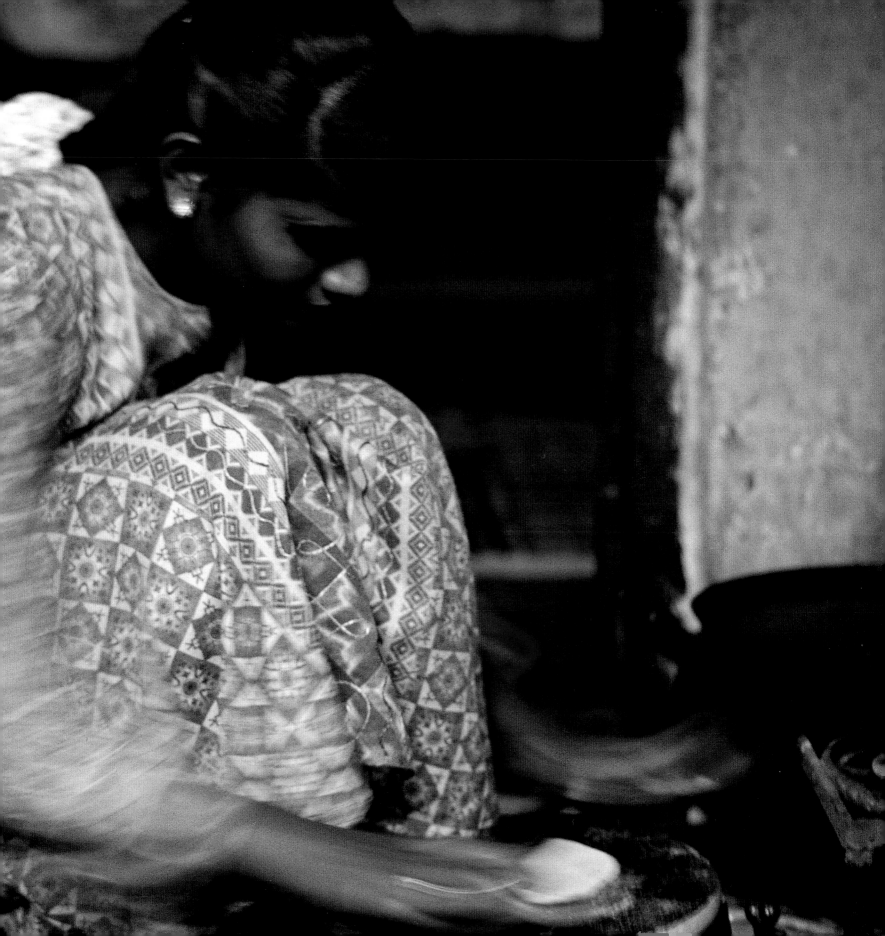

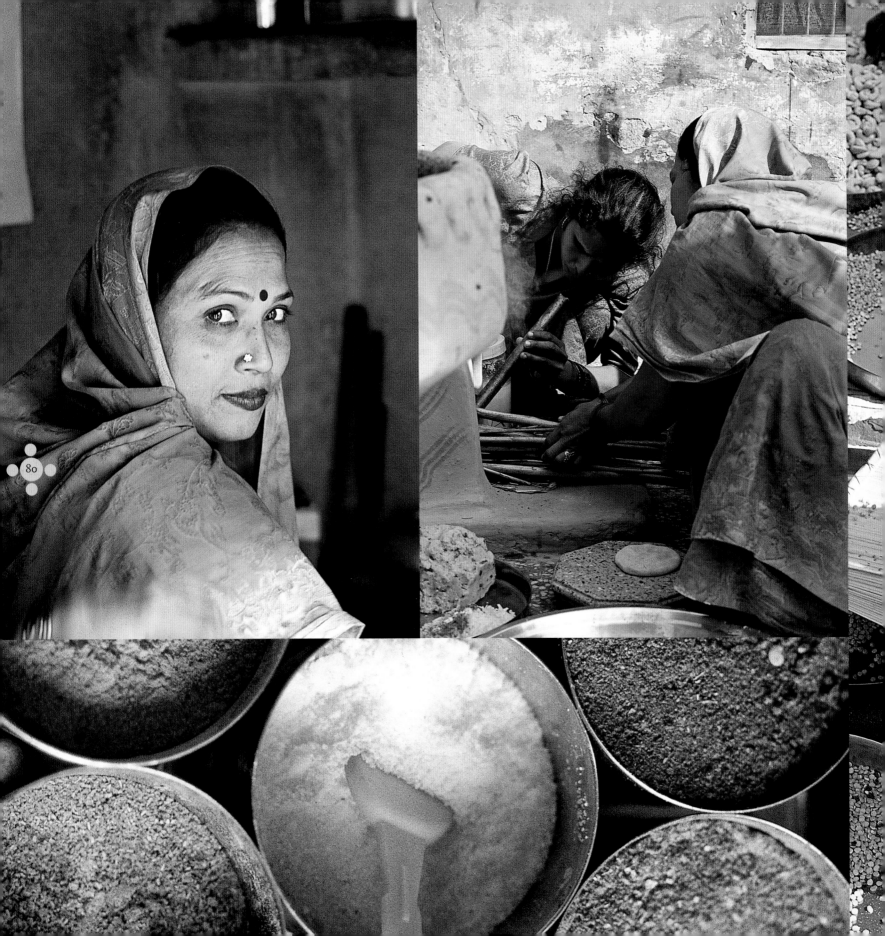

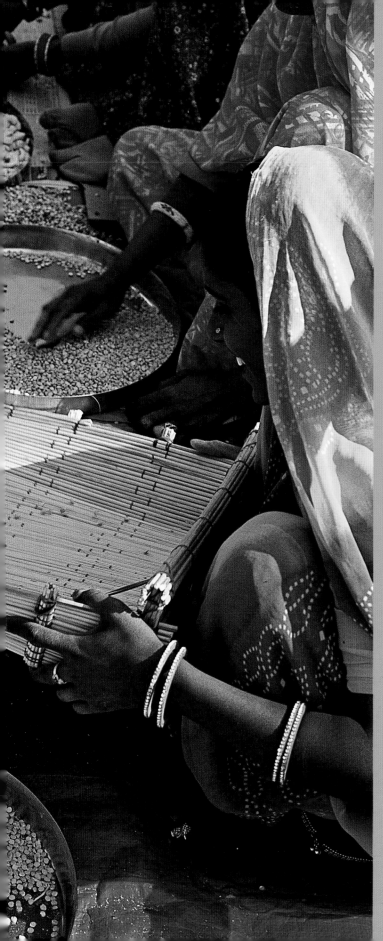

Indian cooking requires few utensils, but it is demanding of time. Fetching water and preparing the fire in the oven are the essential preliminary steps in the country. The different varieties of *dal*, the lentils that are at the heart of every meal, must be carefully picked over before being cooked as a stew, gruel or thin porridge; and the spices that create the dazzling range of Indian flavours have to be measured, mixed, toasted, and pounded in a mortar, to amaze the tastebuds with the scents of *masala*, the aromatic cocktail that varies from season to season and house to house.

LEFT
A glance from an attentive cook in the rural suburbs that surround Delhi. • In northern India, 7 o'clock is the time to light the clay oven to cook *parathas*, potato pancakes stuffed with spiced vegetables. • A rainbow of spices in stainless steel bowls. • Women working together to pick over lentils in Tamil Nadu.
RIGHT
Running water – the most precious of all things in lands on the edge of the desert – is only enjoyed at home by a few city dwellers. As soon as they are old enough to carry it, young girls take their place among the women in the daily task of fetching water from the village well.

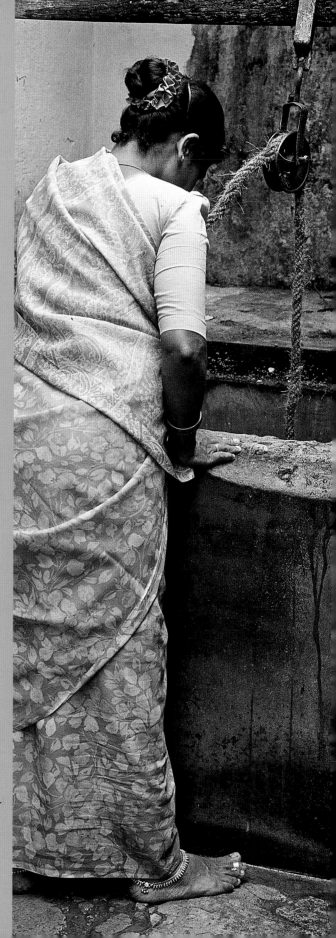

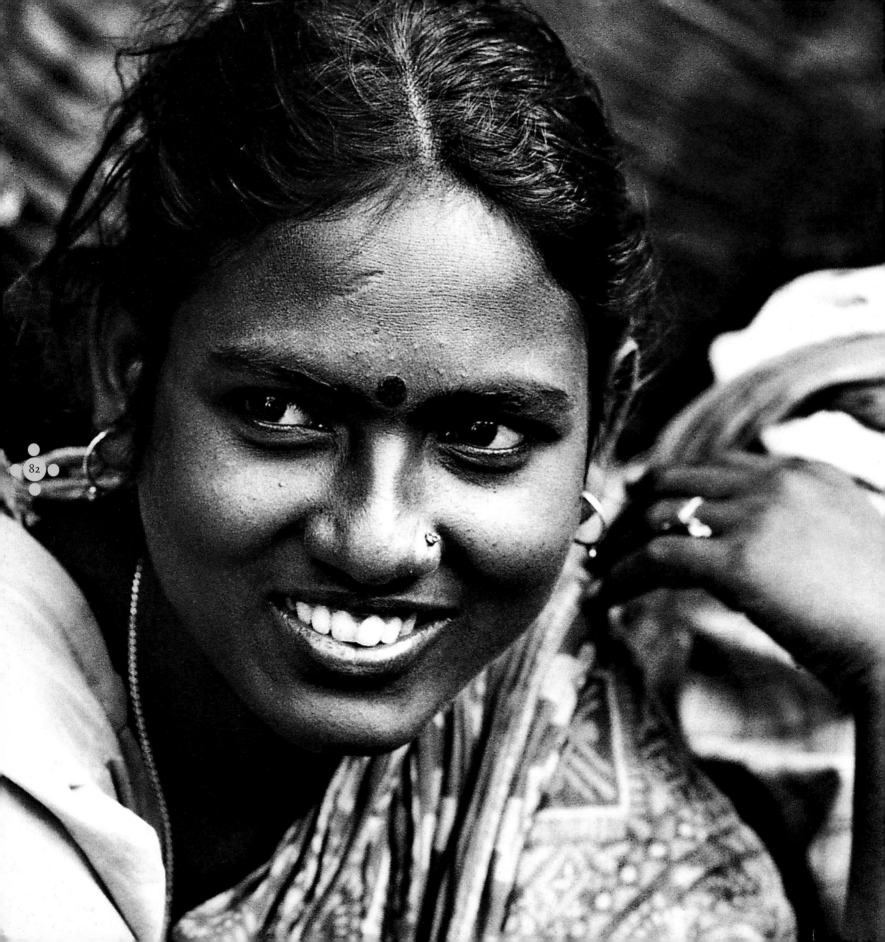

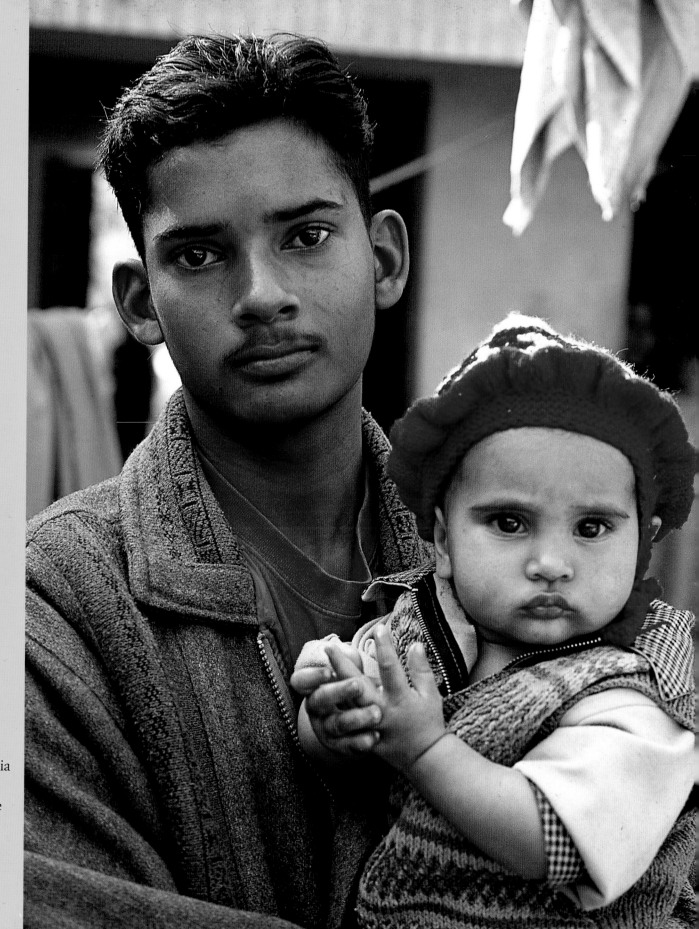

Being born a girl or being born a boy entail two very different destinies. The decisive moment is when a young bride moves into her husband's household. Little girls are cherished like a treasure that you know you will lose one day, while little boys are nurtured like a sapling that will extend the family forest. Even in the India of the twenty-first century, there is little sign of a change in attitude.

LEFT
The radiant smile of an unmarried girl.
RIGHT
The serious look of a young father.

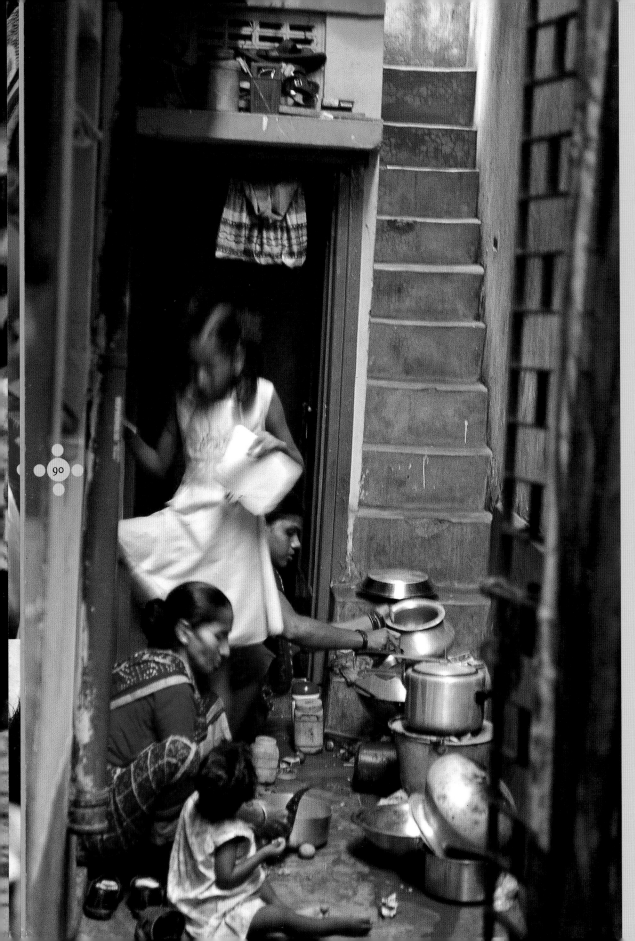

90

Private space has to be won and carefully guarded when you are surrounded by so many people. Women, as mistresses of the household, are in charge of these essential territorial expansions. On the pavement, they jealously guard the family's encampment, using ingenious strategies to colonize the smallest cranny. To protect your property, all you need is a padlock: available in a wide variety of models – some more symbolic than effective – they bedizen everything from chests containing personal effects to front doors and the shutters of shops.

LEFT
The kitchen spills out into the stairwell.
RIGHT
Sunday is the day of padlocks for the thousands of stalls in Mumbai, which close on that day. • Time to enjoy a bowl of delicious *lassi*.

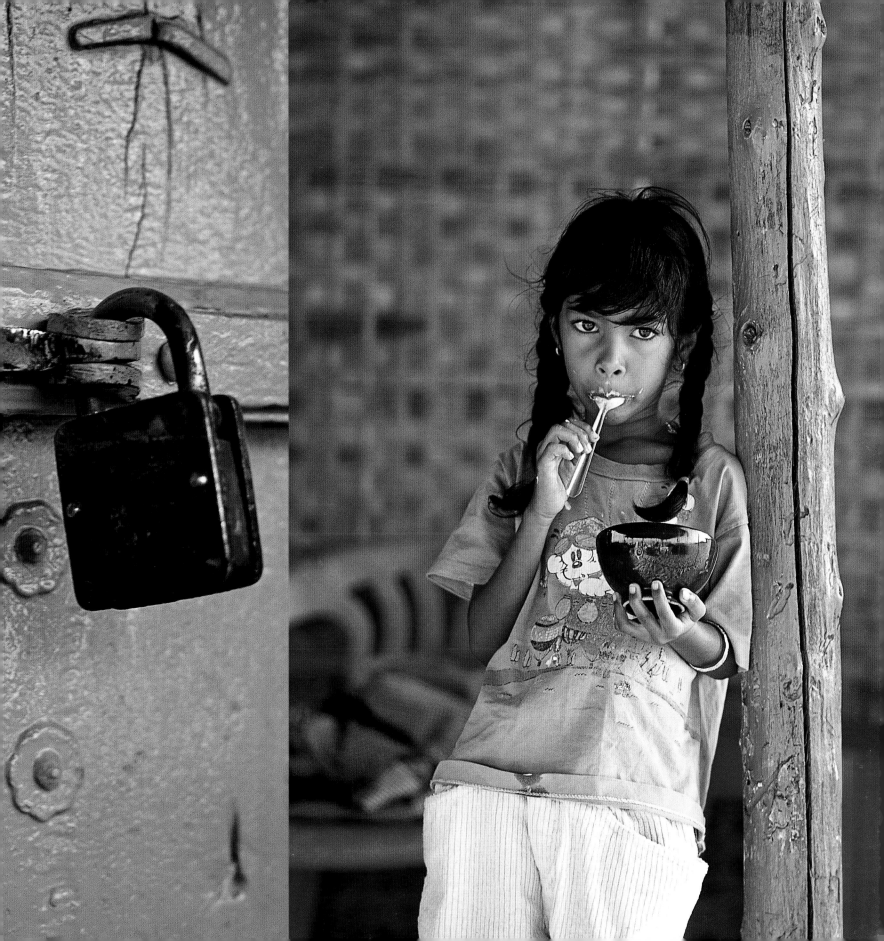

BAZAARS & MARKETS

Squatting in front of the blue tarpaulin, Mr Seth scrutinizes the fishmonger's stall. He decides on a shad, and picks it up – but it is stiff, not fresh enough. He picks up a smaller fish, a sea perch, and opens its gills: scarlet red, perfect, the fish is fresh. Mr Seth pays for it and slips his booty into his plastic shopping bag. Mission accomplished; he now has the central element of lunch – fish, an essential item on the menu in a Bengali home. Taking a shortcut through the shady hall of the New Market, he greets a colleague who has also come for a catch on his way to the office. The market is the belly of the city of Kolkata, but Mr Seth does not spare a glance for all the things on offer there: he would have no idea how to choose among the dozens of varieties of fresh vegetables, which are familiar to him only once Mrs Seth has prepared them and served them up. On leaving the market, his feet lead him towards his favourite sweetshop. His sea perch is perfect, and he deserves a milk sweet as a reward. Mr Seth enjoys his *mishti doi* at the counter, served in the earthenware vessel in which it was slowly cooked. With a casual, detached glance he surveys the activity of the market at this early hour.

Mrs Seth will be here soon. Only she – apart from her mother – knows how to shop in the bazaar: how to choose the vegetable that is in season, how to judge the quality of the various varieties of peas at the *dal* merchant, how not to be cheated by the vendor of rice in bulk, how to renew the stock of spices, are tasks of which women know the secret. They alone have mastered the layout of the urban bazaars. Even here in Kolkata, you hardly ever find anything like a convenience store, let alone a supermarket like those Mr Seth saw when he went to visit their son in the United States. Merchandise is arranged by type, but here as in Mumbai these 'departments' are scattered throughout the city: New Market for goods kept cool, Machua Bazaar for fruit – must remember to ask Mrs Seth whether pomegranates are in season yet – and Bara Bazaar for everything else, i.e. for manufactured goods. Almost everything for the

"No one throws away anything broken, because there will always be someone to patch it up or cobble it together"

kitchen can be bought there – trays, plates and glasses. Mr Seth himself has only been twice to Bara Bazaar. The first time was when he wanted some plastic-coated business cards, and he was directed to the section selling paper and office supplies: there he discovered piles of notebooks of every size, with all sorts of ruling and columns of the sort that Indian administration departments love, for even in the age of computers Indian white-collar workers are formidable consumers of paper. The other time was when he wanted a new gear lever for his car, because the old one had broken. He found an exact match, with a grey Bakelite knob, lurking among levers with flashier plastic handles ornamented with artificial roses or lotus flowers. You can get anything there, true, but it is not easy to find your way around. That Bara Bazaar is patronized by women is clear from the vendors of scrunchies, hair slides and bindis (forehead ornaments) clustered round the entrance. Mr Seth's national pride is a little bit shaken. There are too many reminders of years of penury. When he was

looking for his gear lever, people said he should have it repaired rather than buy a new one. No one throws away anything broken, because there will always be someone to patch it up or cobble it together. And what of all the objects created out of recycled materials – all the containers made from tin cans and oil drums, cut up, hammered, soldered, riveted, fitted with glass, mirrors, hinges, hooks and handles! What a lot of time it must all take! Clearly manual labour here is cheaper than the raw material . . . And then there is competition from things 'Made in China'; Mrs Seth is very proud of her Chinese oilcloth decorated with goldfish. Mr Seth glances at his striped plastic shopping bag – a quintessential product of Bara Bazaar recycling. What geniuses these merchants are, though, he says to himself, as he scrapes out the last *mishti doi* with his spoon: they manage to sell things even to people with almost no money at all! It is said that they build up a fortune, rupee by rupee, from selling strings of detergent in tiny sachets.

The market vendors' day starts in the small hours of the morning. Trucks arrive with loads of boxes, cartons and bales, tied up into pyramids with miles of rope; then men and women porters, armed with baskets, climb barefoot up the mounds and disperse the contents to the various stands in the covered market. Outside, villagers who have arrived from the country – which is never far away, even from the largest cities – set themselves up to sell their vegetables.

PRECEDING PAGES
Unloading cases at Bara Bazaar, Kolkata.
LEFT
Yesterday's newspaper makes a basket for courgettes.
RIGHT
Once a week, families from the country, like this father and daughter, come up to the city to sell their produce.

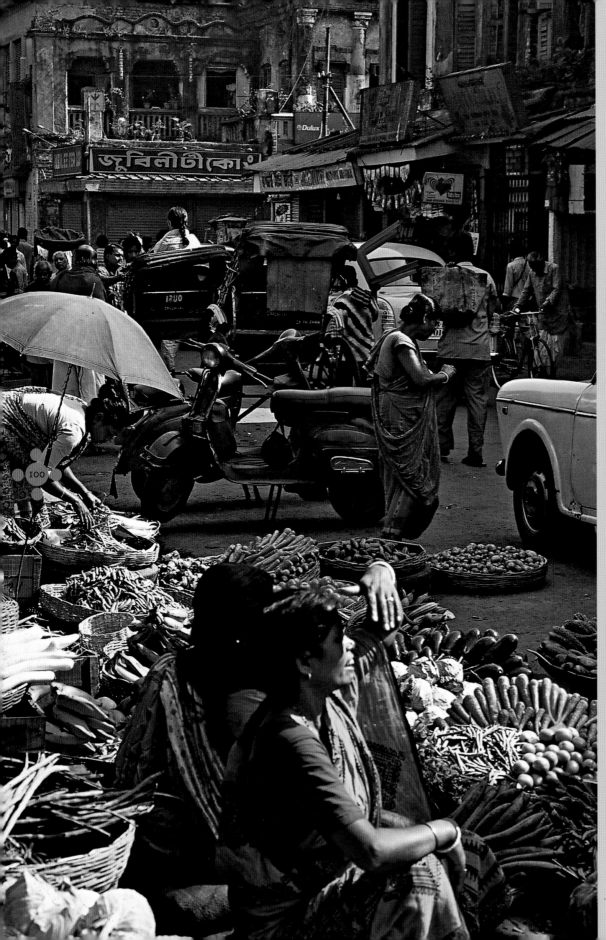

India is traditionally a vegetarian country, but only a very small proportion of the population are vegetarian by conviction. The two main religions of India impose dietary prohibitions: Hindus must not eat beef, and Muslims must not eat pork; but most people do not eat meat or fish for economic reasons. Vegetables grown in the surrounding countryside are sold in the city markets. Given the wide variety of soils and climates in the vast Indian subcontinent, there is an immense range throughout the seasons: cream aubergines marbled with violet, pink-veined beans, dozens of kinds of squash, bunches of spinach and purslane, the slender okra (known as 'ladies' fingers'), cabbages and cauliflowers . . . the list is endless.

LEFT
Vegetable sellers in the New Market, Kolkata.
RIGHT
A selection of squash in the market at Cochin, in Kerala. • A woman carrying serpent courgettes weaves her way through the Monda Market in Secundarabad.

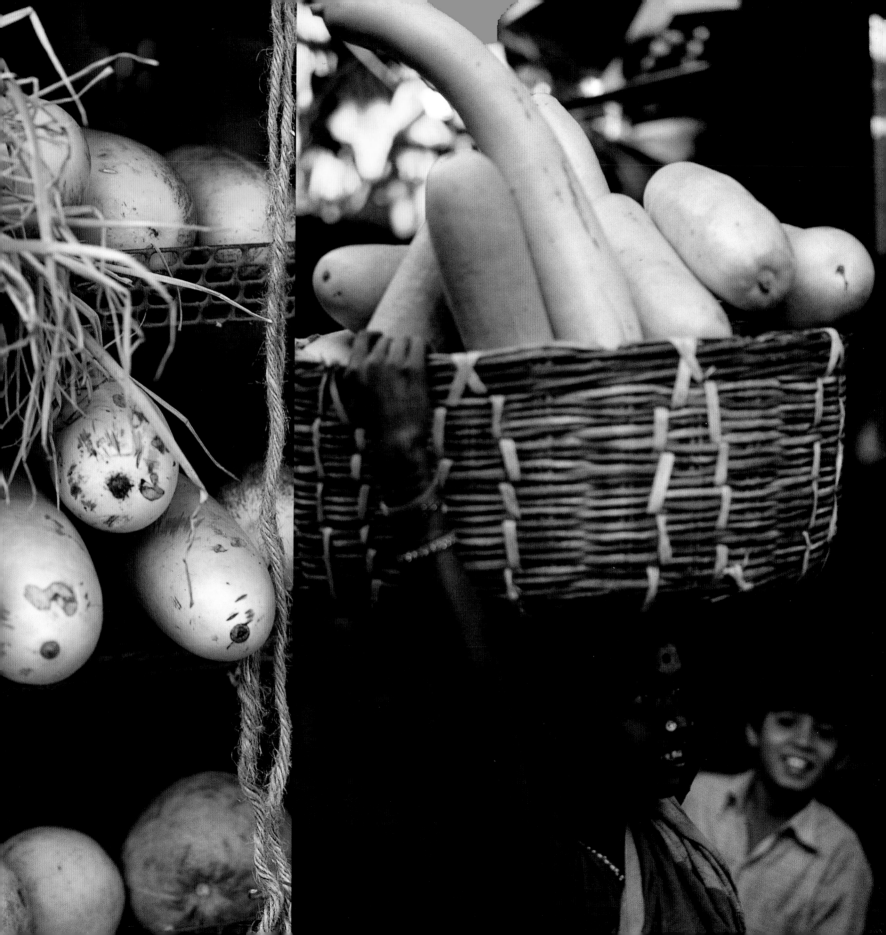

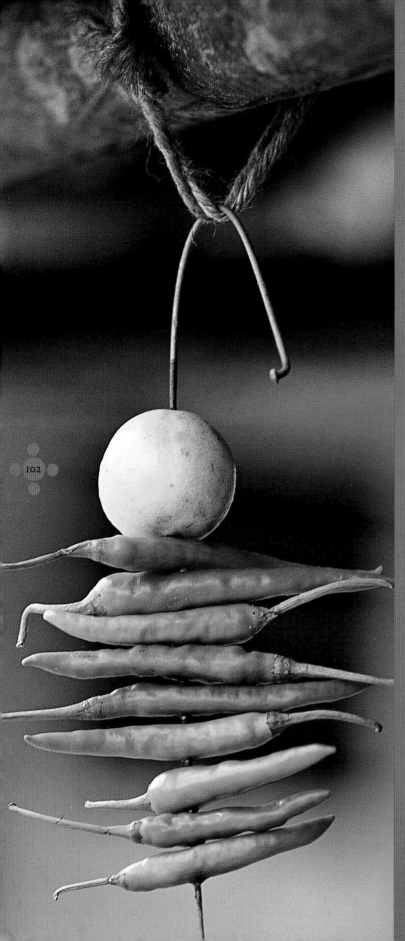

In the decades after independence raw materials were very expensive, while manual labour was plentiful, self-renewing, and very cheap. Thus it came about that India, without particularly wanting to, became expert at every conceivable sort of recycling: necessitated by years of hardship, it became an art. Metal, the most expensive and rarest material, underwent incredible transformations. While China was devising pocket-size blast-furnaces for its communes, India was bending, riveting and hammering scrap metal to make bathroom shelves, souvenir stands, bedside tables with drawers, and suitcases with inner compartments. These ingenious metal products continue to be sold in bazaars, but now they have been joined by plastic: 60 per cent of plastic goods are collected, recycled, and transformed by sorting, weaving and moulding into new vessels, toys, shopping bags and other objects.

LEFT
A composition to avert the evil eye at the front of a shop.
RIGHT
Bowls made of recycled metal in a shop selling pulses. · Marvels of ingenuity in an ironmonger's shop.

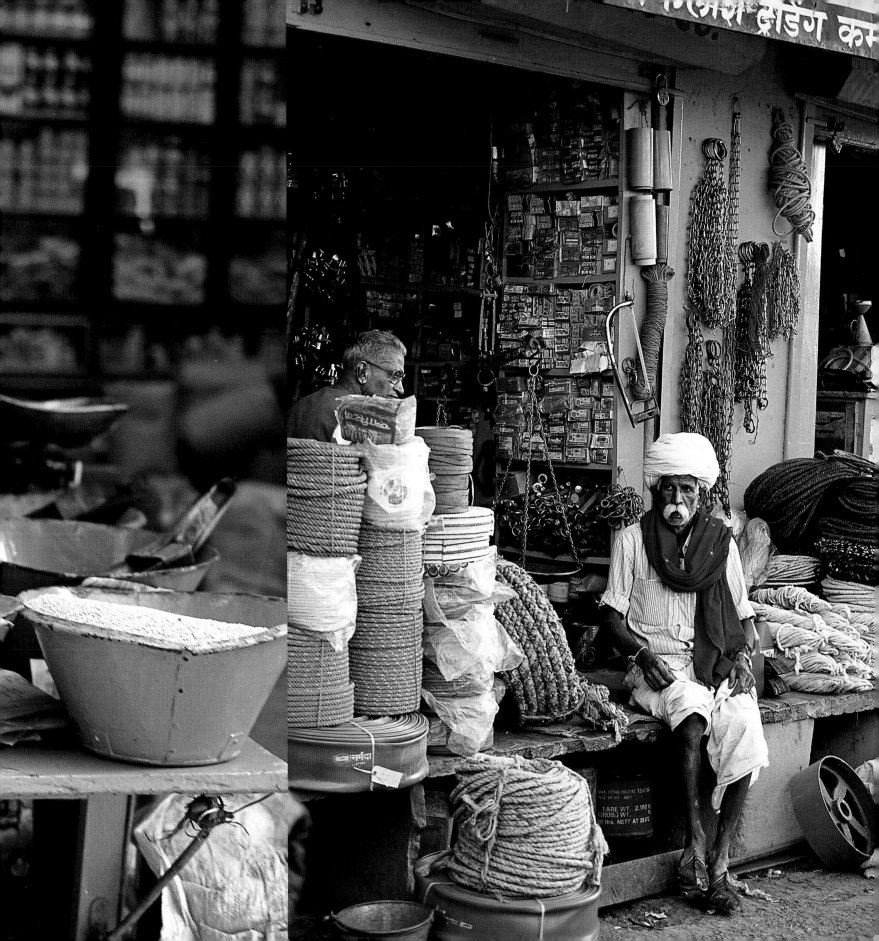

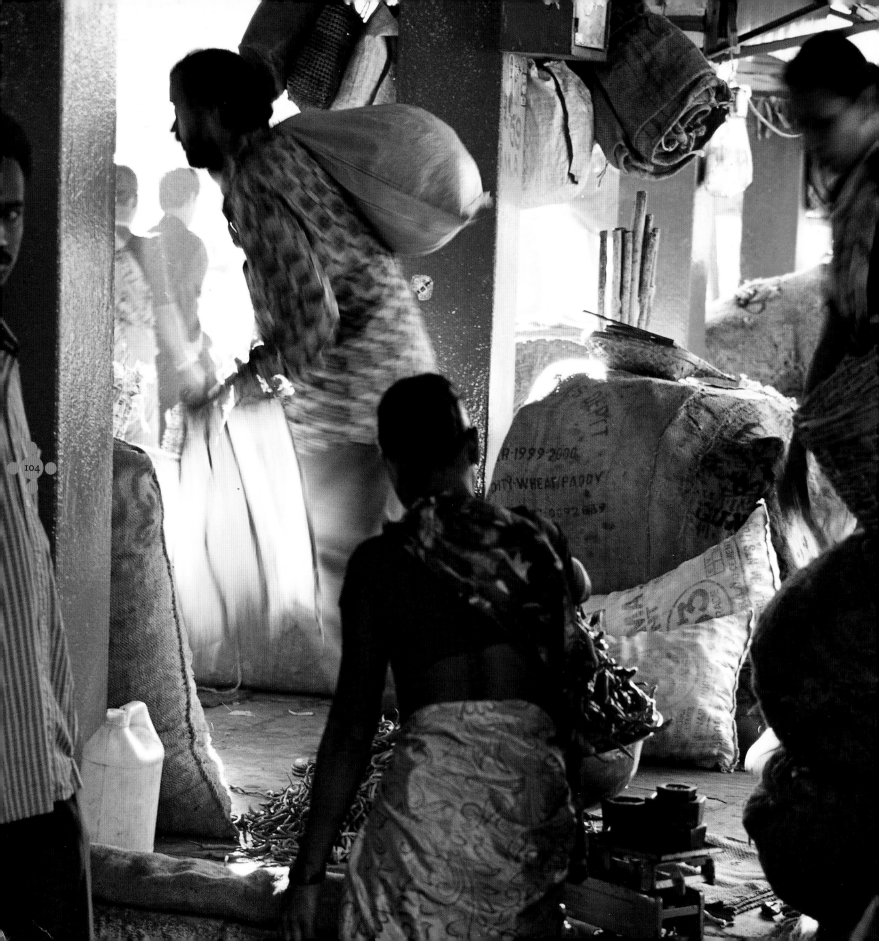

Above all I liked the singing sales pitch of the vendors: gobhi-alu putchee-putchee; alu-gobhi putchee-putchee. Ek rupaiya pyaaz – khaye mian nawab; khaye mian nawab – ek rupaiya pyaaz. Many of the criers were like Hindustani classical musicians, stoking up riveting patterns with the same words. Soft, low, high-pitched, extended, cantering, trotting, galloping. Bhindi-tori, bhindi-tori; le le bhindi, le le tori; tori le le, bhindi le le; le le bhindi, le le tori; tori-bhindi, bhindi-tori; thodi bhindi, thodi tori; tori-bhindi, bhindi-tori. They would go into a trance of chanting, and if you closed your eyes you could imagine you were in a music school with students flexing their chords.

Tarun J. Tejpal, *The Alchemy of Desire*

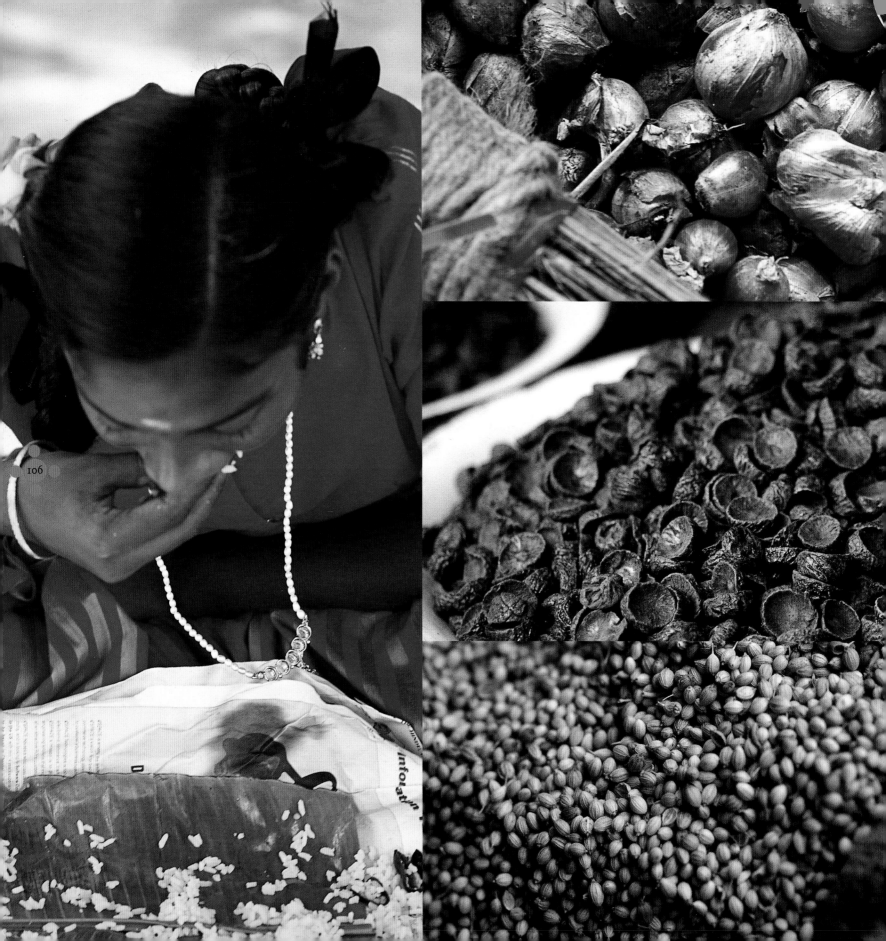

A tour round a market is
a tour round the flavours of
India, heightened by vivid
spices. The word 'curry', used
in Western languages for the
flavours that envelop and
enhance fried vegetables, fish,
a lamb hotpot or a chicken
casserole, comes from the
Tamil word *kari*, which means
'sauce'. The flavours come
from a cocktail of spices and
seasonings, which is called
masala in Hindi and *podi* in
Tamil. There are as many
different recipes as there are
different communities and
cooks. Peppery ginger,
sharp mustard, fiery chilli
and pepper, cool cumin
and cardamom, sweet and
powerful cloves, sweetly bitter
fenugreek – all call out to the
noses of shoppers in the
market.

LEFT
Pilau, the dish of spiced rice, is even
more delicious when you eat it with your
fingers from a banana leaf. · Indian
flavourings: sweet red onions, pepper,
coriander seeds . . .
RIGHT
Curry leaves are in themselves a bouquet
of flavours. · Ripe squash in a shady
covered market. · Very few *masalas* can
do without the fire of chillies.

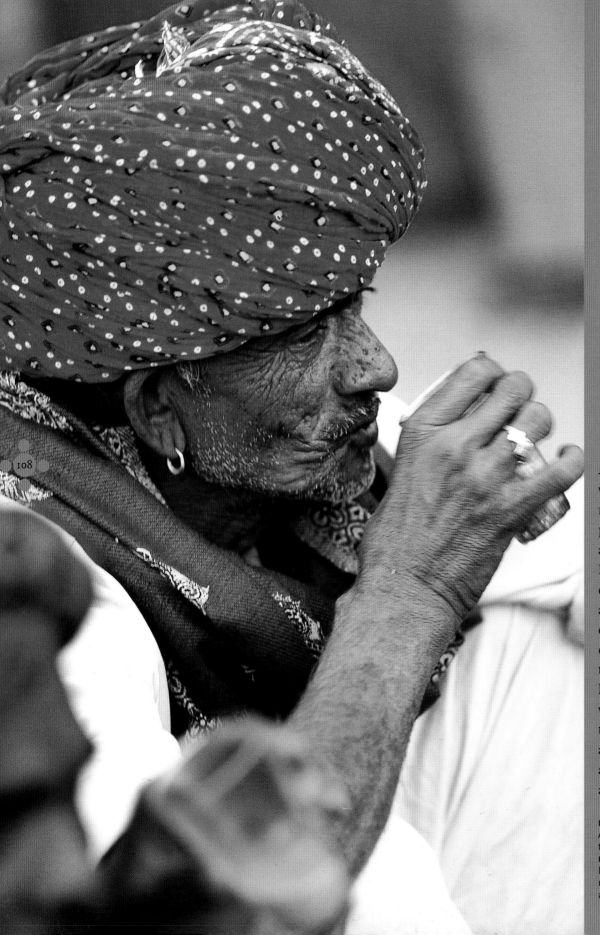

108

As in all the countries of the world where there are food markets, the bazaar is the place for social contact as well as financial transactions. Daily, or weekly in the case of those who come from far away, people meet and talk of common interests and domestic concerns – whether the monsoon rains are early or late, the next holiday, the latest wedding, an imminent birth, the good and bad points of a popular movie actor, and above all the chaos of politics and the corruption of officials.

LEFT
A Rabari herdsman from Gujarat takes a tea-break.
RIGHT
Packets of fruits with the acid taste of redcurrants. · A mother and her son at a food market in Bengaluru (Bangalore).

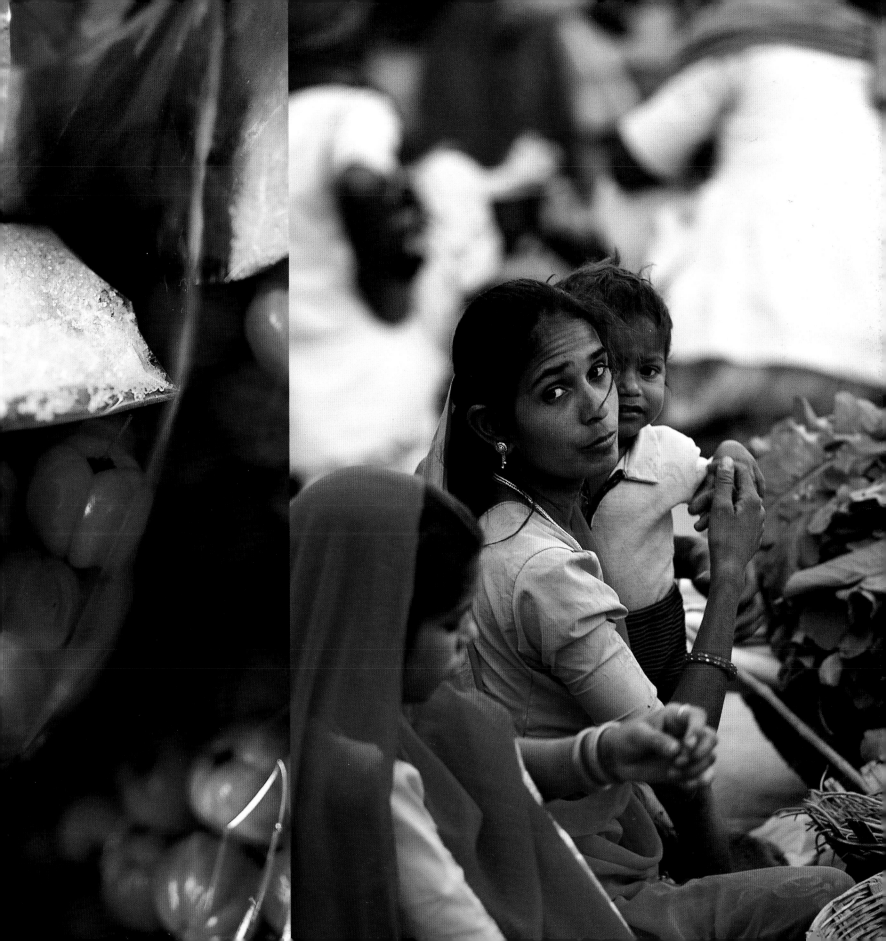

Outside, the peripatetic vendors started to arrive . . .
The potato-and-onion man got louder as he
approached now, 'Onions rupee a kilo, potatoes
two rupees', faded after he went past, to the creaky
obligato of his thirsty-for-lubrication cart as it
jounced through the compound. He was followed by
the fishwalli, the eggman; the biscuitwalla; and the
ragman who sang with a sonorous vibrato:
'Of old saris and old clothes, I am a collector,
Of new plates and bowls in exchange I am giver . . .'

Rohinton Mistry, *The Beautiful Days of Firozsha Baag*

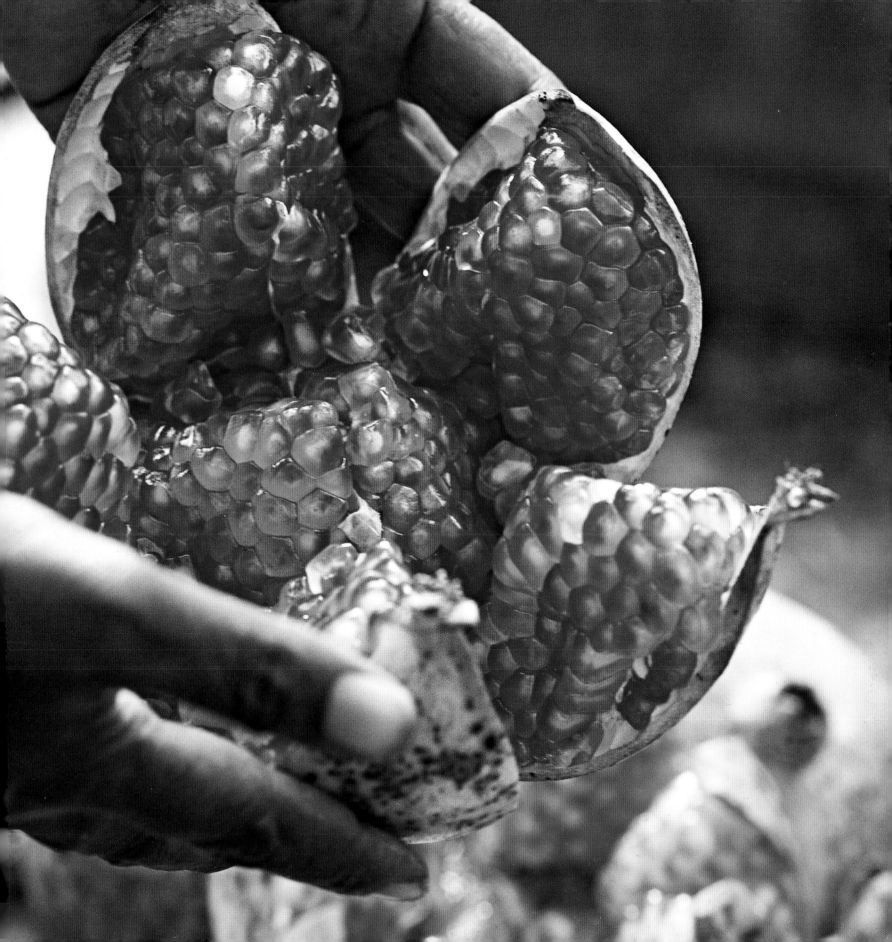

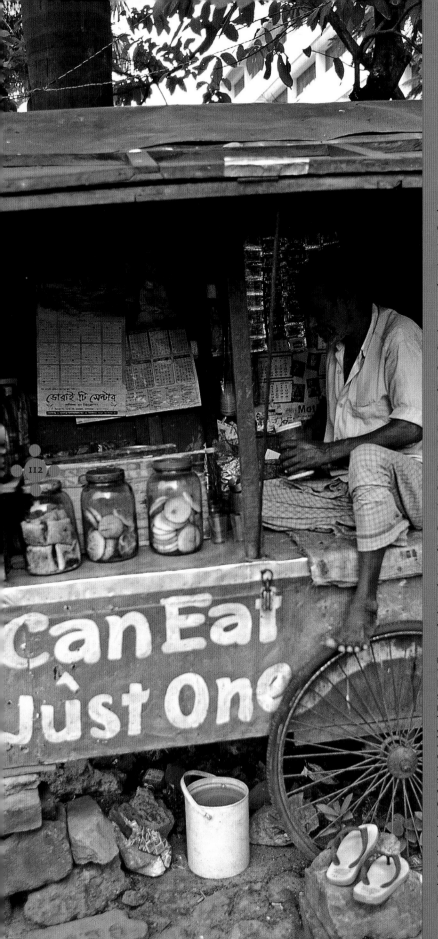

A market without a section of ready-to-eat delicacies is unimaginable. In the North, they are called *chaat*, 'that which excites the palate', in Gujarati *farsan*, and 'tiffin' in Anglo-Indian. There are sweet or savoury things baked in a crust, conical wafers, an astonishing range of crisp and soft pastries, stuffed or plain, sweet or savoury, bite-size or big enough for a meal. At its simplest, the stock in trade of the *chaatwallas*, or sellers of these delicacies, consists of *channa* (a mixture of spiced and salted toasted peas and peanuts), vegetables and fruit, washed down with large glasses of lime-juice-flavoured water, or sugar-cane juice.

LEFT
'Can Eat Just One': you needn't feel you have to buy everything on the travelling stall of this *chaatwalla*.
RIGHT
Turmeric roots give a bright saffron-yellow colour to many delicacies. • Menu and prices for take-away. • *Namkeen*, deliciously spicy fried goodies. • *Sandesh*, sweetmeats made from sweetened and scented curdled milk, pressed into wooden moulds with floral patterns. • *Gulab jamuns*, deep-fried balls of pastry in syrup. • A packet of *panch puren*, the five-spice mixture of Bengal.
The old photographs in the centre show, in the top row, a fruit market and a vegetable market in a school for Brahmins run by French Jesuits in Trichinopoly, 1908; and below, a market in Pondicherry, 1907.

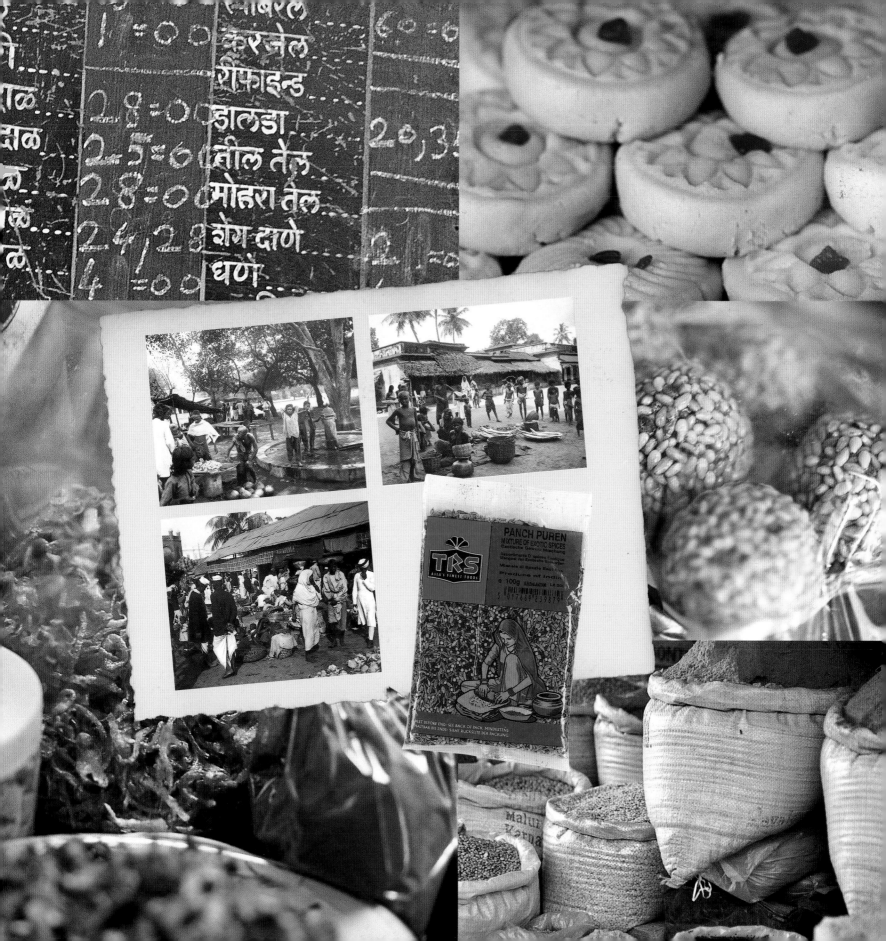

Bazaars reflect hard lives and an economy that has long known poverty. Housewives have no refrigerators, so they shop for the day's meals. There is an impression of plenty, but that is because of the large number of merchants: everything is sold in small quantities. Strings of packets filled with *supari*, a fragrant mixture for chewing, gave people the idea to package detergents and shampoos in the same way and sell them individually. At the heart of this economy is recycling, which gives used raw materials an infinity of new lives.

LEFT
Eggs, sold individually.
RIGHT
Tubs made of recycled metal. • Coins of 1 rupee and 50 paise, the smallest denominations of all.

Something else to look forward to in the market is *paan*. More goes into this powerfully astringent mouthful, which stains not just your saliva but your teeth red, than chopped or ground betel nut. The *paanwalla*, drawing on his flasks and bottles, mixes flavours to entice the customer. On a fresh betel leaf place a drop of lime no bigger than a fingernail, then add a hint of ground pearls, a thread of saffron and a trickle of clarified butter, and you have a promising start; then you can add gambier, camphor, cardamom, tobacco, nutmeg, cloves, musk, essence of rose or ambergris, and, for a gourmet version, a spoonful of date jam. Finally the betel leaf is folded in four and pinned together with a clove.

LEFT
Crushed betel nut and nutmeg.
RIGHT
A *paanwalla*'s scales, suspended from a fish, emblem of the last nawabs of Lucknow.

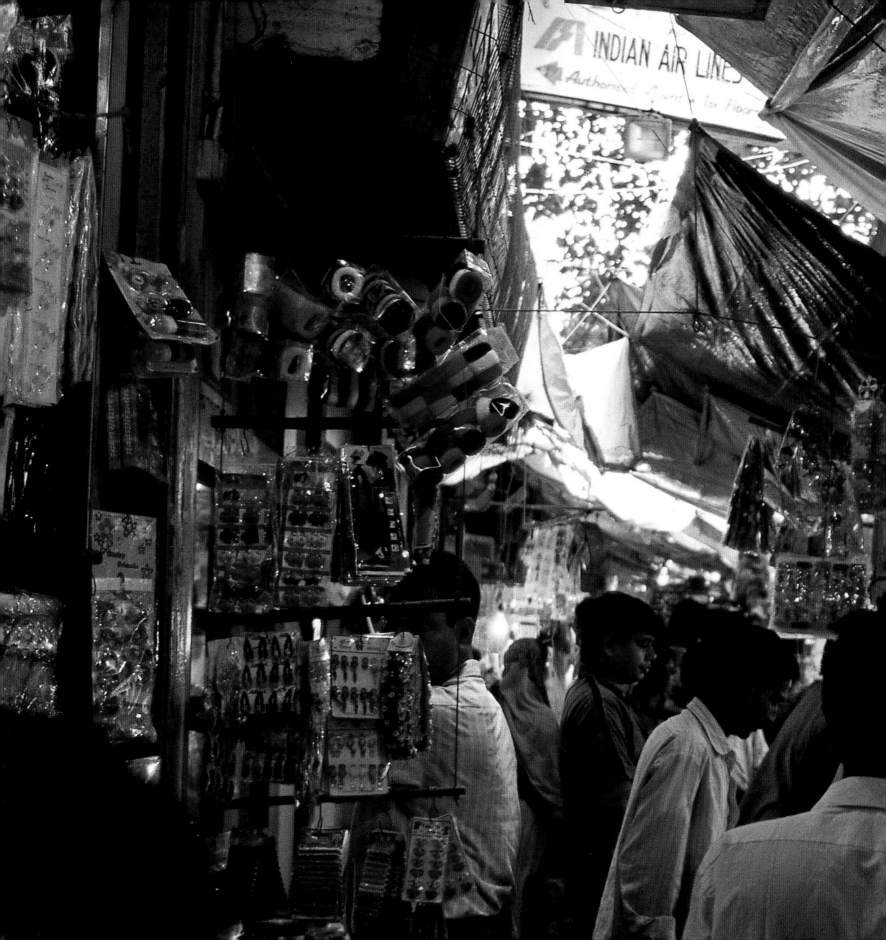

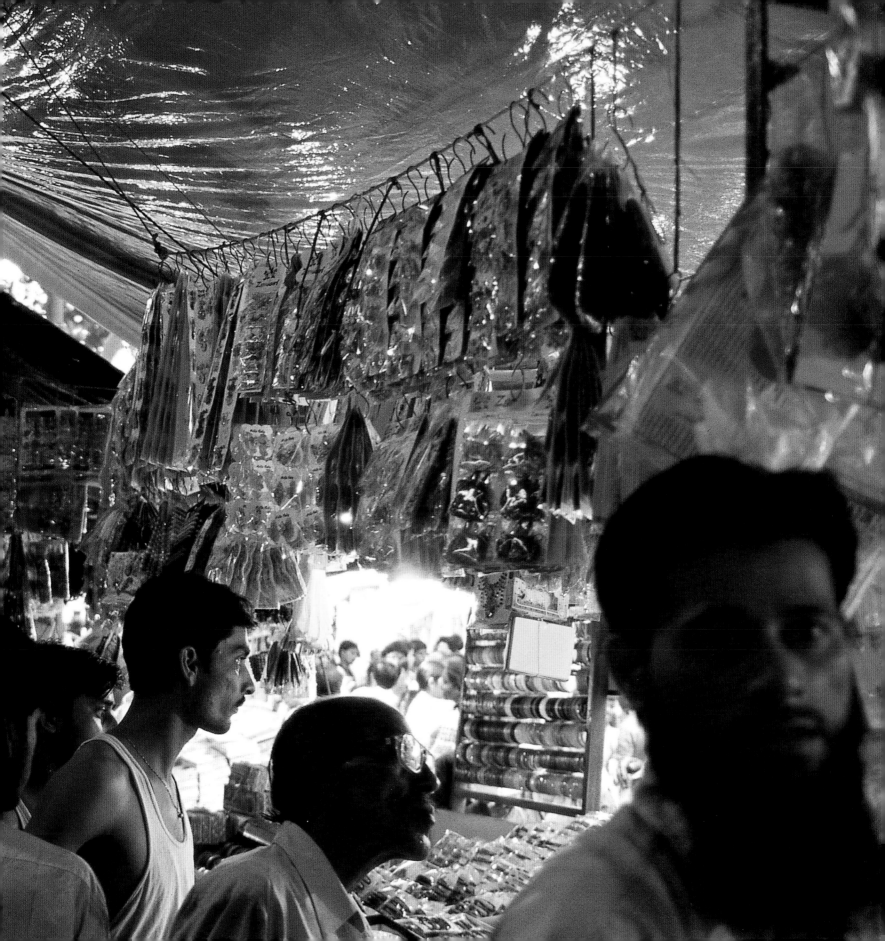

120

*B*ania is the Hindi name for the merchant caste; but in addition to Hindus, Christians, Muslims and Jews play the role of *bania* with equal success. In the first place, presentation and display must be modest: showing off one's money is taboo, and in poor taste. Then, there is the way you go about your business: looking busy is something to be left to businessmen. A *bania* counts the time but gives his own without calculation. Care is required in transactions, both with suppliers and with customers. What is needed is friendly persuasion – bargain without ever raising your voice, and always with a smile.

PRECEDING PAGES
Vendors of ornaments in Bara Bazaar, the great open-air market in Kolkata.
LEFT
A spice sorter in the warehouse district of Cochin in Kerala.
RIGHT
A jute sack displaying Assam tea. •
A Muslim vendor of stuffing fibres in Hyderabad.

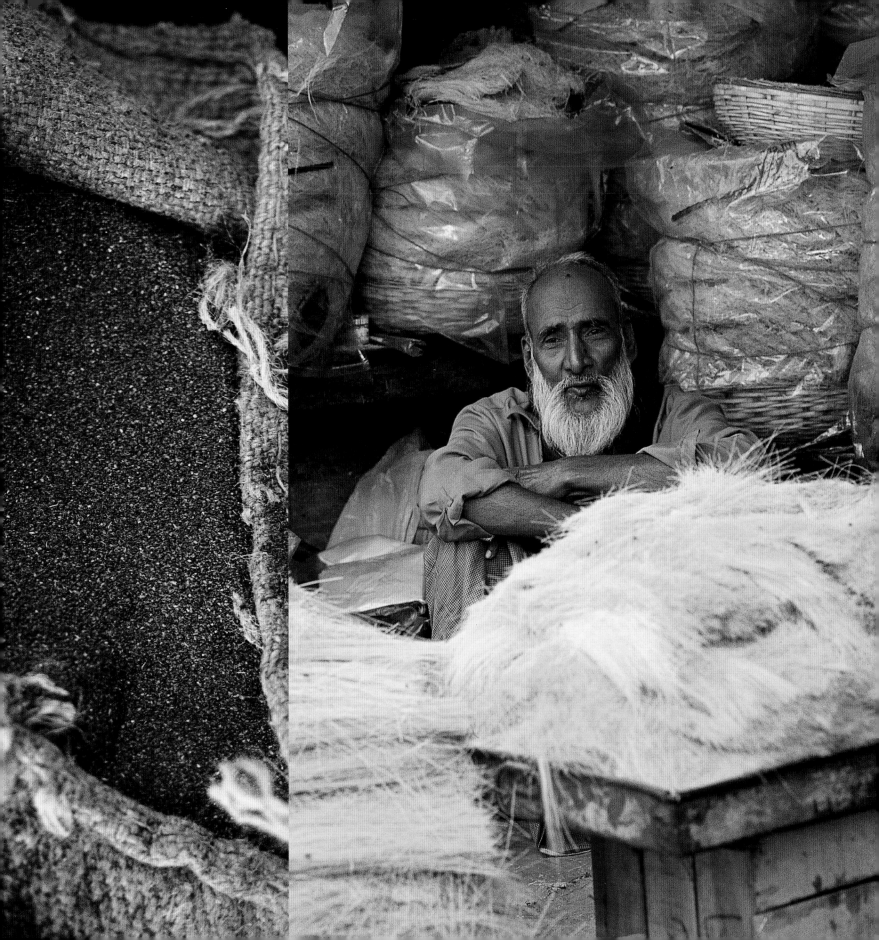

THE TASTE OF TEA

With a graceful gesture of her wrist, Sharmila hands back her empty *chai* glass to the grocer, and delicately licks the last drops of sweet liquid from the corner of her mouth. Even when she was little, when her mother took her along on errands in Darjeeling, she loved the taste of the tea prepared on a corner of the counter in this same grocery store. Sharmila smiles; many years have gone by, but the tea still tastes the same. The grocer's son, who succeeded him, measures out the mixture of milk, sugar, tea, and the little touch of cardamom exactly as his father had done, and he does it with the same dented spoon. He smiles as he takes the glass. He is Bengali. She is a Gurkha. Her eyes crinkle up above her cheekbones, which are tanned by the high altitude sun. It is Sharmila's weekly day off from the Ging tea plantation, where she works as a picker. Her mother and grandmother had been tea-pickers too: they had come from Nepal to work on the plantations before Indian independence, in the time of the British. Before the British, her grandmother told her, none of this had existed – not the acres of plantations on the steep flanks of Kanchenjunga, nor the tea factories with the name of the company written in enormous letters on their zinc roofs. Sharmila's husband works in the Ging factory: when she comes to meet him, she loves to smell the tea leaves lying in the shade on the upper floor – better than the ripe apple scent of tea being processed on the ground floor, where weird machines make a terrifying noise. She also loves the scented warmth of the drying house, when you go into it in the cold of winter. However, the tea here is not as good as that of the grocer in Darjeeling. She tasted it once, when the director of the plantation organized an anniversary celebration for all his employees, and it reminded her of the medicinal drinks she had been forced

> ## " The taste of the tea prepared on a corner of the counter in this same grocery store . . . "

to swallow when she caught a cold as a child, with a less disagreeable taste but not enough flavour. Outside, a great din signals the arrival in the station of the little train that has climbed up from Siliguri in the plains below. She has never taken it, and has never been to Siliguri. Her grandmother told her that the train, too, did not exist before the arrival of the British and the transformation of the high valleys surrounding Darjeeling into tea plantations. But tea – what an odd thing to choose! It seems that foreigners adore it. Several times she has seen groups visiting the factory and making purchases – Japanese, Europeans, she cannot remember what nationalities they were. What amazed her even more was the price they were ready to pay for something that had so little taste. That was quite normal, said the director of Ging, for Darjeeling is the 'cham-paan' of teas: Sharmila was not sure what this meant: it apparently had something to do with

a sparkling alcoholic drink made in Europe. About prices, on the other hand, she was not in doubt: she had seen them in the bazaar in Darjeeling, where a tiny packet cost more than 300 rupees! She is paid 55 rupees a day for 5 kilograms (11 pounds) of leaves, and she always picks a little more, for an extra 4 rupees a kilo. Sharmila shrugs her shoulders. Yes, they are heavy, all those leaves in the basket that she carries on her back as she works, bent over on the Ging slopes; but Sharmila loves her work: while her hands hunt out young leaves on the tea bushes she can gossip with her fellow-workers in her own language and listen to them singing popular songs in Nepalese, and when the monsoon rains are over she can see the snowy silhouette of Kanchenjunga against the blue sky.

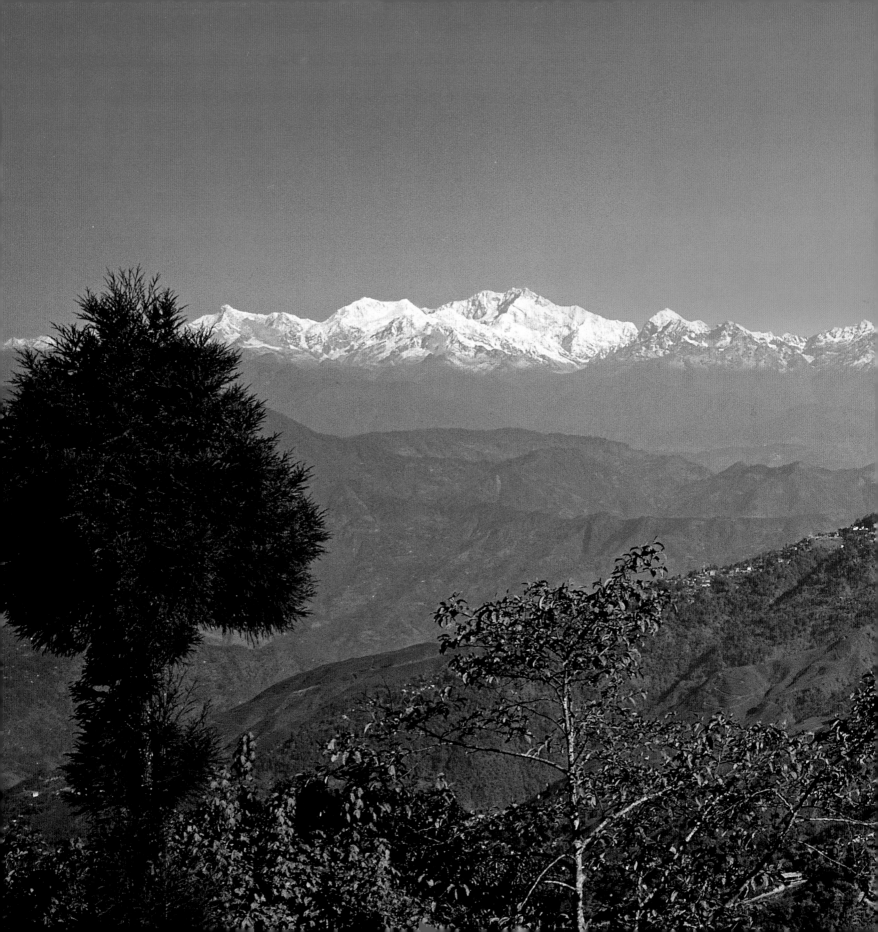

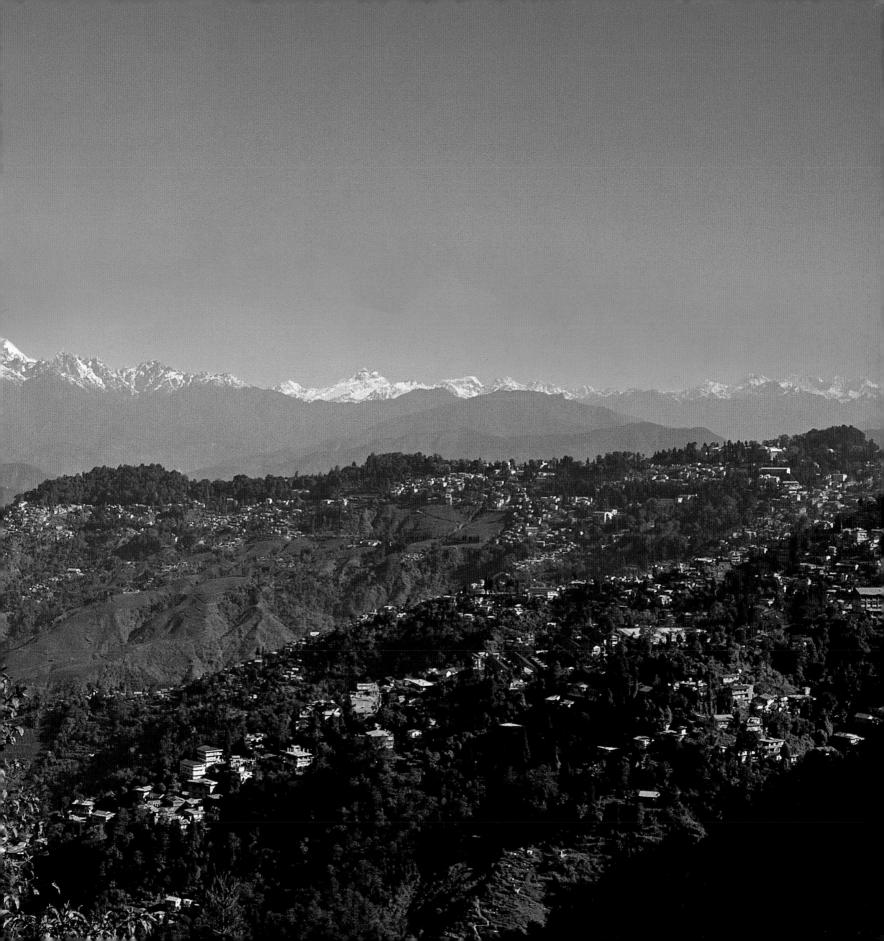

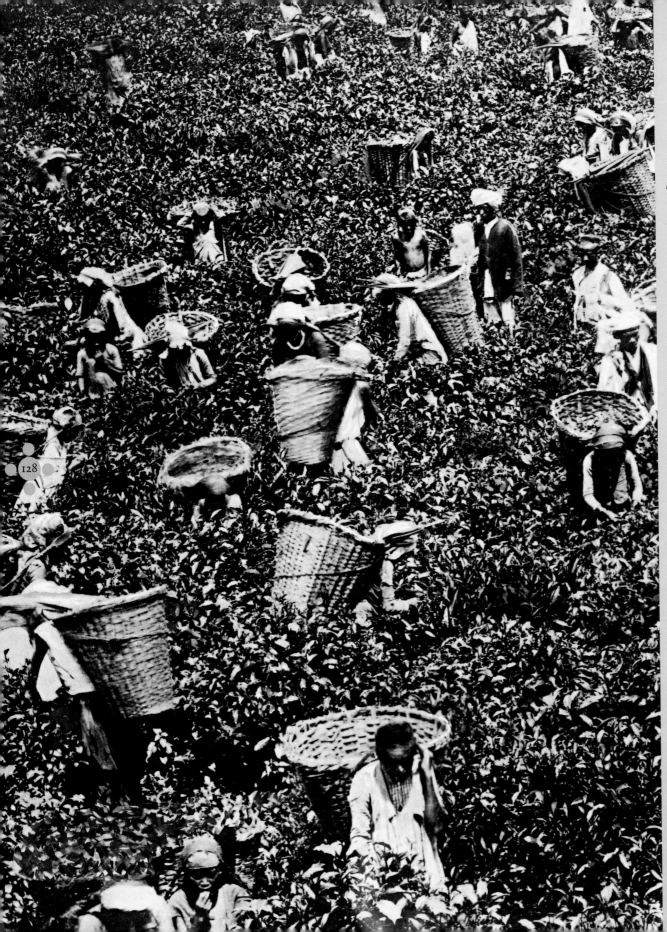

Tea picking goes on year-round, except in the rainy season. Ever since tea plantations were established by the British, it has always been women's work. In Darjeeling, in the foothills of the Himalayas, the tea-pickers are almost all Nepalese, descendants of brave Gurkhas who in the nineteenth century, when they were no longer needed as warriors in the kingdom of Nepal, turned to the new colonial industry. On the slopes, sometimes dizzyingly steep, work is hard, but the atmosphere is that of a village square. As they pluck the leaves from the tea bushes the pickers chat, laugh and sing in their own tongue. As a tribute to these hard workers, packets of Darjeeling tea bear as a trademark in a roundel the silhouette of a tea-picker holding a shoot with its bud and first two leaves.

PRECEDING PAGES
Darjeeling, seen against the backdrop of the Kanchenjunga range.
LEFT
An army of tea-pickers in colonial times.
RIGHT
A team of tea-pickers today. Thanks to the Plantation Act they wear stout rubber boots, and may call on an umbrella to protect themselves against the strong mountain sun.

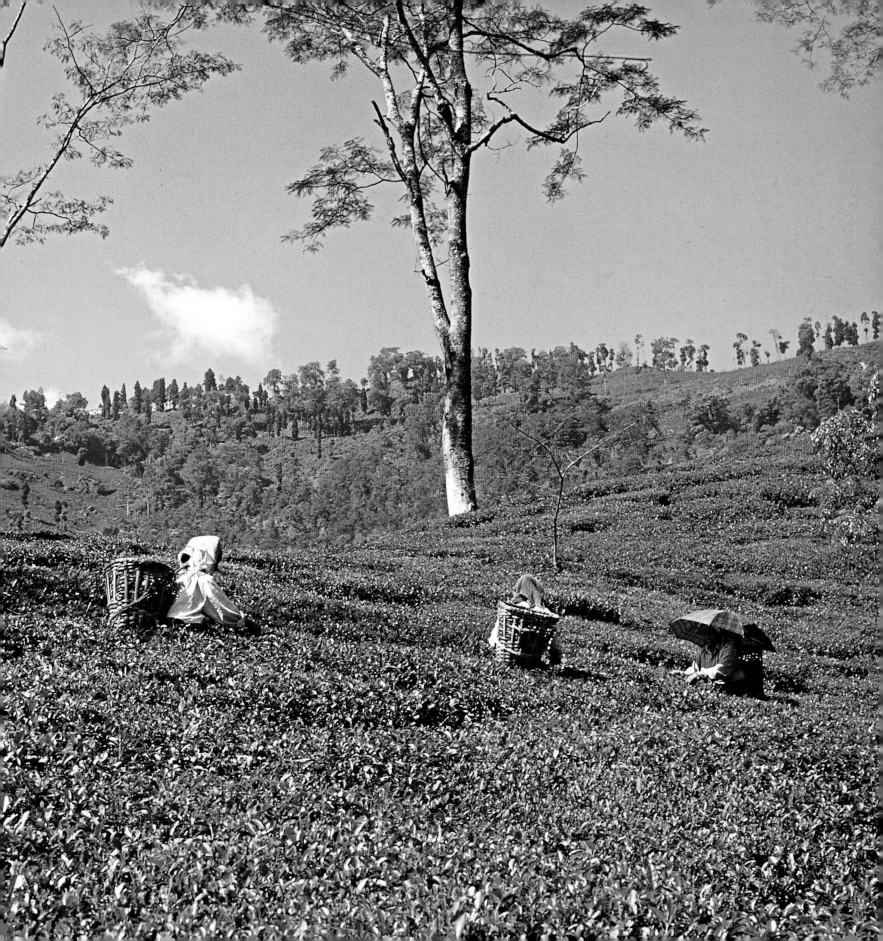

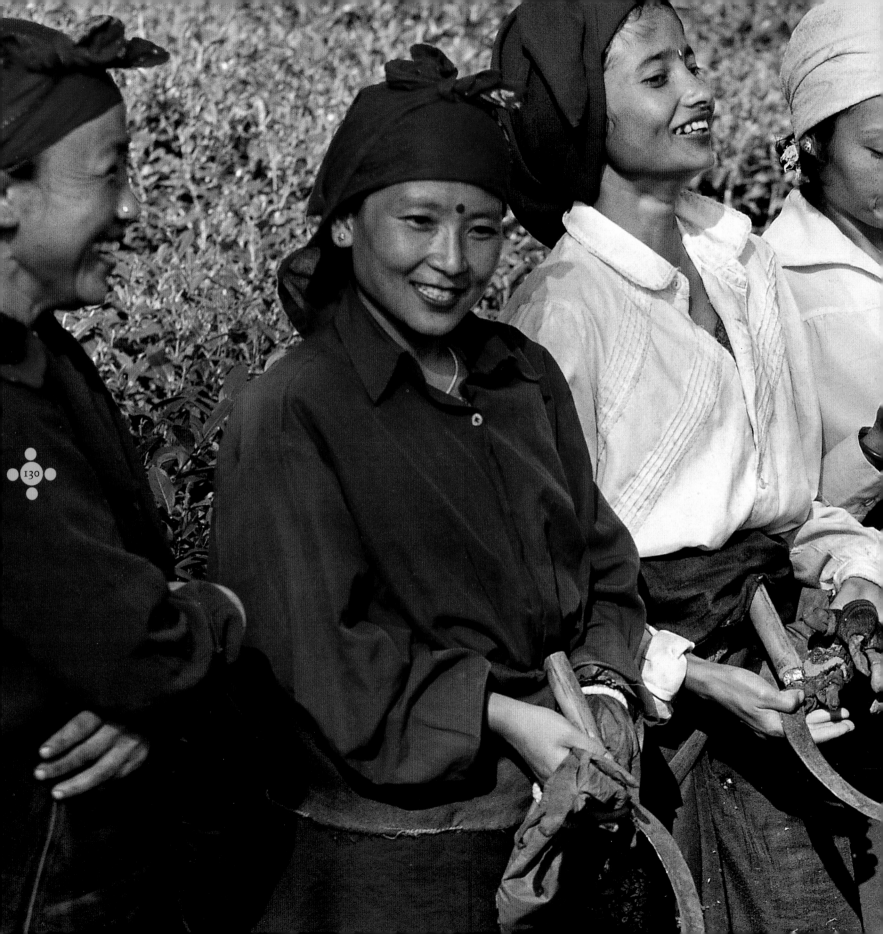

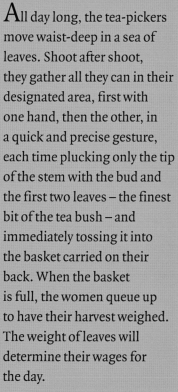

All day long, the tea-pickers
move waist-deep in a sea of
leaves. Shoot after shoot,
they gather all they can in their
designated area, first with
one hand, then the other, in
a quick and precise gesture,
each time plucking only the tip
of the stem with the bud and
the first two leaves – the finest
bit of the tea bush – and
immediately tossing it into
the basket carried on their
back. When the basket
is full, the women queue up
to have their harvest weighed.
The weight of leaves will
determine their wages for
the day.

LEFT
Tea-pickers of Tumsong, armed with
sickles for weeding.
RIGHT
A Gurkha tea-picker.

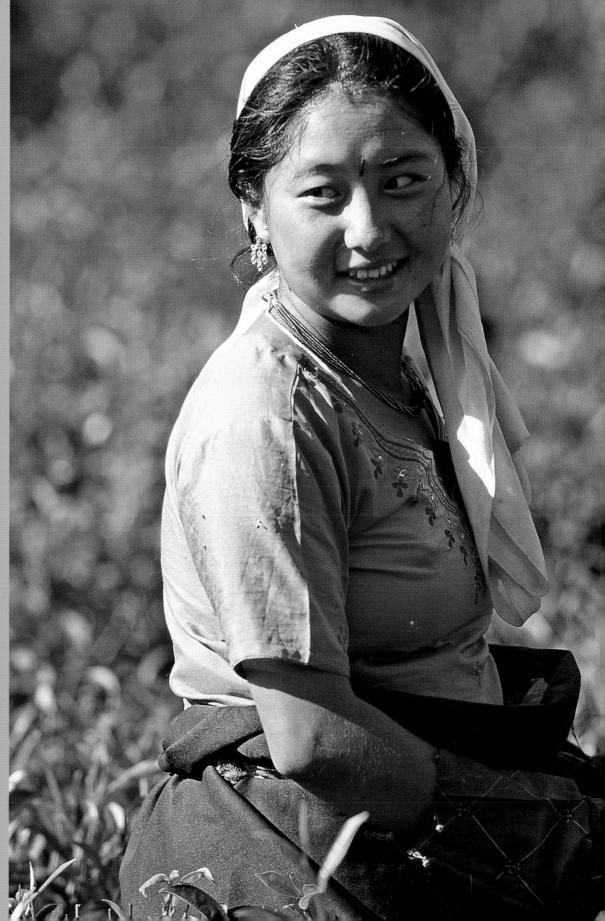

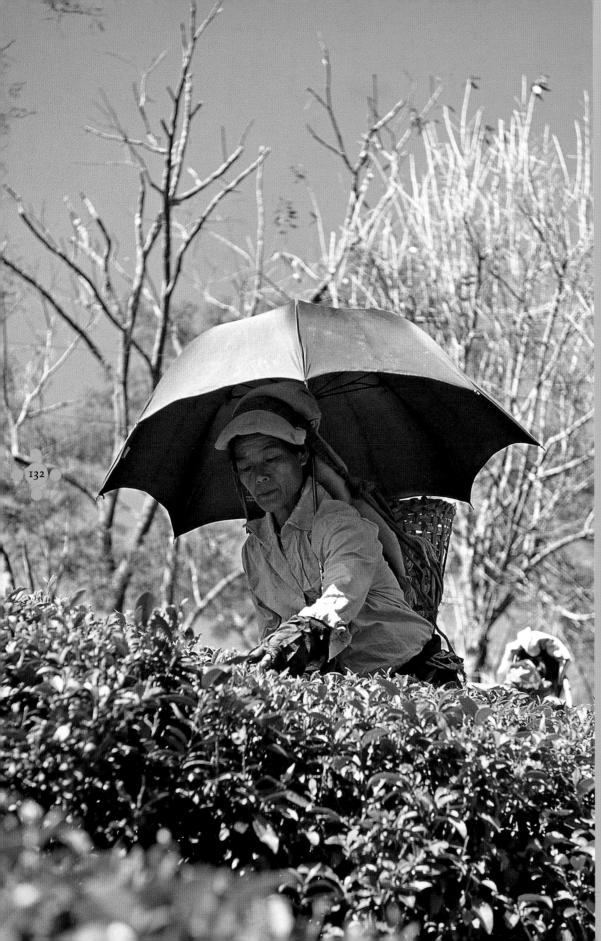

The secrets of growing and processing tea, developed by the Chinese, were introduced to British India in the second half of the nineteenth century, and plantations spread with great speed, replacing acres of jungle in Ceylon (now Sri Lanka), the Nilgiri Hills and Assam. Tea was planted as far north as Darjeeling, a Himalayan escarpment which had been taken from the king of Sikkim for the construction of a sanatorium. Dr Archibald Campbell, founder of the sanatorium, planted tea in his vegetable garden in 1841; the Chinese plant, *Camellia sinensis*, flourished at that cool height, and by 1874 Darjeeling had 112 tea gardens. The champagne of teas for connoisseurs, Darjeeling is the very finest of all Indian teas: it constitutes barely 1 per cent by volume of annual Indian tea production, and can fetch enormous prices.

LEFT
A tea-picker.
RIGHT
A high-altitude tea garden in Darjeeling.

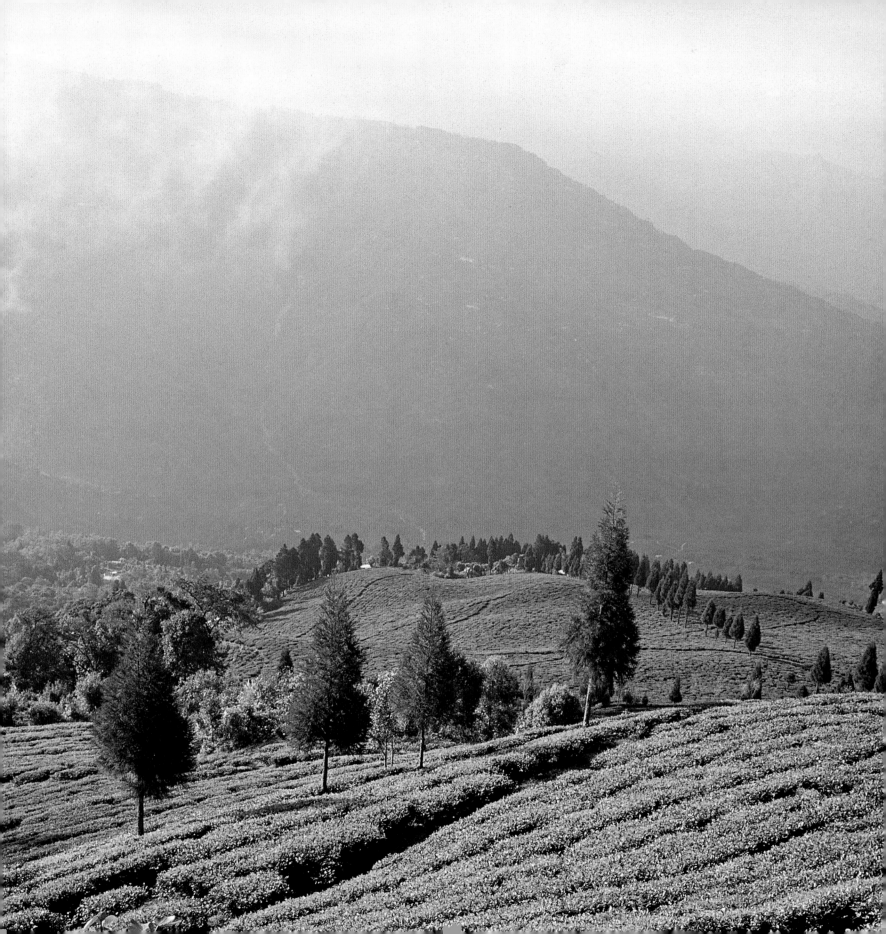

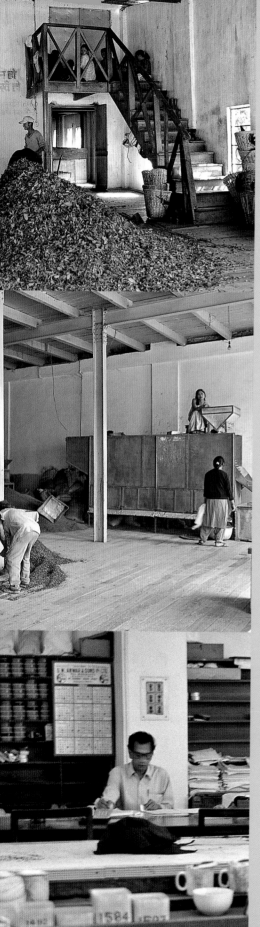

Fresh leaves must be processed at once. Tea factories in the centre of the plantations, with the names of the companies that own them painted on their zinc roofs, operate day and night. A tea factory has three floors. On the upper two, the fresh leaves are spread out to wither. They are then tipped through trapdoors to the machine room on the ground floor, where they are rolled; when they are ready, they are left for a few hours to ferment; and finally they are heated in a drier, to fix the scent that the tea will have when it is infused.

LEFT
A tea plantation. • A tea-picker. • A day's harvest. • Samples of manufactured tea • The trade mark or logo of Darjeeling tea. • Wooden tea-chests. • Fresh leaves newly delivered. • Inside a tea factory. • A tea taster checking quality.
The old photographs show, clockwise from top left, the preparation of tea leaves, an itinerant tea vendor in the early twentieth century, and tea picking in the early twentieth century.
RIGHT
A tea break.

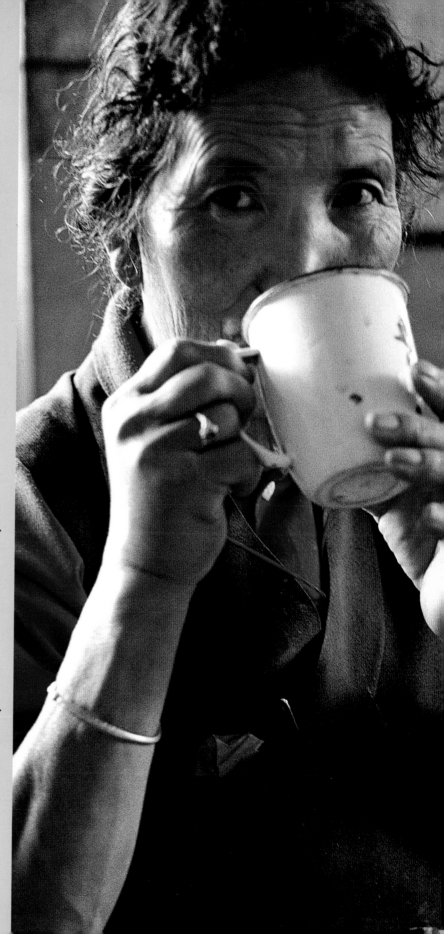

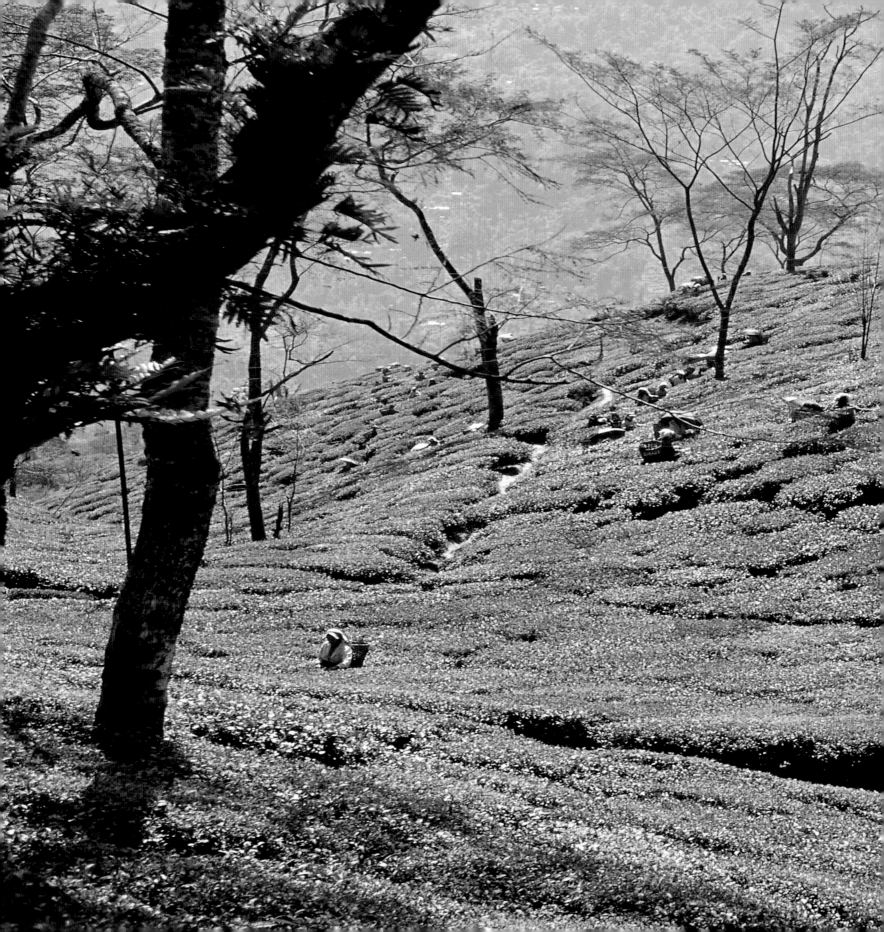

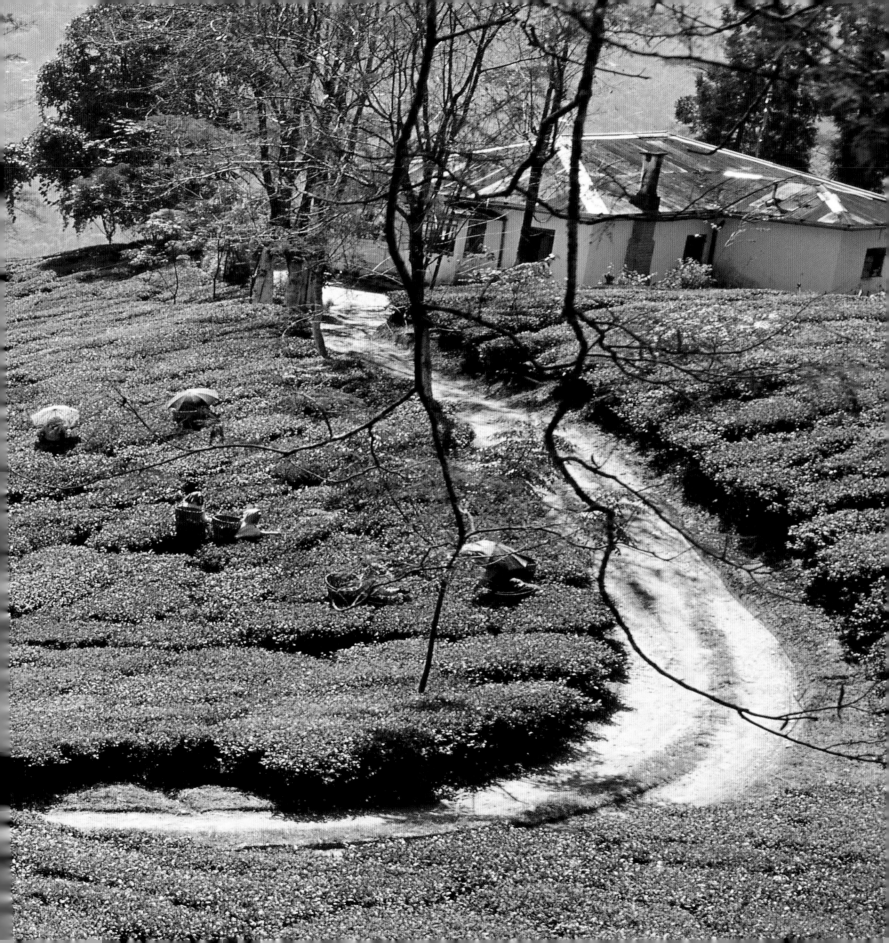

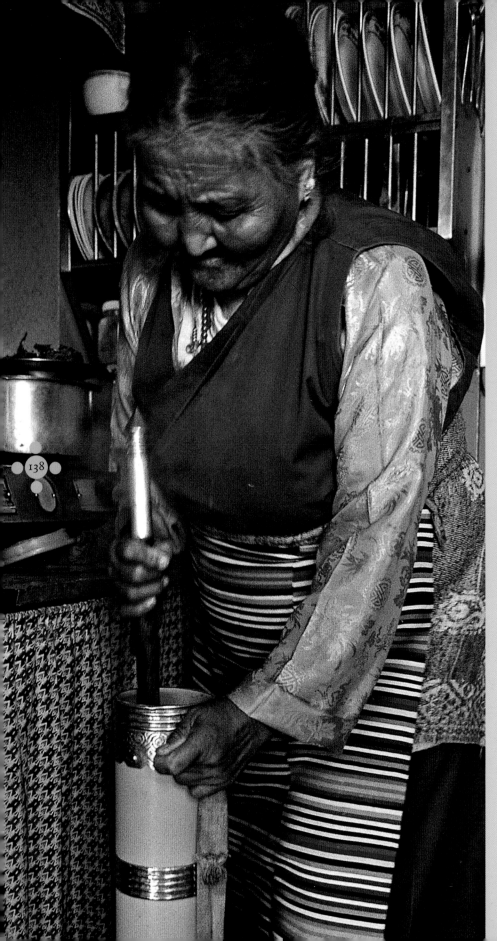

The Tibetan Refugee Self-Help Centre in Darjeeling was founded on 1 October 1959, when thousands of Tibetans were fleeing their country, invaded by the Chinese army, and making for India in the footsteps of their spiritual and temporal leader Tenzin Gyatso, the 14th Dalai Lama. The building was a sad concrete structure, but the refugees – there are now some 120–130 families – have transformed it into an outpost of their distant country of mountain peaks, a place full of joy, with photographs of Lhasa, images of their peaceful or ferocious gods, and coloured blankets woven from yak wool. Here they cook their fortifying food, designed to give strength to walkers and shepherds and all who wander in the heights where nothing grows but lichens. *Momo*, plump ravioli filled with meat, is accompanied by Tibetan tea, prepared by brewing then stirring for a long time with milk, salt and butter.

PRECEDING PAGES
In the Ging tea garden.
LEFT AND RIGHT
Making tea in the Tibetan way.

138

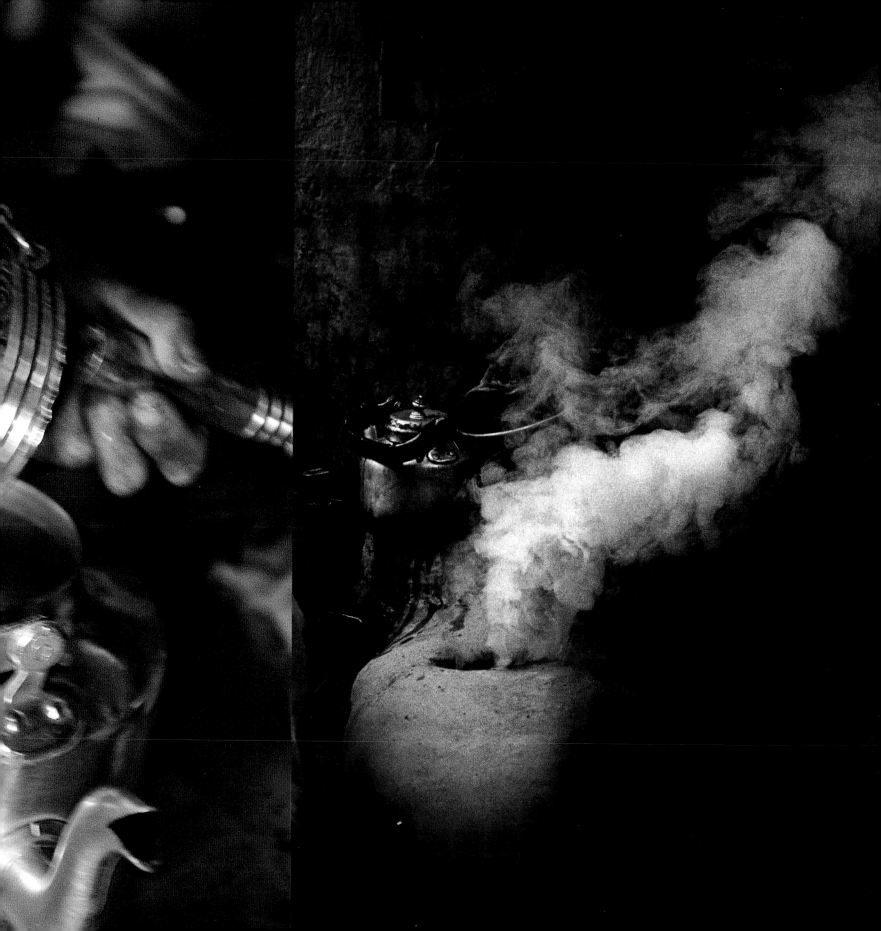

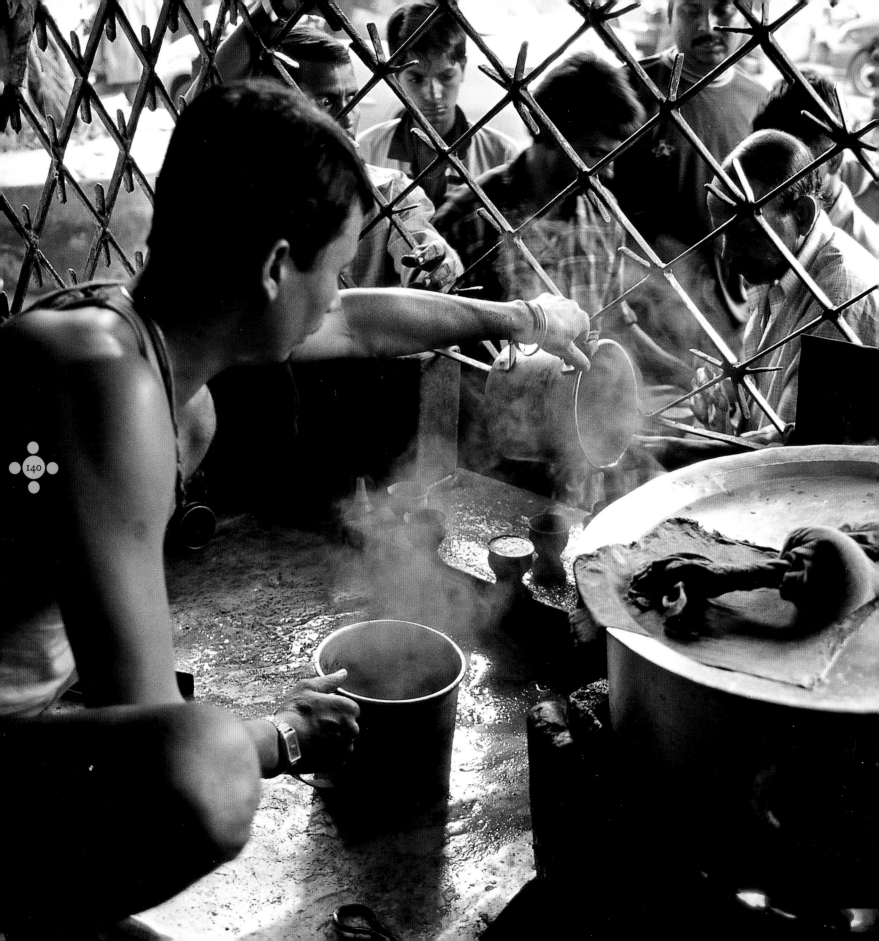

As a Brahmin, Doc could not eat with non-Brahmins; still less could he eat foods forbidden to his caste and prepared by impure hands. However, although the invitation seemed to imply a certain insolence, he was not offended, and accepted a cup of tea, which he left untouched.

Sarah Dars, *Nuit Blanche à Madras* (Sleepless Night in Madras)

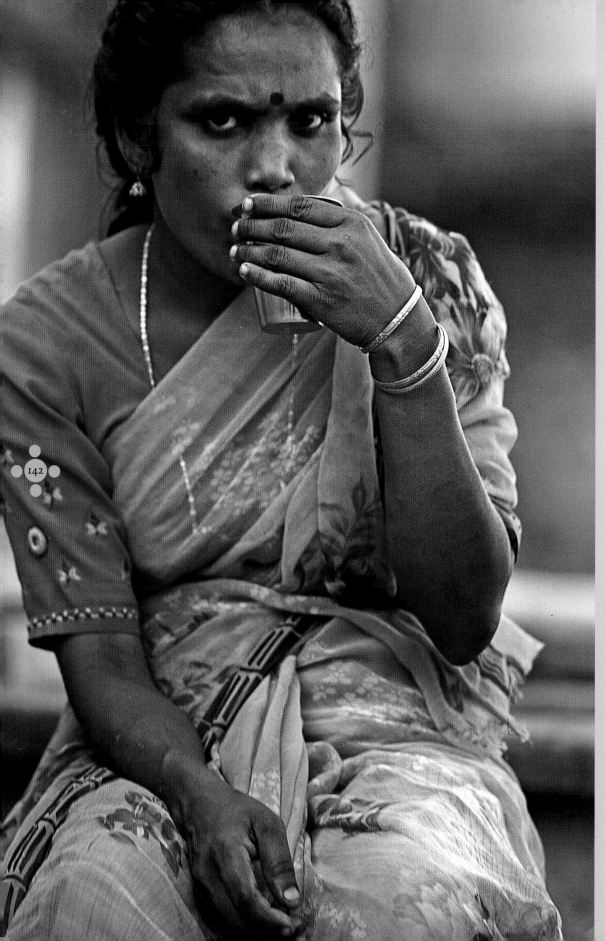

Chai is the basic drink in India. It is tea, but tea completely transformed by a culture that loves spices. Strong tea leaves provide the basic flavour: they are heated in sweetened hot milk, and scented with a pod of cardamom, a touch of ginger or a thread of saffron. The result is a creamy, perfumed liquid that ranges in colour from brown to pinky beige, and has a slightly caramel-like sweetness. *Chai* is sometimes prepared at home, but the true pleasure is to sip it outside, at the stall of a *chaiwalla*, a master tea-maker in the streets of India, who brings his own distinctive touch to the mixture.

LEFT
Time for *chai* in South India.
RIGHT
Chai painted on a wall in Kolkata, and enjoyed on a street corner in Gujarat.

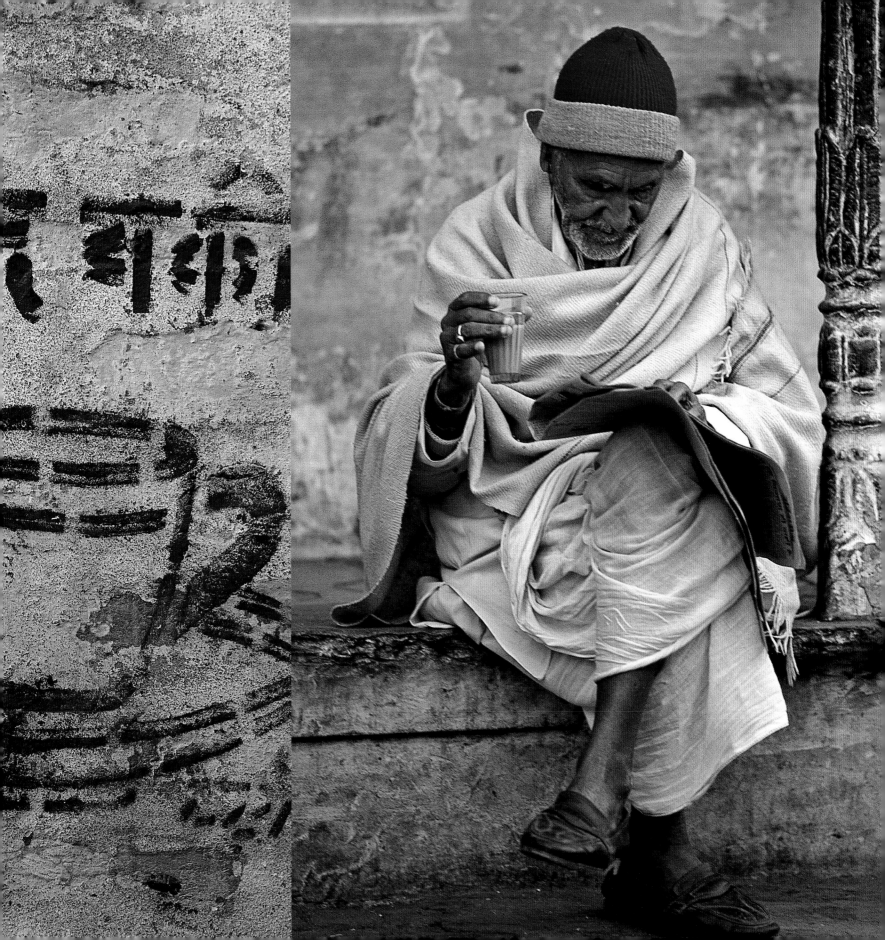

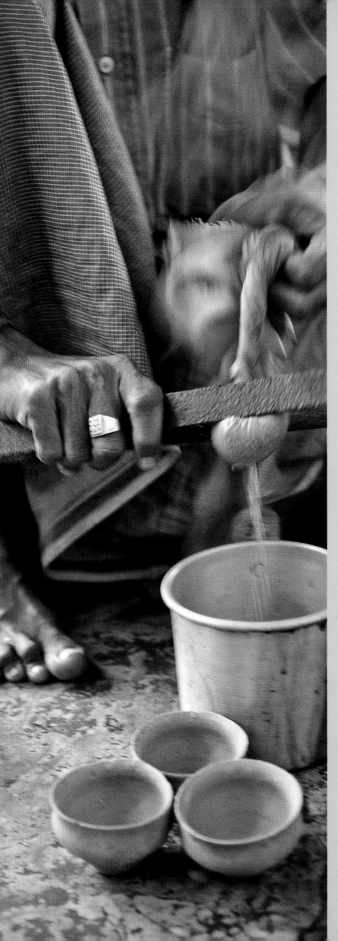

There is not a single village, neighbourhood, bazaar or crossroads without its *chaiwalla*, the tea-maker who, from dawn onwards, directs his ballet of utensils over the flames. The stage can be a mat on the pavement, a board resting on trestles, a movable counter, or simply the shade of a banyan tree. Making *chai* in the streets demands a theatrical precision of gesture. In an enamelled metal pan milk is heated; into it go spoonfuls of tea, spoonfuls of sugar and pinches of spices, and with a flick of the wrist the *chaiwalla* stirs his mixture; at the first sign of boiling, watch out, for the liquid is about to turn into *chai*. The officiant takes the pan in one hand and a metal jug in the other, and presto! he pours the frothy mixture in a ribbon from one container to the other. In this the *chaiwalla* is a magician, for in contact with the air, the tea's colour is adjusted to the shade desired. Then he pours the drink into goblets, without wasting a single drop.

LEFT AND RIGHT
The art of tea, in the streets.

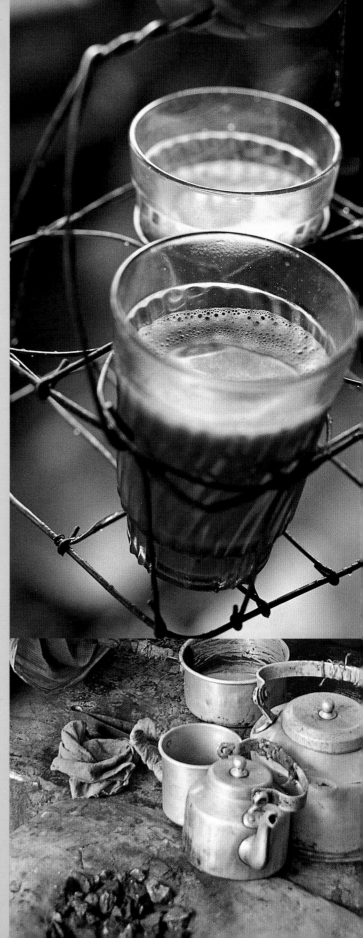

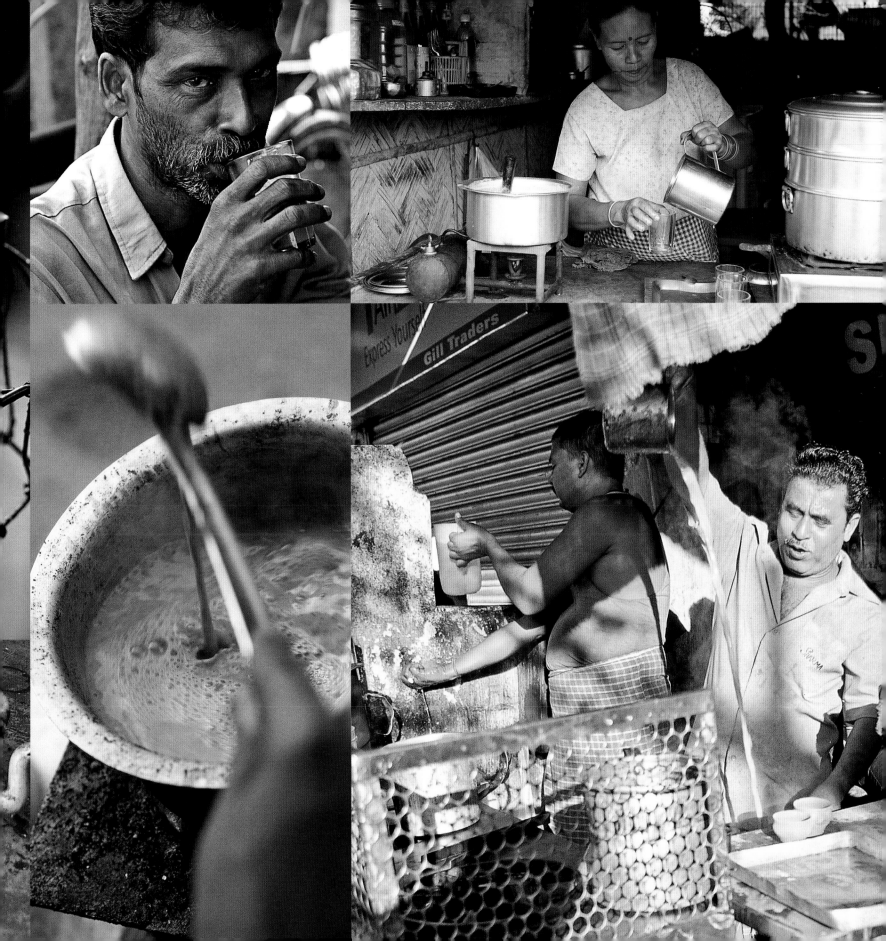

The steaming pot had hardly been placed in the
middle of the table before you could see all the faces
relax; everyone's sense seemed caressed
ahead of time by the thoughts of the pleasures that
this sweet drink was going to bring to each.
The conversation became more pointed and quick.
There was a discussion but no conflict.

The British Magazine, September 1828

RIGHT
A wire glass-carrier for
the morning *chai* hangs
above the flames in a
teashop in Ahmedabad.

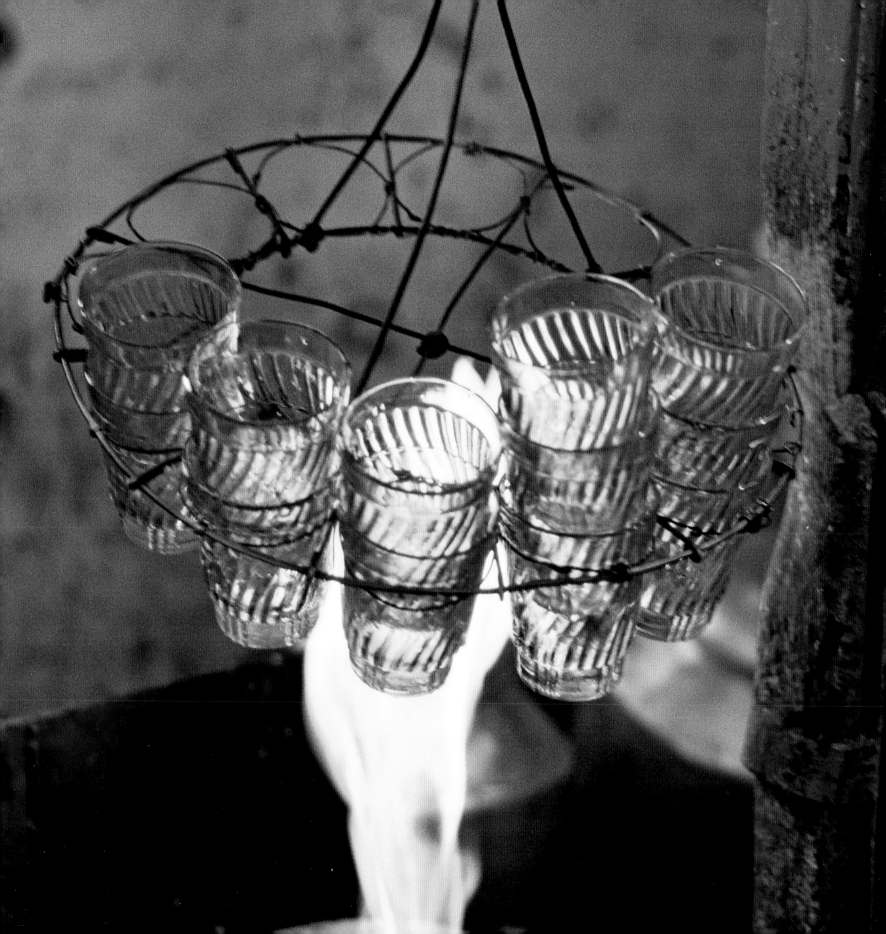

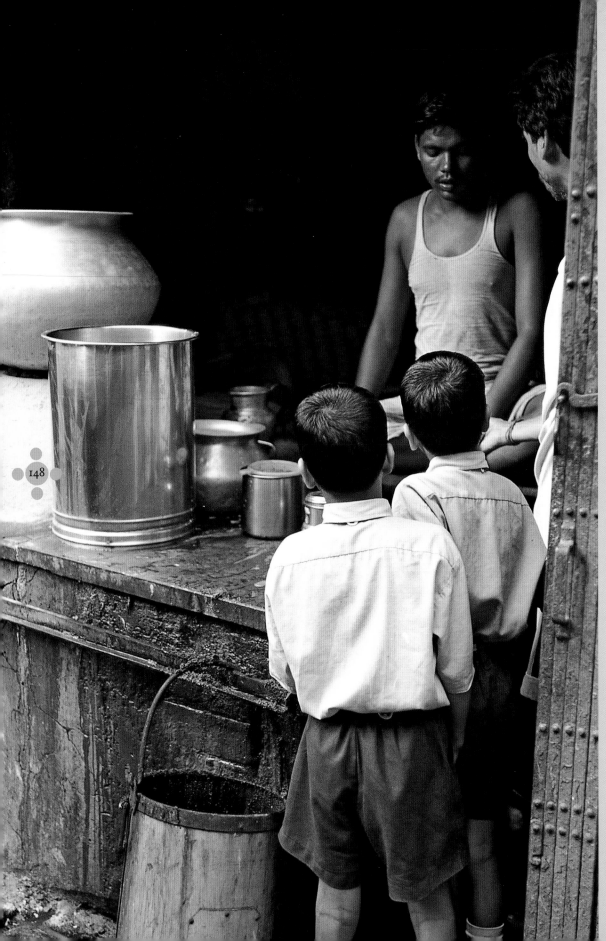

By the end of the twentieth century, India had yielded to throwaway plastic to serve food and drink in the street. Kolkata alone – the capital of tea in India, whose fourteen million inhabitants each drink two or three glasses of *chai* a day – has resisted, and in Kumartoli, the potters' quarter, vessels continue to be made for *chai* that is drunk in the streets. The earthenware cup, or *bhan*, is shattered on the ground as soon as the tea has been drunk from it, and the thickness of the covering of shards indicates the best places for tea in the city. In the past, all India observed this custom, which was both hygienic and ecological. The earthenware cup gave the liquid a scent of clay, and it provided one of the pleasures of travelling by railway: after the *chai*, bought when the train stopped in a station, had been enjoyed, the cup was thrown empty from the window as the train pulled out.

LEFT
A drink of *chai* on the way to school.
RIGHT
Earthenware cups, freshly made by a potter in Kumartoli, ready to be delivered to the *chaiwallas* of Kolkata.
• Morning tea.

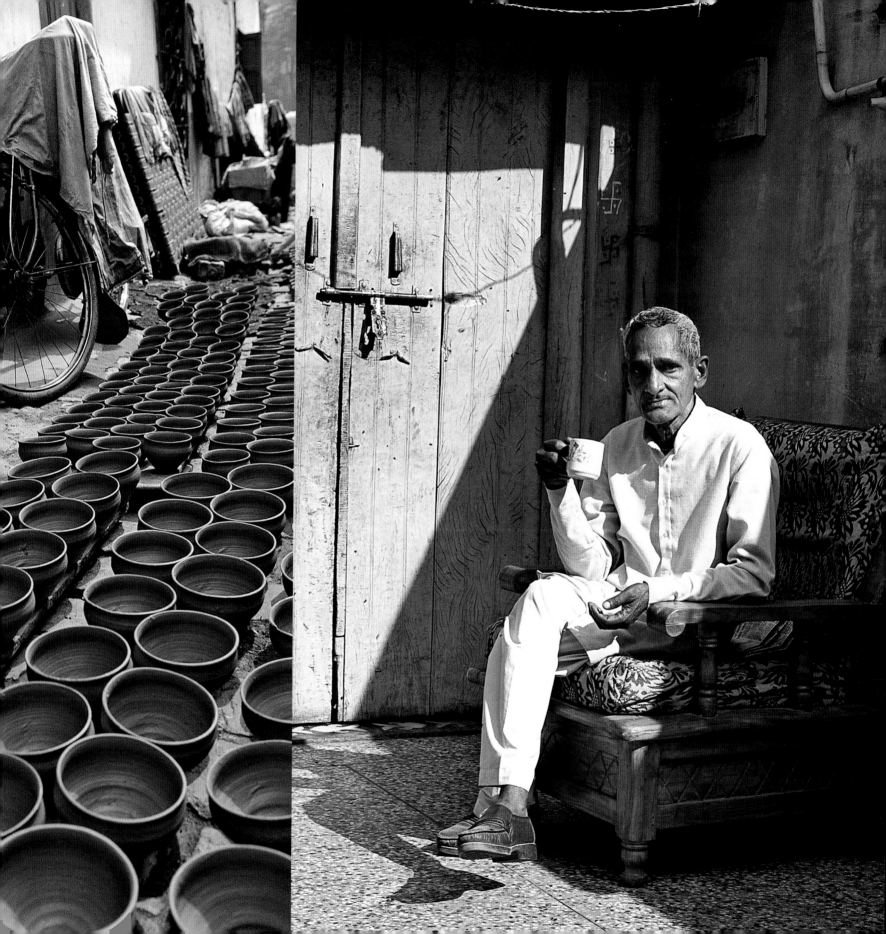

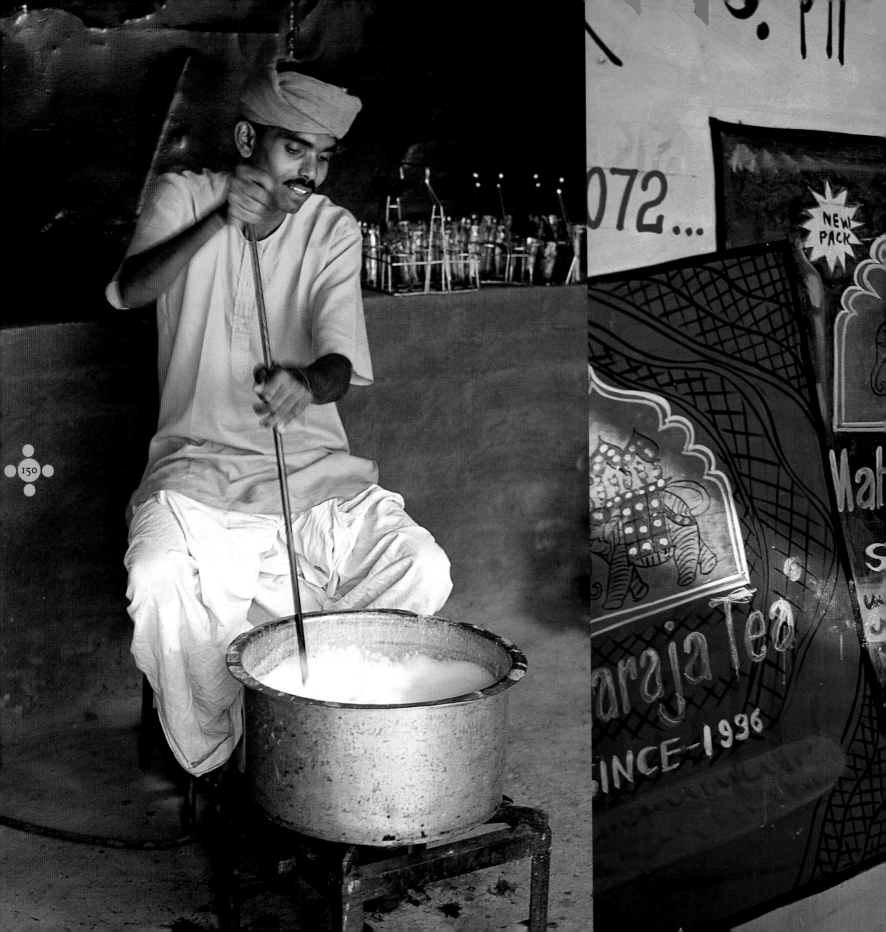

Tea English style, always presented in a silver-plated tea service, is a luxury unfamiliar to most Indians. It is still available in a few clubs and tearooms from the days of the Raj, but these are now extremely rare in a country where tea comes from the *chaiwalla* on the street corner. Flury's, in the fashionable Park Street district of Kolkata, is one of these aristocratic survivors. Whereas *chai* is drunk in the cacophony of the street, here fine Darjeeling, robust Assam and chocolate-flavoured Nilgiri teas are enjoyed in measured sips, in an island of quiet and muffled conversations, accompanied by the hum of great ceiling fans.

LEFT
The art of stirring tea with milk demonstrated in Gujarat, which produces *chai* as excellent as that of Kolkata and West Bengal. •
Advertisements for tea on a wall in Kolkata.
RIGHT
Tea-time at Flury's.

FROM THE MOUNTAINS
TO THE SEA

An overloaded Tata truck drives by at top speed, its horn blaring. Unperturbed, Chutu drives the village sheep in front of him along the road. He strides along, proudly sporting the immaculate white costume that he has had the right to wear since he turned ten, which is the emblem of the tribe of the Rabari herdsmen.

Under his pleated tunic, made by his big sister, he is wrapped in a *dhoti*. His turban is a little large for him and slightly conceals the silver earring he wears as a sign that he is a man; his parents had put it on him on the day of his marriage to a little girl of his own age, whom he had never seen until then. She belongs to the Maru clan, who are breeders of camels, while he belongs to the Chalkia clan, who only rear sheep and goats. Their families had met during the *dang*, the great annual event when the Rabari drive their flocks across the deserts of Gujarat and Rajasthan in search of grazing. In that same year, he had made another long journey with his parents: after the rainy season, at the full moon in the month of Kartik, they went on pilgrimage to the temple of Brahma in Pushkar, on the other side of the Snake Mountains. Chutu did not much enjoy bathing in the temple's sacred lake, which was very crowded. He much preferred the *mela*, the camel fair, where he could admire the camels' magnificent coats ranging from light brown to charcoal grey with geometric motifs cut into the hair around their necks, their engraved saddles covered with embroidered rugs, and their *gorbhands* or harnesses decorated with pompons and mirrors. It was great fun playing with the other children and wandering round the circus, hearing people scream on the big wheel and watching motorbikes tearing round the wall of death at full speed. But most importantly, it was the first time he had seen a real town, with shops. They even went to eat in a *dabba*, and he spent the rest of the day there watching the television which the owner had left on. In his village there was no television; there was not even electricity. He argued with his sister, who

> **66** *The breeze brings the taste of the earth, and along with that a new, strange smell — at the same time acrid, sweet and musky"*
>
> Charles Müller, *Cinq mois aux Indes (Five Months in India)*

wanted to watch a love story in which the heroes spent their time weeping and dancing: he preferred serious stories about his fatherland, like those he heard in the evenings when the men gathered together to talk and smoke the hookah while the women went to fetch water from the well. He had learnt that his fatherland was very powerful and very modern, even though most of its inhabitants lived in the country, like the Rabari. The men also spoke of the serious problems encountered by country people: they are sometimes so poor that they cannot feed their family, so they leave the village to seek work in town, and there they have to live on the street because they have no home to go to. On the television in Pushkar he saw pictures of the countryside in the South – what an enormous country! There the landscape was very different, with lots of trees and flowers, and everything was green. The people had no camels, and no sheep: instead they had white zebus, humped oxen, which they used to pull ploughs and carry fodder.

In January, the inhabitants organize celebrations to give thanks for a good harvest, and they paint the horns of the zebus in all kinds of colours so that they become almost as beautiful as the camels of the *mela* in Pushkar. There the sea was nearby too, as it is near his village in Kathiawar. His clan settled there two years ago, building new tent-shaped huts out of clay, of which Chutu is convinced that his family's is the best; his mother and sister decorated the whole interior with little mirrors. The sea is half-an-hour's walk away, and uniformly grey, except where people have collected salt and piled it into little white heaps. In the South, people wade into the sea with enormous nets and catch incredible quantities of fish; they also build boats, and set out in the middle of the night on the black water (how brave they are!) from which they bring back even larger fish. Chutu kicks a stone, and wonders what the fish caught by the people of the South taste like.

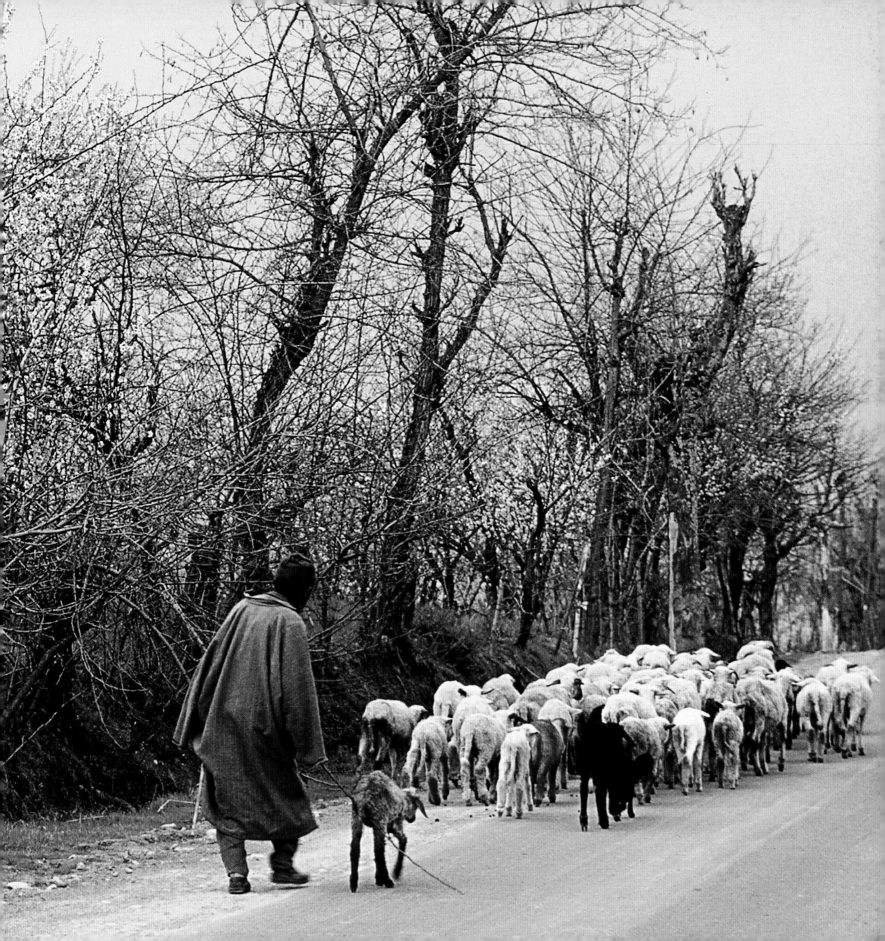

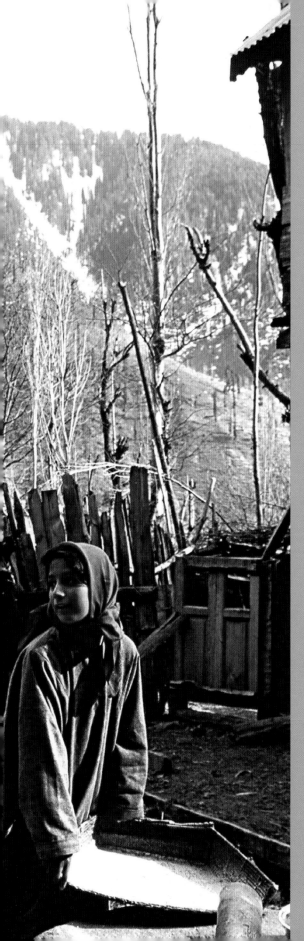

The geography of India seems to have been inspired by one of the stories of its great mythology. Some twenty million years ago, it set off to meet the world. Drifting on the surface of Thetis, the primordial ocean, the Indian continent crashed into Eurasia. That collision left an enormous scar, the Himalayas, the 'roof of the world', a section of the earth's crust over 8,000 metres (26,000 feet) high that was lifted up by India then and that is still rising under the inexorable pressure of the mass of the Tibetan plateau. Thus was born the Indian subcontinent, which pushes out into the Indian Ocean like the prow of a ship. On the west, the Malabar Coast looks towards Arabia Felix, while on the other side the Bay of Bengal is the gateway to the Far East.

PRECEDING PAGES
Spring makes a tentative appearance on a mountain road in Kashmir, in the western Himalayas.
LEFT
Barley flour is the staple winter food of the people of the Himalayas from Kashmir to Sikkim.
RIGHT
Weaving a wool rug that will give protection against the winter chill.

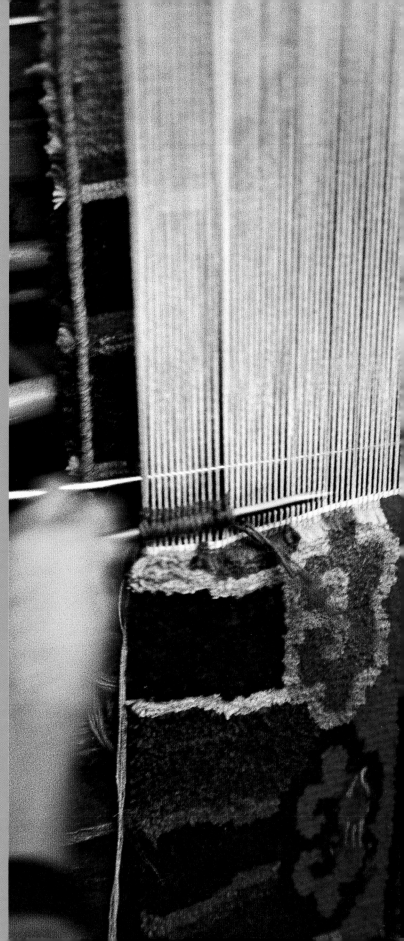

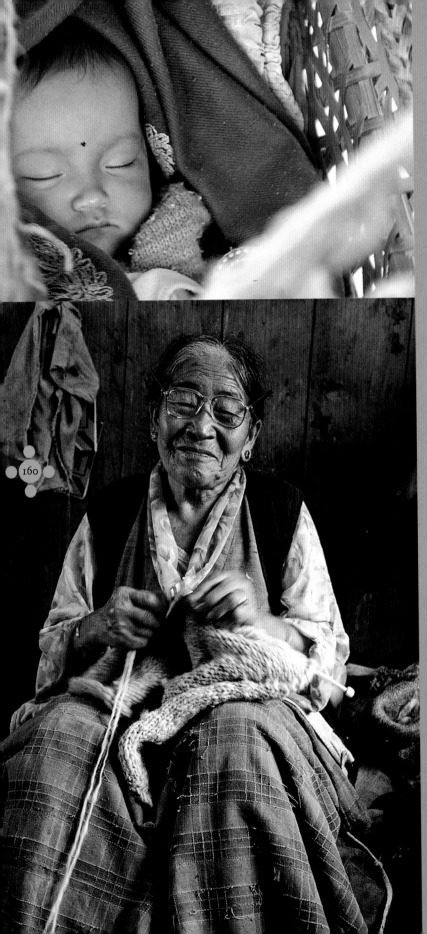

The ancient kingdom of Tibet, in the eastern Himalayas on the other side of the Kanchenjunga range, has always maintained diplomatic and commercial relations with Bengal. On their 4,000-kilometre (2,500-mile) track between Lhasa and Darjeeling, Tibetan caravans used the mountain pass of Nathu La, 3,410 metres (11,188 feet) above sea level. When the 'Land of the Snows' fell under the brutal control of the People's Republic of China at the end of the 1950s, Tibetans in their thousands set out on the ancient route and never returned. Others left their native villages in 1962 after the brief war that broke out between India and China over a few acres of ice and rocks in the Himalayas. Nathu La became the road of exile, and from Darjeeling to Dharamsala Tibetan refugees rebuilt their life in the peaceful atmosphere of the high valleys of the Indian Himalayas.

LEFT AND RIGHT
The Tibetan Refugee Self-Help Centre in Darjeeling.

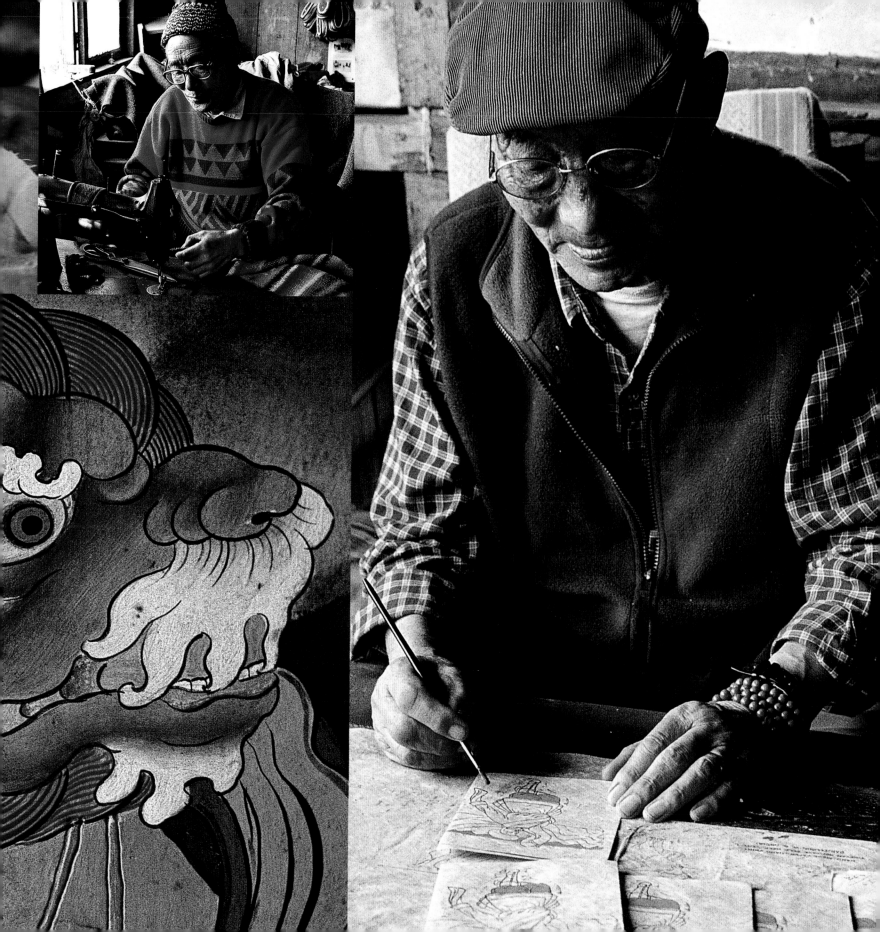

The monsoon cycle articulates the seasons in India. In winter, the dry trade winds from the north-east sweep across the subcontinent. In early March the air begins to heat up and then the thermometer goes mad, quickly rising to dizzy heights, as the thirsty sky becomes white-hot, and the whole country is plunged into a stupor by the intense heat. Then June arrives with its moisture-swollen winds – winds which in the past filled the sails of merchant ships travelling from Arabia to the Indian coasts across the Arabian Sea – and when these monsoon winds meet the mountains of the Western Ghats they burst into torrential rain. People flounder in the mud in Mumbai and paddle in Goa, but life goes on regardless, and nature awakens: from Cape Comorin to Kashmir, the monsoons revive the subcontinent with their nourishing rains.

LEFT
A sunny day is washing day in Darjeeling, and things are hung out to dry on every floor. · Nature is at its most beautiful at the end of the monsoon season, when winter is just beginning to set in.
RIGHT
The peasants' lives are regulated by the alternation of dry and rainy seasons.

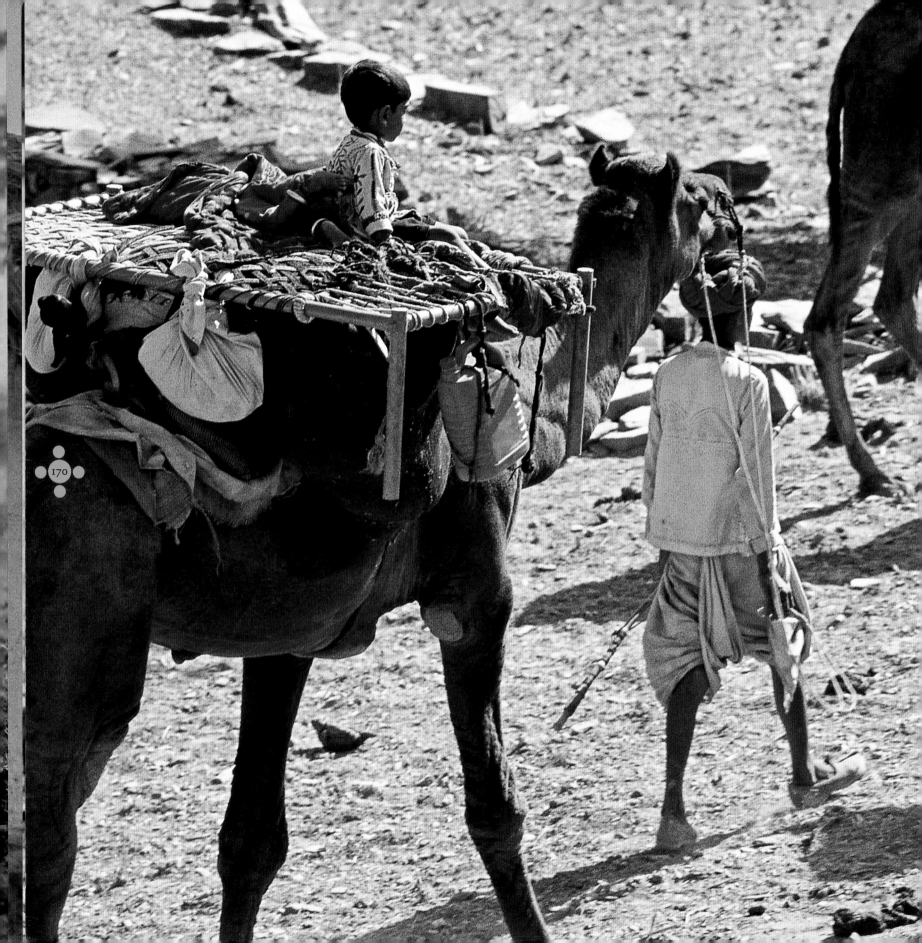

The two vast states of Gujarat
and Rajasthan, along the
border with Pakistan, are
lands of great deserts – Kutch,
Kathiawar and Thar – and
of Rajput lords, Marwari
nomadic merchants who have
become captains of industry,
and Bharwad and Rabari
herdsmen. If South India
is the land of elephants, the
North-West is the land of
camels, who are led by the
Rabari on great drives in
search of grazing. Camel
fairs take place every year
in February at Nagaur and in
November at Pushkar; leather
and brightly coloured wool are
plaited to make *gorbhands*, long
harnesses for the camels
embellished with mirrors and
pompons typical of the desert
lands; the lands themselves
are celebrated in wild tunes
by hurdy-gurdy players, while
bards still recite the ballad of
Dhola and Maru, the Romeo
and Juliet of the desert, swept
away on the back of a black
camel through the dunes
of Marushtali, the 'Land of
Death'.

LEFT AND RIGHT
Scenes of the *dang*, the great seasonal
migration of Rabari herdsmen across
the deserts of Gujarat and Rajasthan.

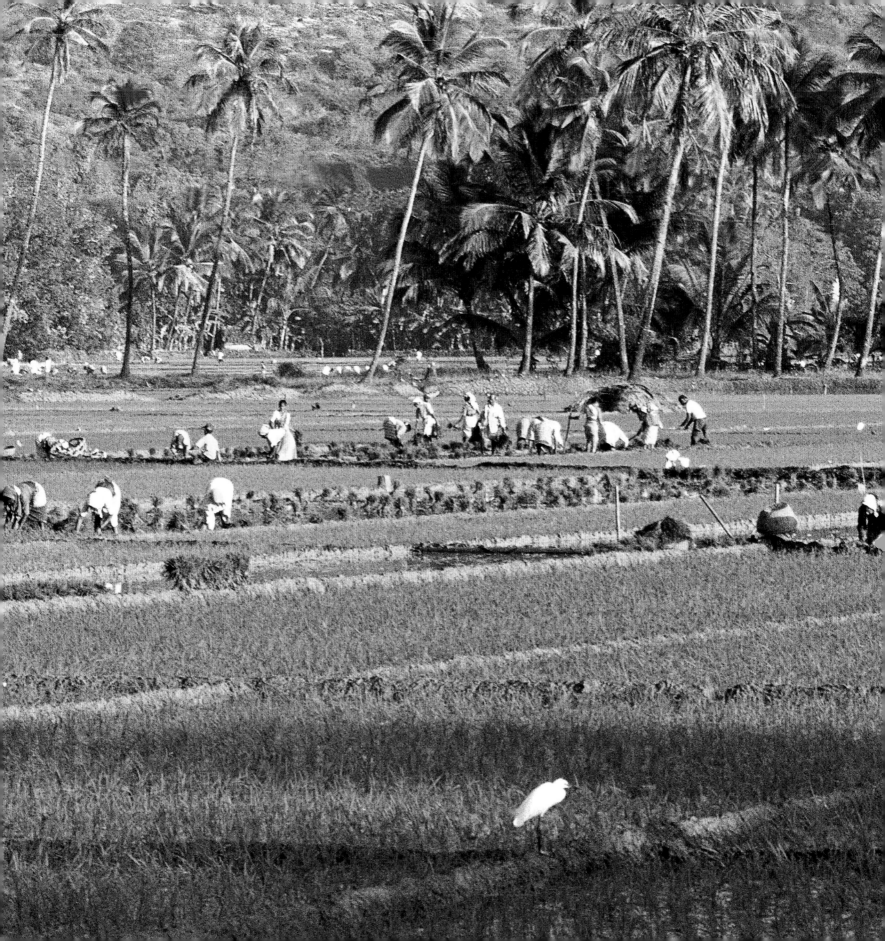

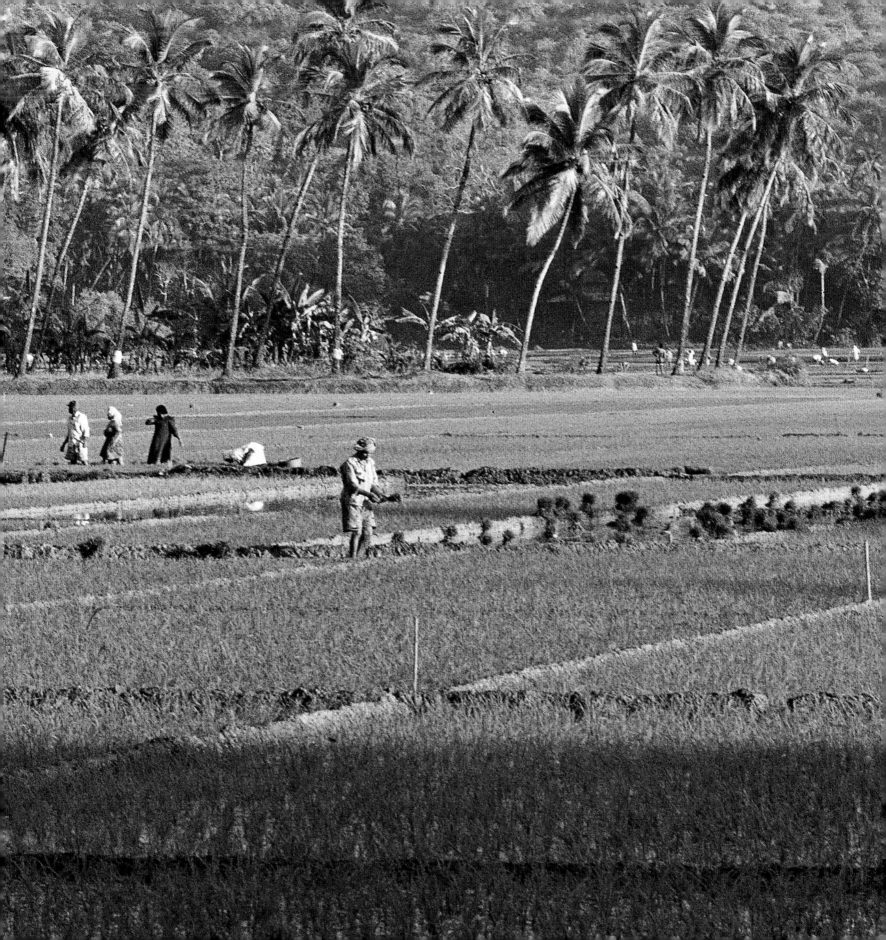

In leaving Madras for Tanjore, then Trichinopoly,
the city of the monolithic rock, the exuberance
of the tropical vegetation is striking.
Everywhere are areca palms, palm trees, banana
trees, broken here and there by purple bougainvillea
and red hibiscus. All this swings and sways
above giant green rice paddies.

Robert Chauvelot, *Mysterious India*

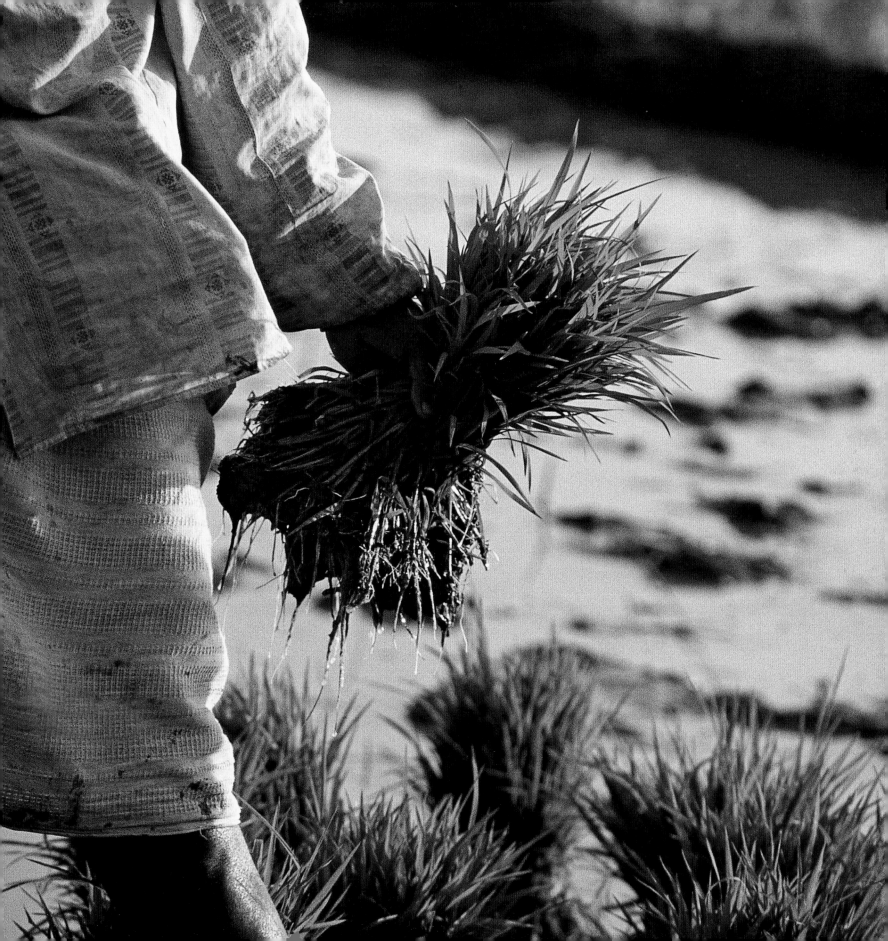

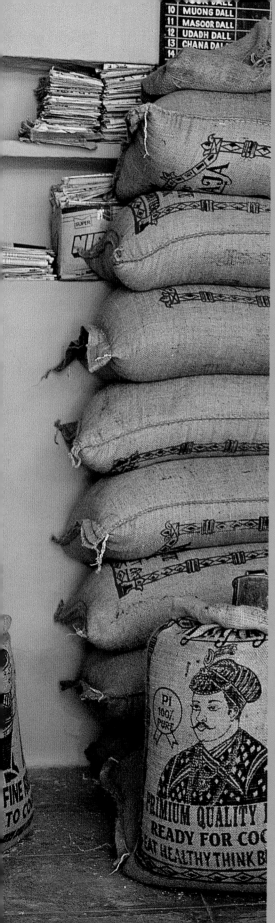

By tradition, habit and thrift, the Indian countryside has remained more vegetarian than the towns. Even at wedding banquets, when several hundred guests come together in the marriage season between November and February, meat is rarely on the menu, and all sorts of spicy combinations based on vegetable ingredients rich in proteins provide a healthy substitute. Fingers – of the right hand only – replace knives and forks. There are two ways to take mouthfuls of food: with the aid of *roti*, *chapati*, *naan* and other types of leavened or unleavened bread, the favoured manner in the North, or with rice, which is more common in the South and the Ganges delta.

LEFT
To ensure that rice grows healthy and thick, it must be thinned and the seedlings pricked out. • Winnowing separates the rice grains from the husks. • Sacks of 'Premium Quality' rice, worthy of a maharajah's table. • A rice packet bears the image of a god.
The old photographs show, on the left, winnowing rice in Darjeeling around 1916, and on the right, children pounding rice on the Malabar Coast in 1908.
RIGHT
The pleasure of eating with your fingers, and enjoying the flavours of a *thali*.

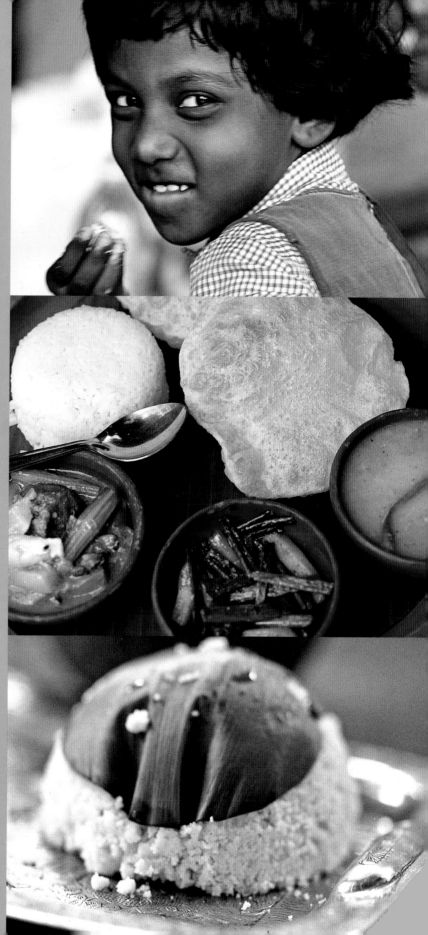

बासमती

१ ३०

Of all the religious communities in India, the Jains have the greatest respect for all forms of life, down to the tiniest. The most devout Jains cover their mouths and sweep the ground in front of them as they walk so as not to swallow or tread on any living creature, be it a mosquito; they only drink water that has been filtered several times to make sure that every trace of life has been removed; and they never eat in the dark, to make sure they do not swallow an insect that might have landed on the food. In their temples the Jains use grains of rice to draw symbols and incantatory formulas on wooden tablets. In their eyes rice embodies what they are striving towards – ending the cycle of reincarnation (which they aim to do by doing good to others) – because, once it has been winnowed, rice is the only grain that does not germinate: it has only one life.

LEFT
Basmati rice, grown at the foot of the cool Dehra Dun hills in Uttaranchal, is the 'white gold' among the many varieties of Indian rice, which include the brown rice of Kerala and Govinda Bhog, 'Krishna's food', the very white small-grained variety grown in Bengal.

RIGHT
Sifting to remove any impurities is the last stage before rice is sold.

178

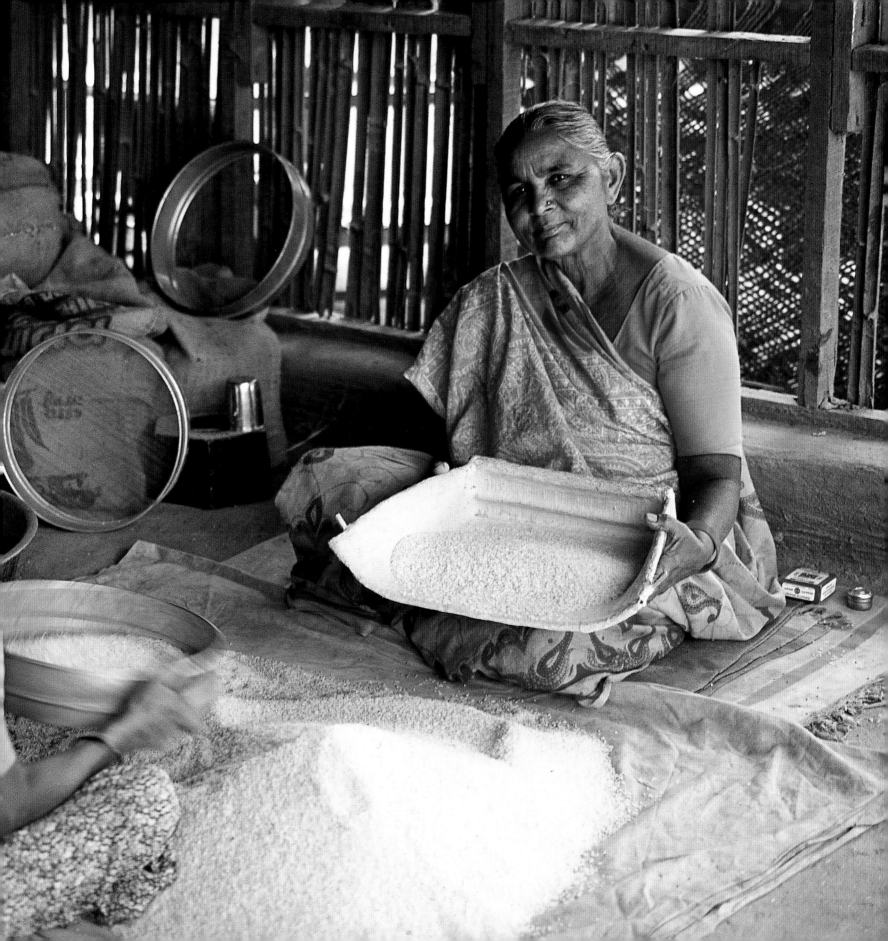

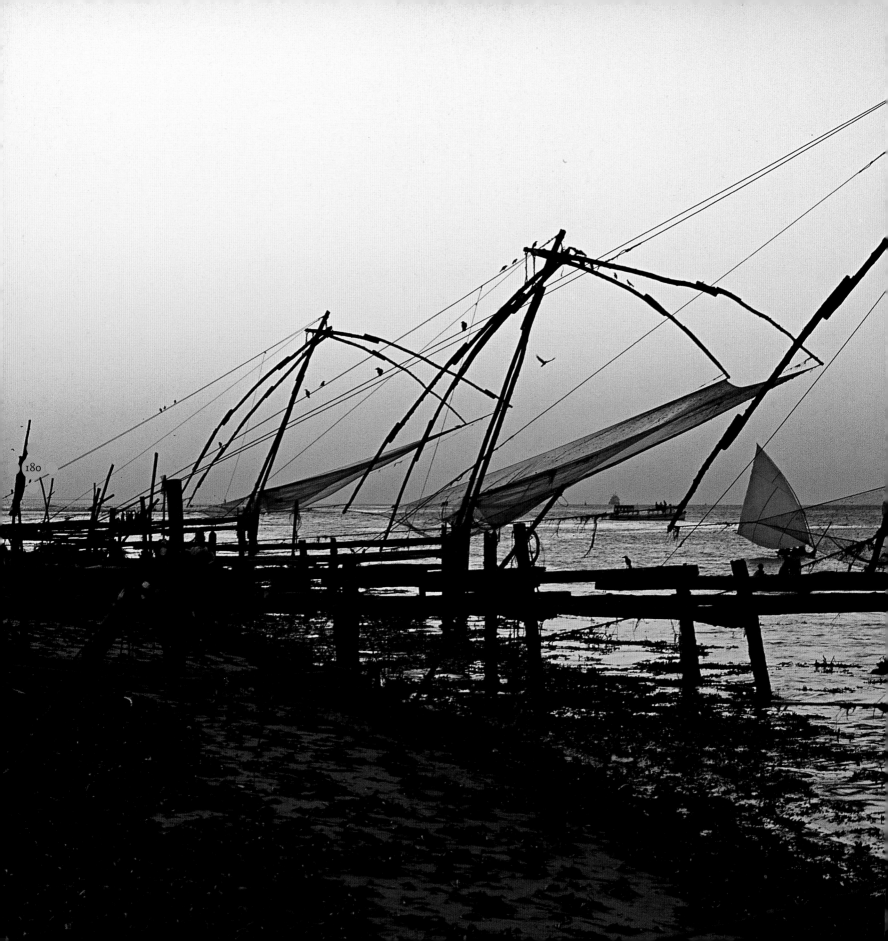

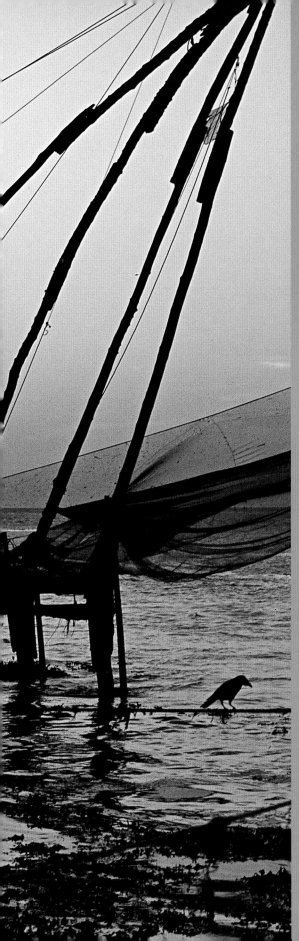

Although India has 7,000 kilometres (4,350 miles) of coastline, the country does not look out towards the sea and Indians are not a seafaring people. According to Hindu legend, Manu, the first man, caught a fish in his net, and to his great surprise it started to speak, and announced an impending flood. It promised Manu that it would save him if he kept it with him, so Manu filled a bowl with water and put the fish in it. The fish grew and grew, forcing Manu to transfer it to ever larger vessels, until it became so large that it had to be released into the ocean. 'Quick!', the fish cried out to Manu as it touched the water, 'here comes the flood! Climb on my back and you'll be safe!' Manu obeyed, and thus mankind was saved from the flood by the giant fish, who bore the first man across the seas.

LEFT
Chinese fishing nets drying at Cochin in Kerala.
RIGHT
Dried skipjack tuna.

The Malabar Coast in
Kerala has a sandy, relatively
straight shore more than
550 kilometres (340 miles)
long, which looks out towards
the Arabian Sea and the
Laccadive Islands. Parallel
to the coast, inland, are the
backwaters, a network of
canals linking numerous
lagoons. Both salt and fresh
water provide a miraculous
harvest of fish all year round.
In the shallow lagoons, the
fishermen use cast nets, fitted
with weights, which they toss
out into the water while
holding onto two of the
corners. On the beaches in
the South, fishing villages
work together and use a seine:
people wade out as far as
possible with an enormous
net, and then drag it back to
shore, closing it like the jaws
of a trap. Offshore fishing, on
the other hand, is run by state
cooperatives. They fish at
night, and every morning
at dawn the boats return to
Cochin to unload their catch
on the quays. Skipjack tunas,
sardines, mackerels, and
pomfrets like silvery crescent
moons are small fry compared
with creatures like frigate
tunas, swordfish, and sharks.

LEFT AND RIGHT
Fishing on the Malabar Coast.

182

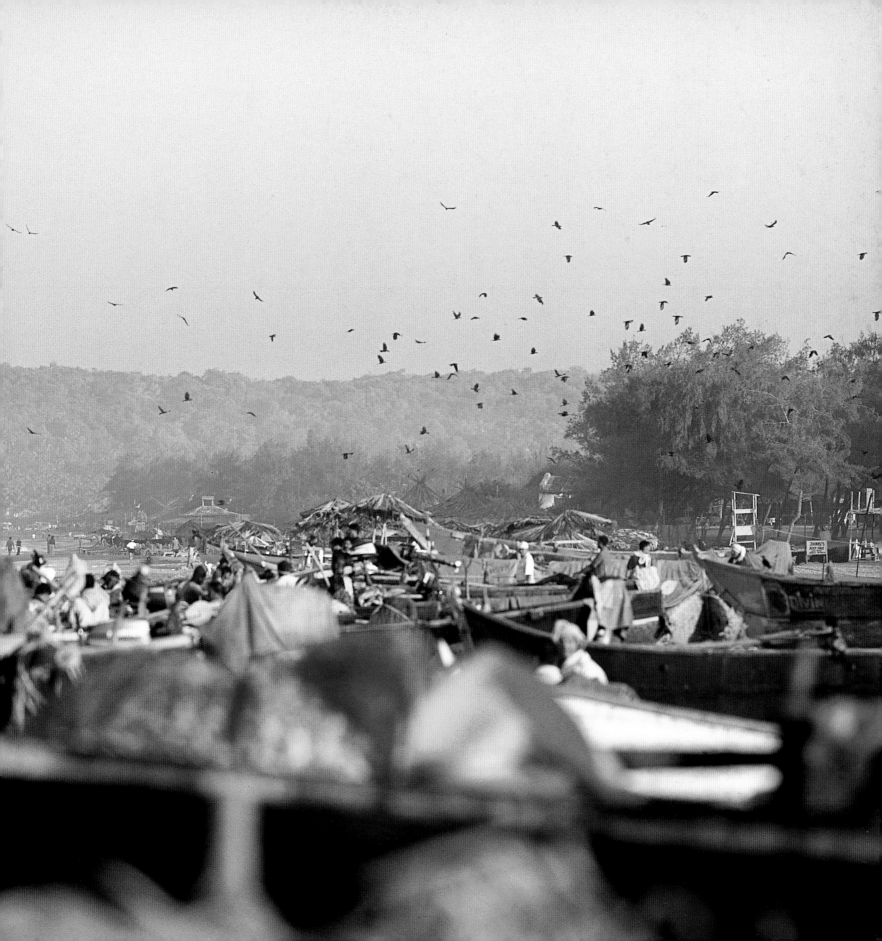

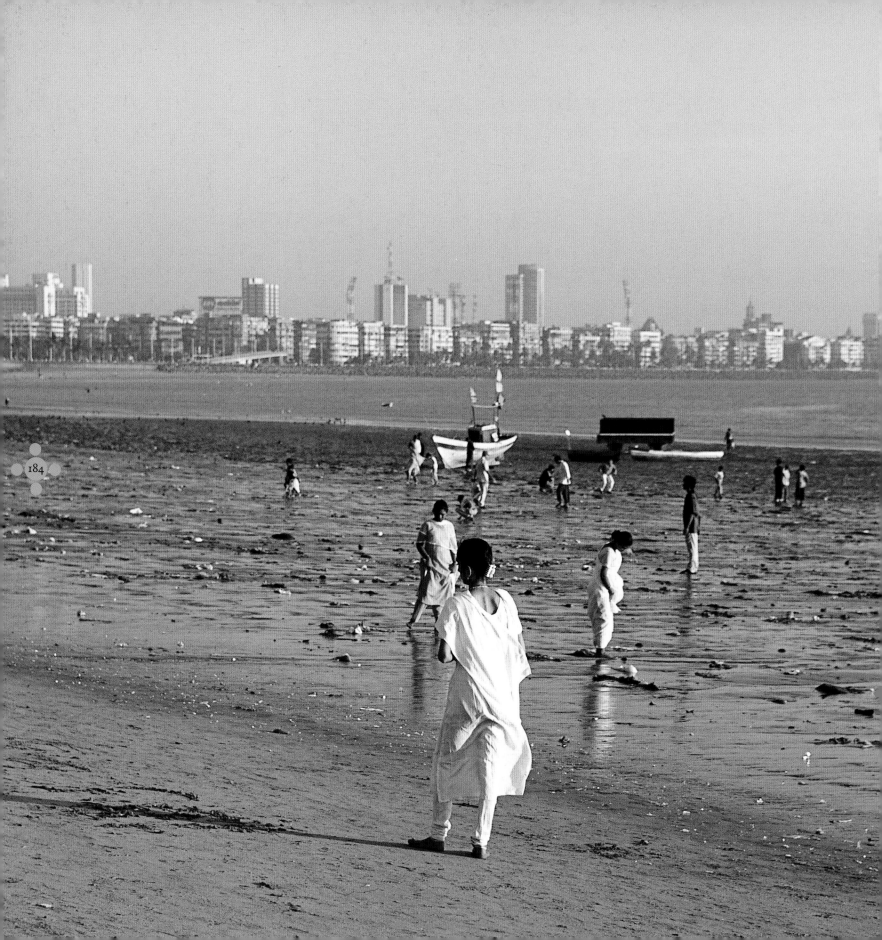

The newly-weds also enjoyed taking walks on Juhu beach, only a mile or two away from the Dwarika house. Juhu beach was a long, clean strip of untainted beauty: the east side was lined with lissom coconut trees whose crevices in their ringed trunks allowed wild parrots to nest. At the other end spread out the shimmering magnificence of the Arabian Sea, its silver honour of ripples, its monsoonal fury and winter susurration.

Siddharth Dhanvant Shanghvi, *The Last Song of Dust*

LEFT
Chowpatty Beach in Mumbai,
with the business district of
Coloba in the background.

The Malabar and Coromandel coasts are the realm of fishermen who supply the markets with prawns and skipjack tuna, and also of men who collect palm sap by sliding along cables stretched from tree to tree. The sap harvested by these tightrope walkers is used to brew a beer called *toddy*; when distilled, this produces *arak*, a strong, amber-coloured spirit. In their munificence, palm trees also produce coconuts, of which the grated pulp flavours food and yields copra oil; the fibres are used to make *coir*, a decay-resistant rope from which mats and nets are made; the shell is used as fuel; the leaves serve for roofs and fences, and their softest fronds are plaited to make decorative garlands for festive occasions; and the trunk provides timber for building.

LEFT
A beach in Goa, sheltered by palm trees.
RIGHT
Outrigger boats in Turicorin, *c.* 1914.

186

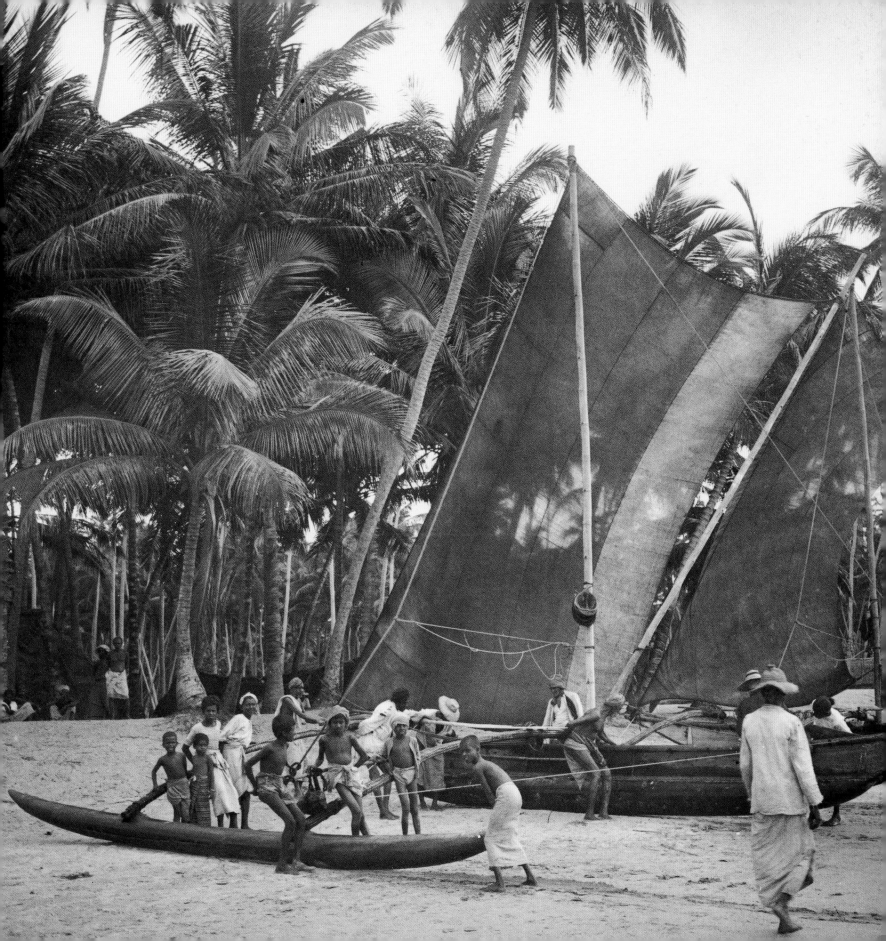

LAND OF A MILLION GODS

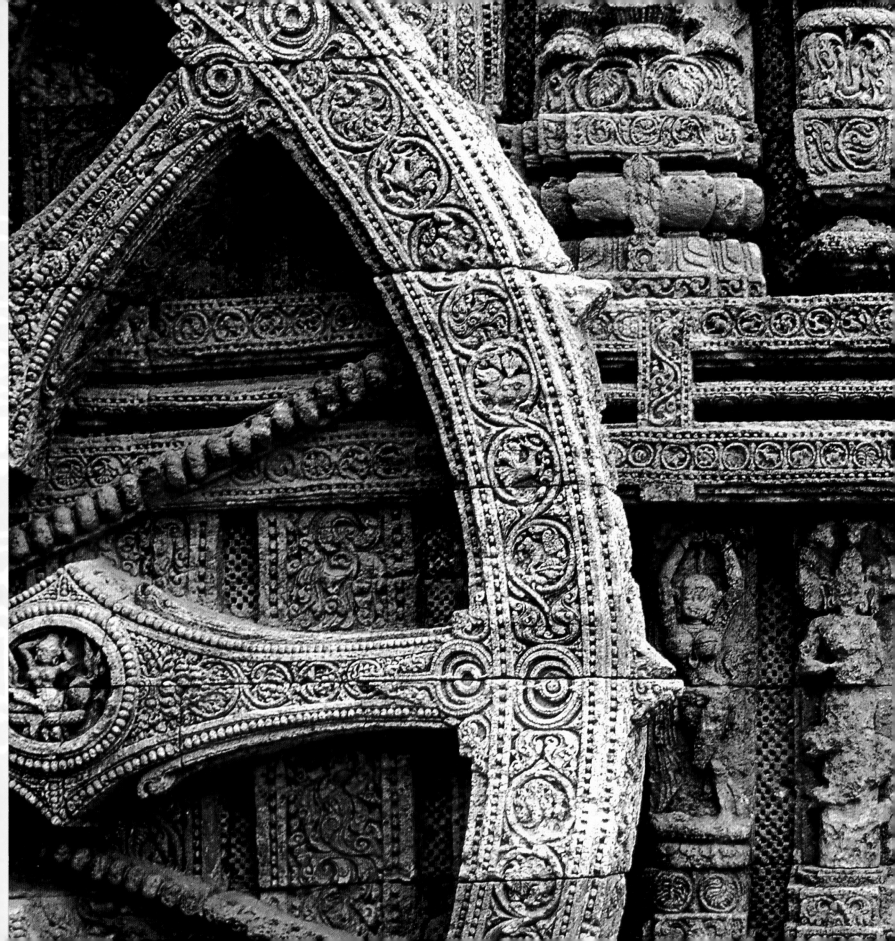

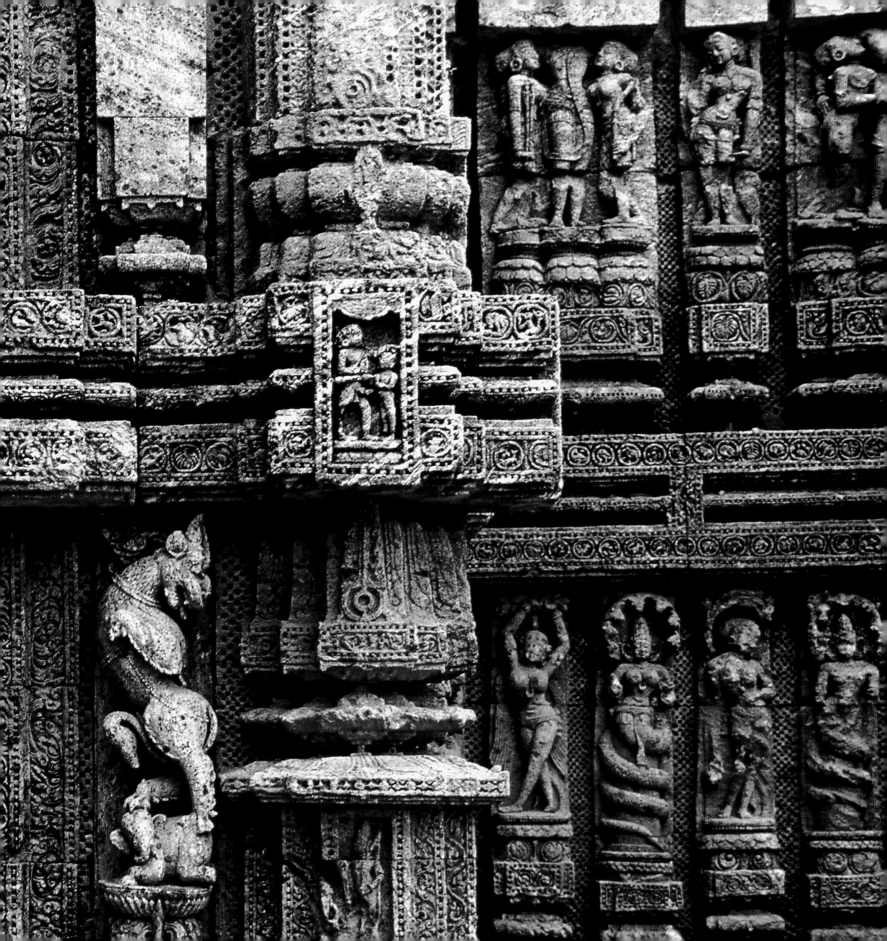

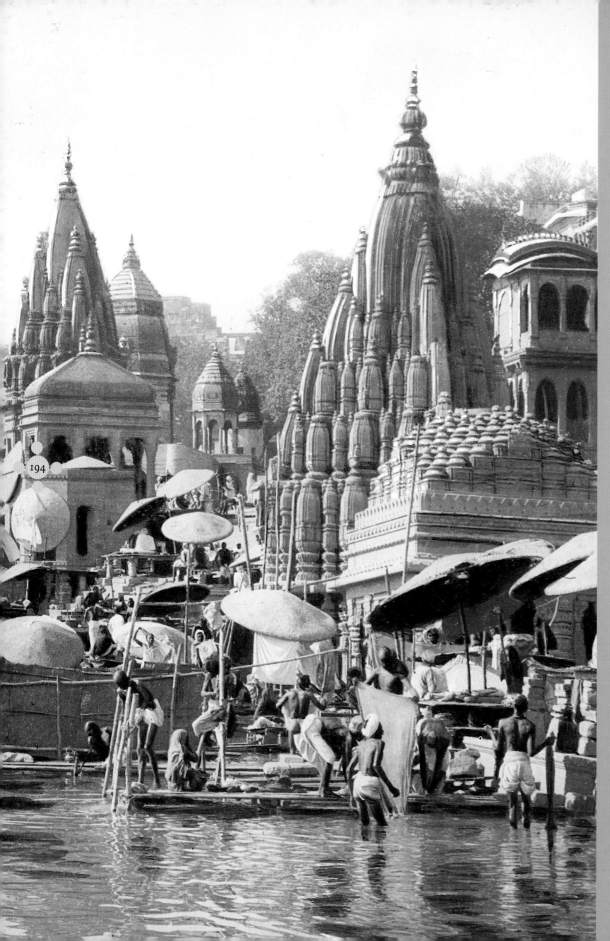

In the Middle Ages India began building temples throughout the land to honour its gods. Until then people had worshipped in caves and caverns, either natural or man-made. The first sanctuaries they built were of fairly modest proportions, but as Indian master builders learnt the technique of building in stone, they gradually increased in size until some were almost as big as a town. All were richly decorated with reliefs narrating the great sacred stories, reflecting the artists' extraordinary skill in depicting the human body.

PRECEDING PAGES
The temple of Konarak, built in the thirteenth century in the dunes of the coast of Orissa on the Bay of Bengal, is dedicated to Surya, the sun god.
LEFT
The Ganges at Varanasi (then Benares) about 1920.
RIGHT
The rulers of Lucknow, who were Shia Muslims, commissioned enchanting architectural fantasies, drawing on the centuries-old skills of master masons. • Bhubaneshwar, in Orissa, boasted some seven thousand Hindu temples at the height of its splendour: this sculpture is on the eleventh-century Brahmeshwara Temple.

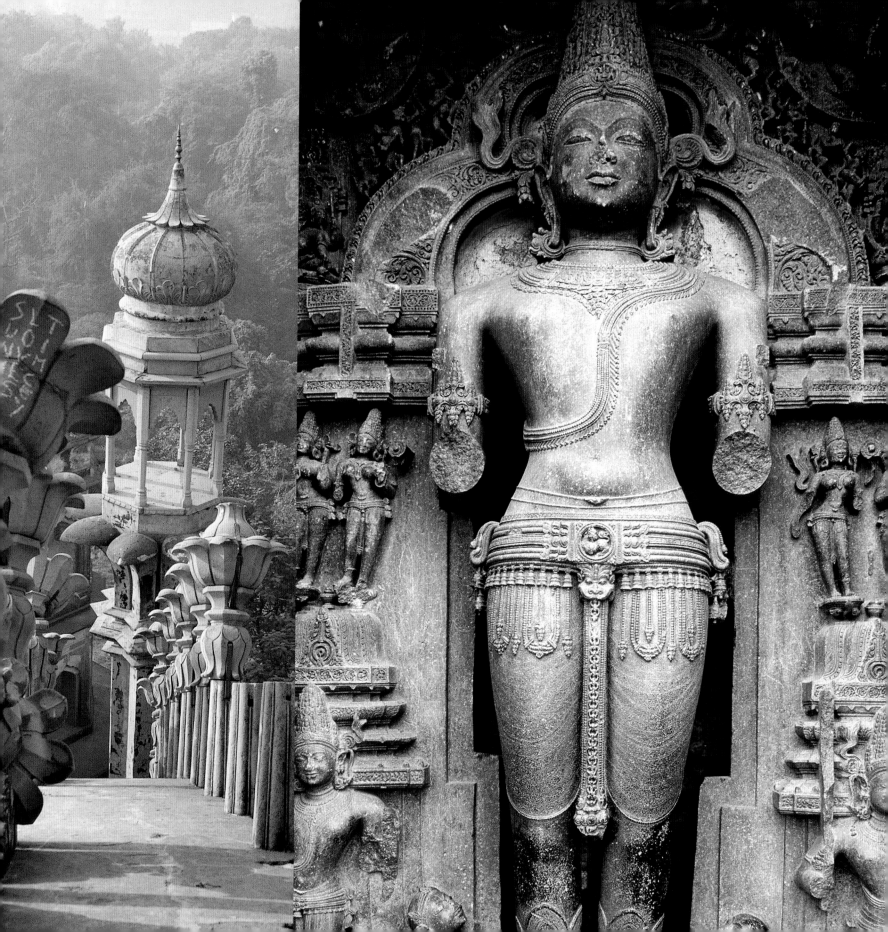

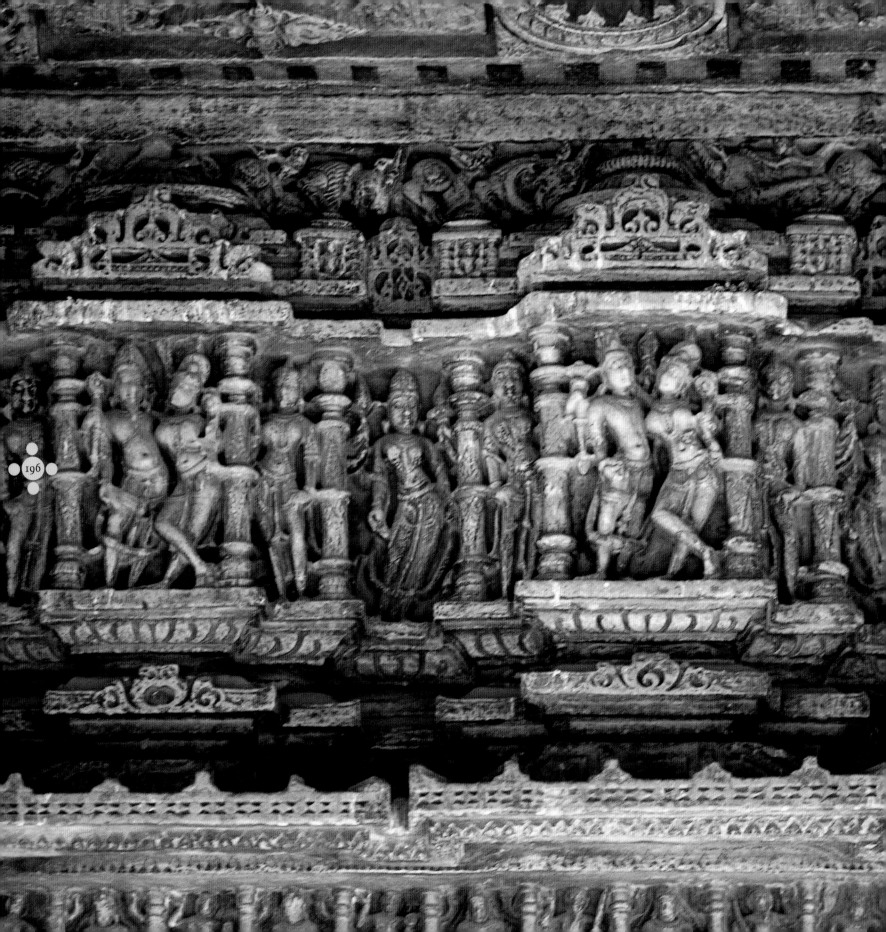

Hindu temples, governed by complex symbolism that transforms them into the universe in miniature, are seen both as the house of the god and as a reliquary containing his or her effigy. In the North, the focus is on the tower or *shikhara* above the holy of holies; in the South, it is on the monumental gateway, the *gopuram*, that signals the sacred enclosure from afar. In all temples, the image of the god is housed in a small, dimly lit cell, where only initiates may enter.

LEFT
Lovers, or *mithuna*, entwined in poses at times of the most unrestrained eroticism, form part of the decorative vocabulary of classical Hindu temples.
RIGHT
With its *shikhara* pointed towards the sky, the Rajarani Temple in Bhubaneshwar is a perfect expression of the architectural style of Northern India.

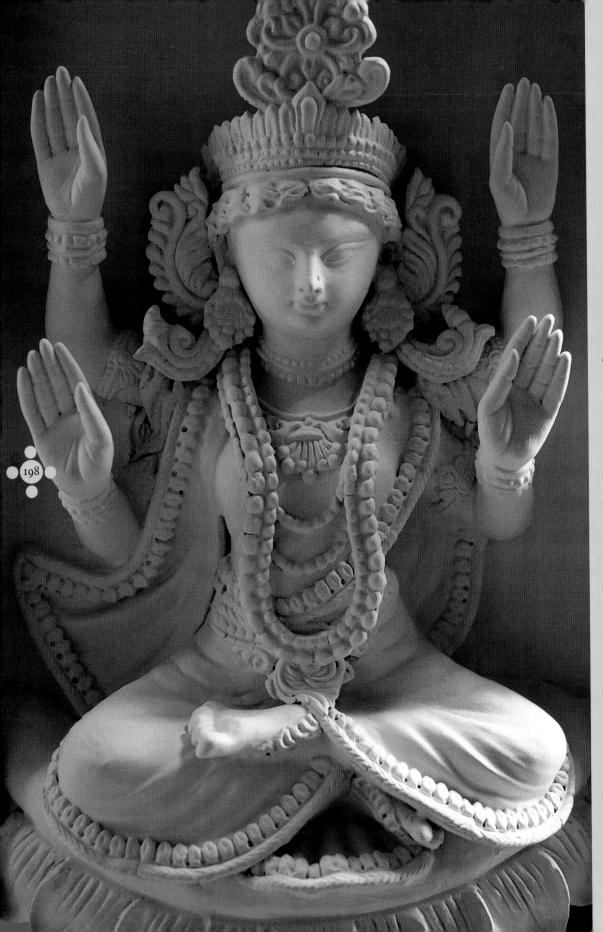

198

The sacred buildings of ancient India are a fusion of architecture and sculpture. Their creators are not mentioned in treatises: rather, sculptor and architect were seen only as 'revealers', who freed the latent image of the god from the stone that imprisoned it. In the past, craftsmen who worked on temple sites were paid not for the end product but according to the weight of dust accumulated as they chiselled and carved the stone to reveal the hidden shapes of the gods. Funding came from two castes: warriors moved by the spirit, and devout merchants.

LEFT
While Hindu temples often use colour, Jain temples favour white marble and whitewash, but their sober monochrome is offset by dazzling sculptural decoration that plays with light.
RIGHT
Domes and loggias overlooking the Ganges in Varanasi, city of two thousand temples.

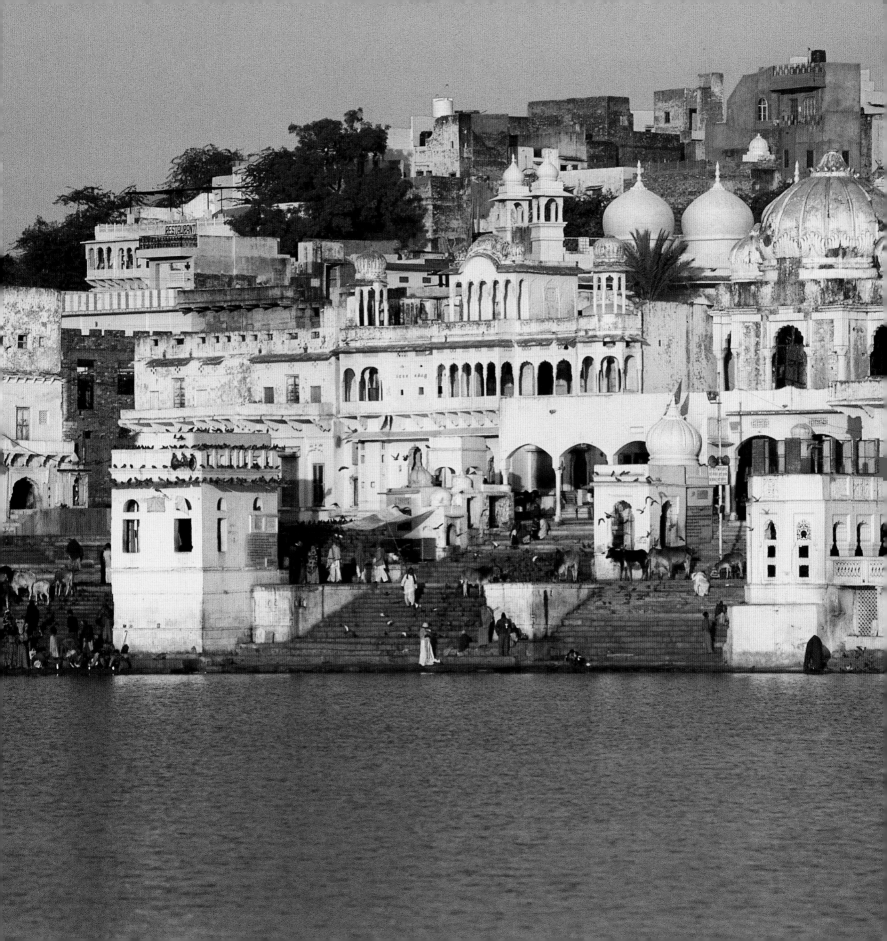

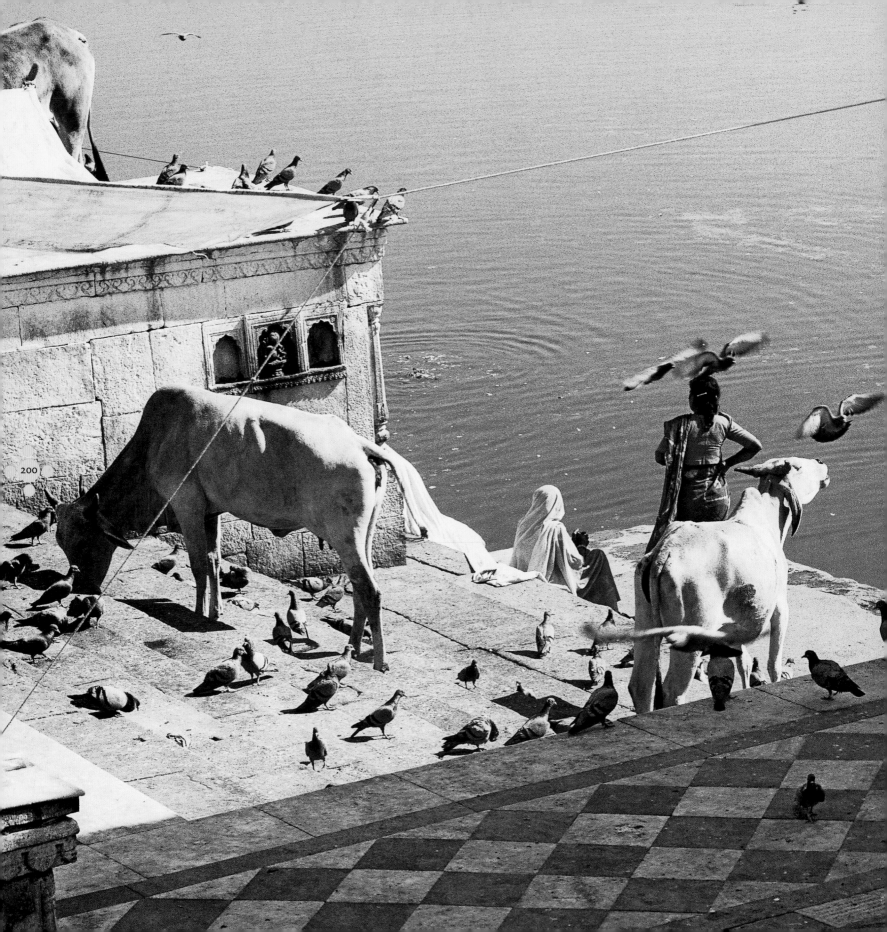

Once upon a time in the heavens there was a river goddess, who was insolent and capricious; her name was Ganga, and she would become the Ganges. The gods sent her down to earth, which was hungry, pillaged by demons. In her wild head, Ganga schemed to wander across the earth – entailing floods. So, when she prepared to jump, the god Shiva with the cobra collar stood below the young goddess and imprisoned her in his hair. Ganga would be released only when she knew how to behave.

Catherine Clément, 'Le Mahabharata' (The *Mahabharata*)

LEFT
On the ghats, life seems like
a long, smooth-flowing river.

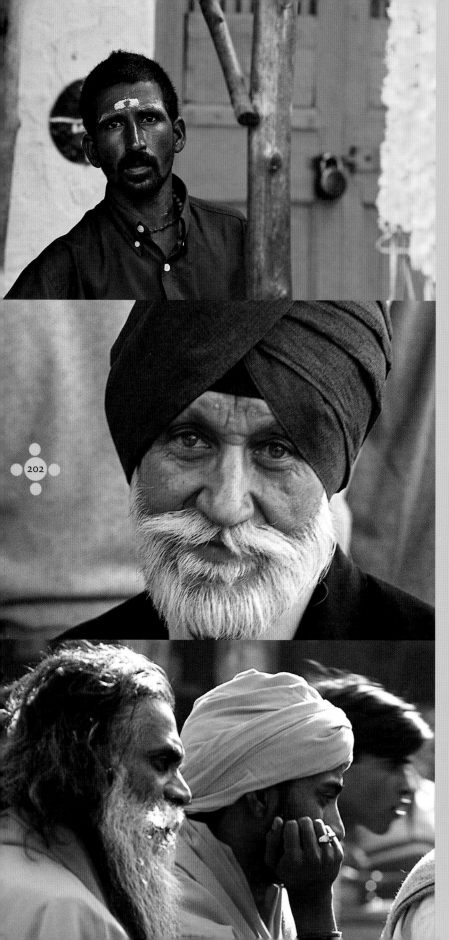

India holds the world record for public holidays, with 144 – a paradoxical situation for a nation with a secular constitution. The large number of holidays reflects the need to worship 330 million divinities in the Hindu pantheon alone, and others as well, since India is one of the most religiously diverse countries in the world. Slightly more than four-fifths of the population are Hindu; but there are also 150 million Muslims who pray to Allah, 20 million Sikhs who follow the teachings of Guru Nanak, 20 million Christians devoted to Jesus of Nazareth, 3 million Jains who follow Mahavira and his many prophets, several hundred thousand men and women who have elected to follow Buddha, and fifty thousand Parsees who worship Fire, in the tradition of their ancestors who came from Iran in the Middle Ages.

LEFT AND RIGHT
Faces and rituals reflecting the religious plurality in India.
The old photographs show, clockwise from top left, preparations for a cremation in the early twentieth century, a Brahmin in Mahe on the Malabar Coast in 1908, and the twin *gopurams* of the Meenakshi Temple in Madurai, c. 1908.

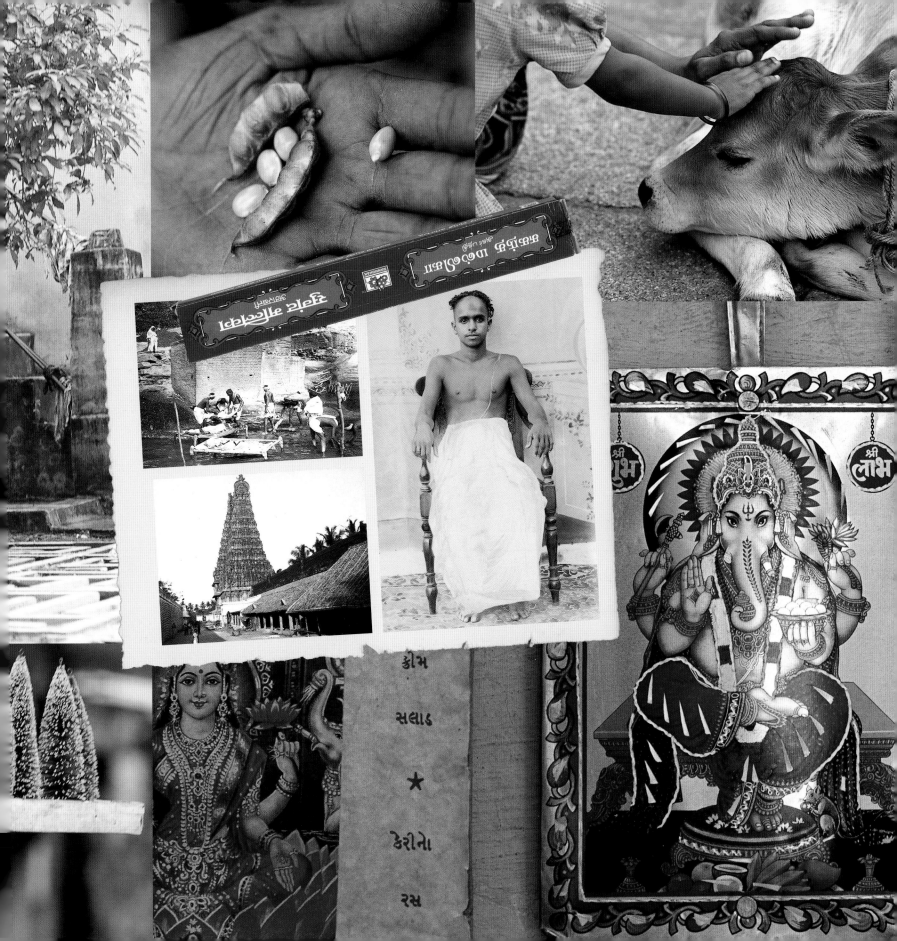

'Let's get back to India as you saw it. I want you to explain to me why India is the land of religion. And first of all, what religion?'
'India is not the land of a single historically defined religion, with a founder, an evolution, a past, a present and a future. India is the land of religion as an existential situation. Religion, by itself. One might even say that in the absurd event that there were no religions at all, India would still be the land of religion.'

Alberto Moravia, *Un'idea dell'India* (An Idea of India)

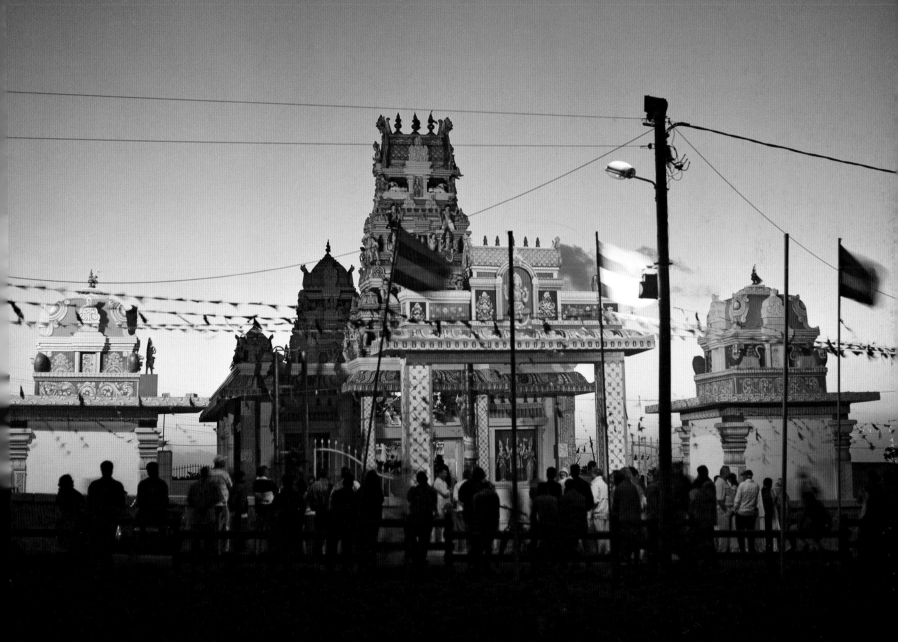

Devi, the Goddess, is the Hindu divinity who is both one and many. Devi has many guises, whereas there are only three male gods: Brahma, Vishnu and Shiva. Another of the Goddess's names is Shakti – strength, energy, daughter of all the gods, sometimes generous, sometimes mothering, and sometimes murderous, the bearer of epidemics and death. She is also Durga, equally full of tenderness and wrath, the cosmic mother. Depending on a person's degree of spiritual awakening, she appears to them as Maya, illusion, the elusive mirage of creation, or in the form of Kali, the dark one, the destroyer, who gathers round her Kala (Time) and the forces of chaos. She can be Viveka, discrimination, enabling people to distinguish good from evil; or Vidya, the enlightening conscience, faithful wife of the spirit of the sage who, having become one with god, has been able to tame his passions and know himself fully. Parvati, daughter of the mountains, and Uma, the Dawn, are yet other names of Devi.

LEFT AND RIGHT
Some of the many faces of Devi.

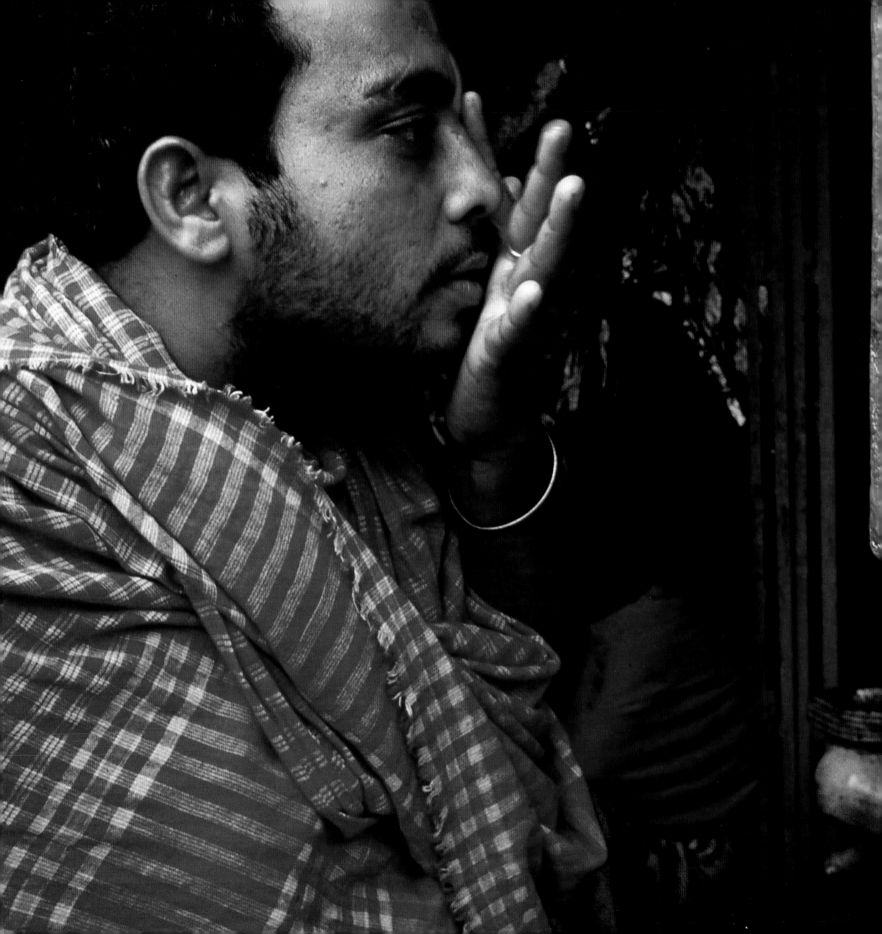

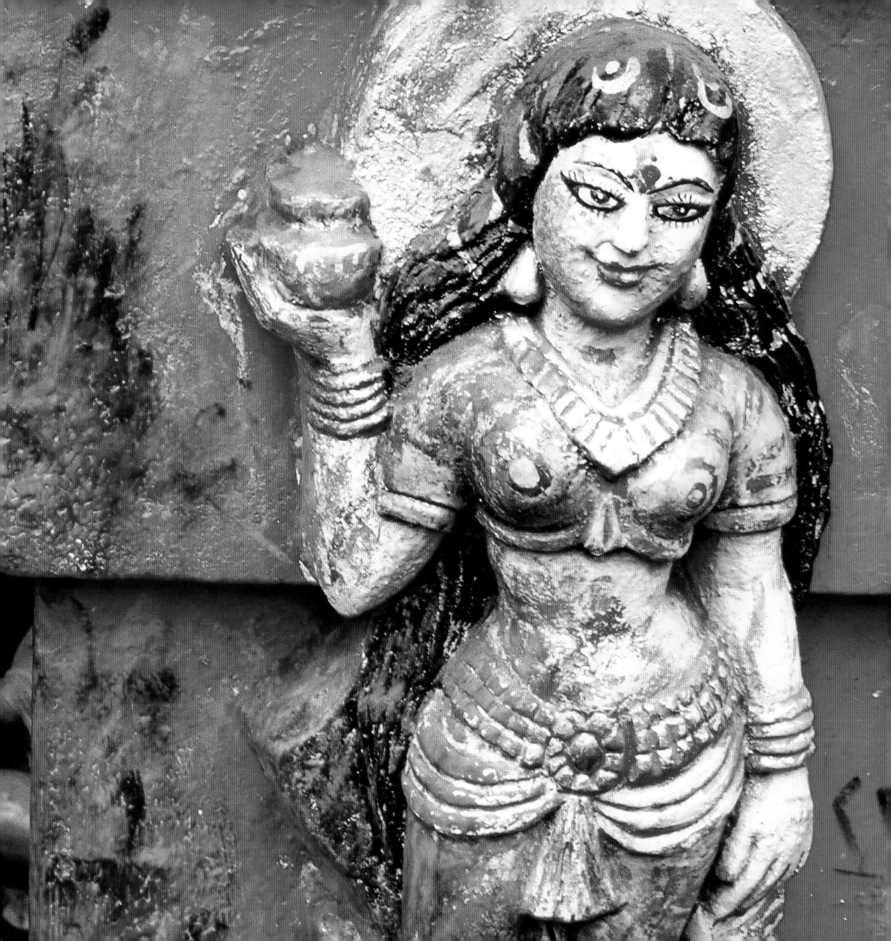

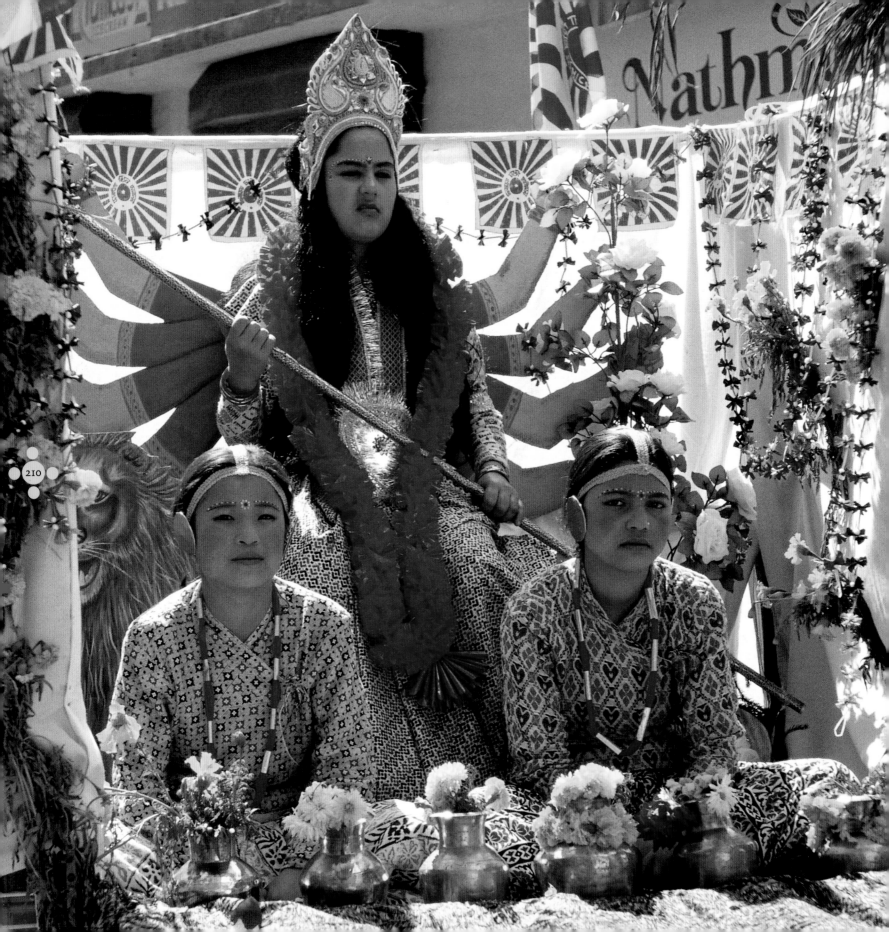

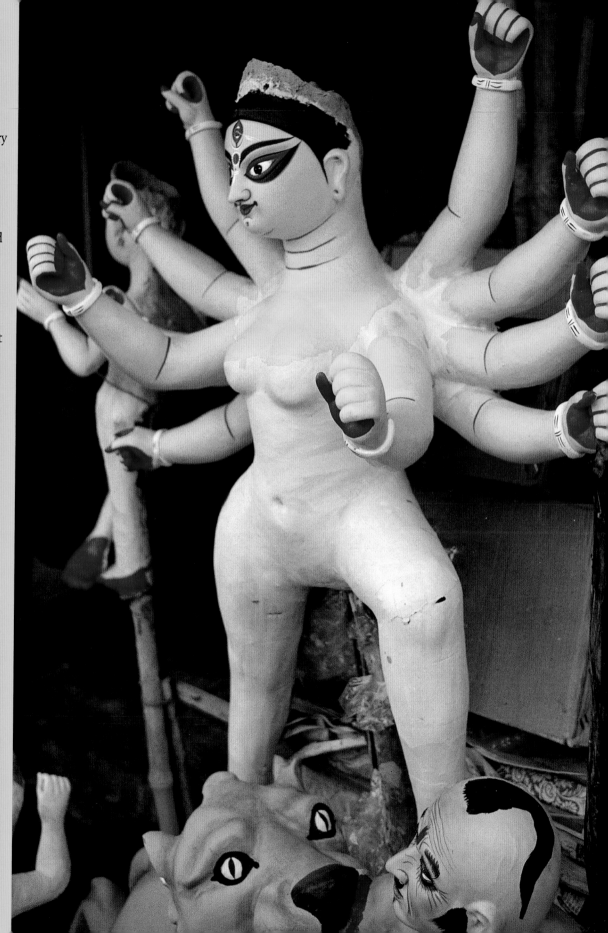

Each autumn the festival of Dusserah celebrates the victory of the goddess Durga over the fearsome buffalo-headed demon Mahishasura. Infuriated by the tyranny of this evil creature, the gods and sages met together, and from their concerted minds a ball of fire was born that took the shape of Durga, a smiling dark-haired woman with eight arms and eight weapons, each one the gift of a god – the discus from Vishnu, the trident from Shiva, the lightning from Indra, and so on. Roaring with laughter, Durga climbed onto the back of a fierce lion and swooped down on Mahishasura and his hordes, destroying them. The cult of Durga is strongest in Bengal. In Kolkata the potters of Kumartoli make thousands of effigies of the goddess, which are displayed in temporary shrines made of paper and clay. At the end of the nine days of celebrations, all the statues are carried in procession to be consigned to the waters of the Hooghly.

PRECEDING PAGES
A pilgrim praying at the entrance to the temple of Jagannath in Puri.
LEFT
In the north of Bengal, a young girl embodies Durga for the Nepalese in Darjeeling.
RIGHT
A statue of Durga, half-finished, in Kumartoli, Kolkata.

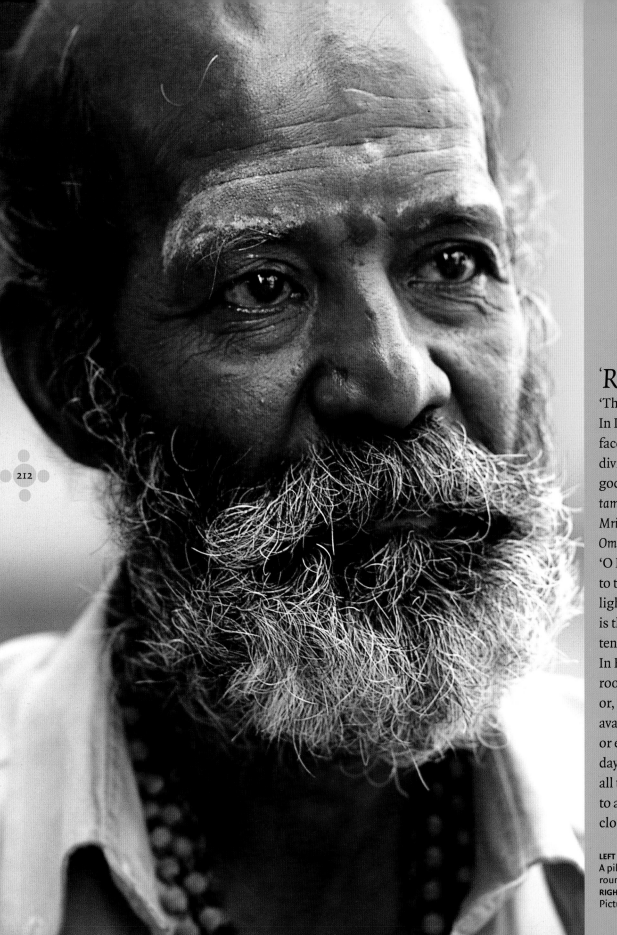

212

'Ram nam satya hey!' –
'The name of God is truth!'
In India, this God is many-
faced, and men approach the
divinity through their own
gods. 'Om asatoma Satgamaya
tamasoma jyothir gamaya.
Mrityor ma amritam gamaye.
Om shanti, shanti, shanti' –
'O Lord, lead us from untruth
to truth, from darkness to
light, from death to life.' This
is the prayer that rises from
tens of thousands of temples.
In Hindu homes, the 'puja
room' may be an entire room,
or, depending on the space
available, merely a cupboard
or even just a shelf; but every
day, the deity's effigy receives
all the marks of respect due
to a lord – baths and perfumes,
clothes and food.

LEFT
A pilgrim with prayer beads
round his neck.
RIGHT
Pictures of gods on walls.

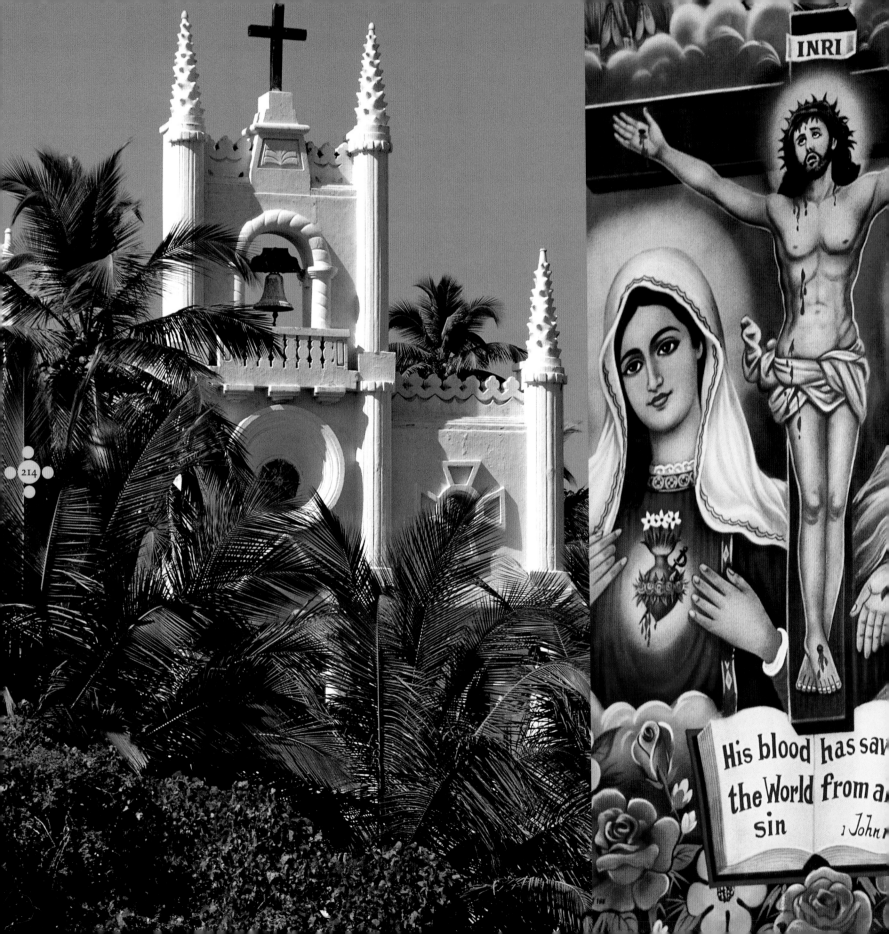

In the days of the sea route to India, Portuguese venturers landed on the Malabar and Coromandel coasts, and there they converted people to Christianity, as well as buying pepper, cinnamon and cardamom for enormous sums. They also discovered Christian communities that had existed in India for many centuries. The Christians of Kerala trace their history back to the Apostle Thomas, who is said to have founded the first churches on the Malabar Coast in AD 52. They follow the Syrian rite and have remained close to the Eastern Church, using the Syriac language in their liturgy. These Christians form extremely active minority groups, involved in many public works such as the foundation of schools and colleges, with the result that Kerala has the highest literacy of any state in India. The women in particular are very devout, and between breakfast coffee and morning mass they never fail to hang a garland of jasmine on the statue of Christ in their home.

LEFT
A church in Goa. • The Holy Family, Catholic style.
RIGHT
The Holy Family, Hindu style.

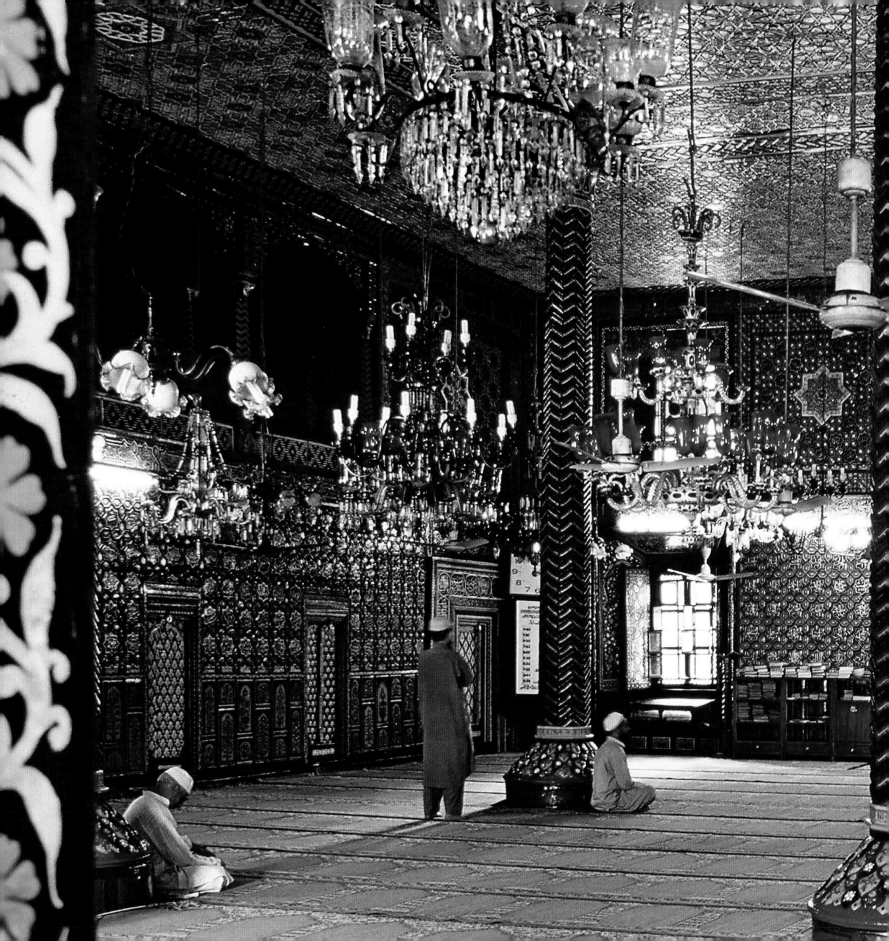

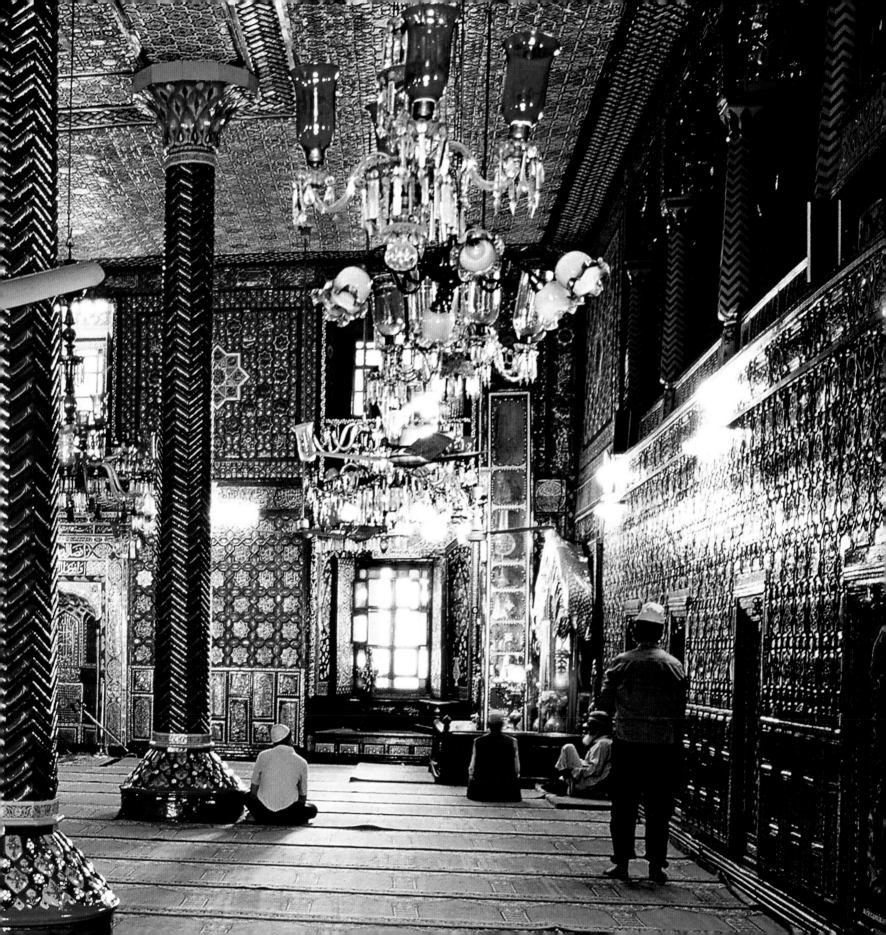

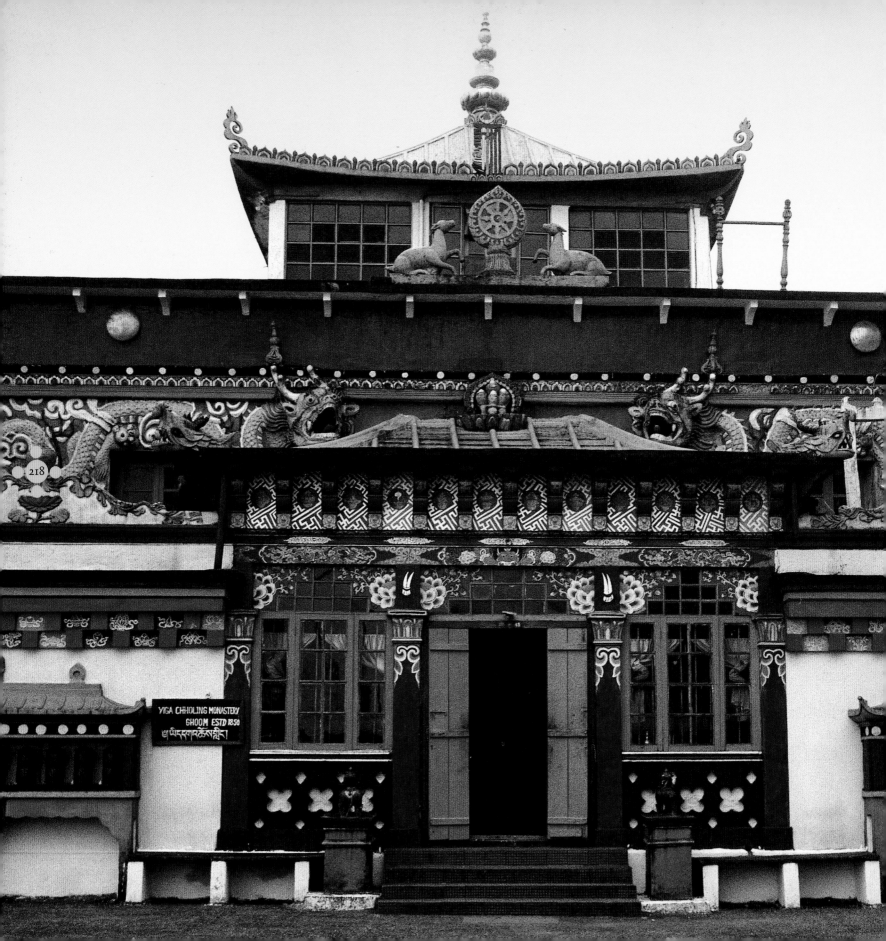

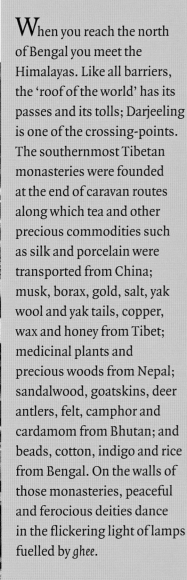

When you reach the north of Bengal you meet the Himalayas. Like all barriers, the 'roof of the world' has its passes and its tolls; Darjeeling is one of the crossing-points. The southernmost Tibetan monasteries were founded at the end of caravan routes along which tea and other precious commodities such as silk and porcelain were transported from China; musk, borax, gold, salt, yak wool and yak tails, copper, wax and honey from Tibet; medicinal plants and precious woods from Nepal; sandalwood, goatskins, deer antlers, felt, camphor and cardamom from Bhutan; and beads, cotton, indigo and rice from Bengal. On the walls of those monasteries, peaceful and ferocious deities dance in the flickering light of lamps fuelled by *ghee*.

PRECEDING PAGES
The prayer hall of the mosque of
Abdul Qadir Jeelani in Srinagar.
LEFT
The façade of a Tibetan monastery
in Goom.
RIGHT
A fierce deity from the Tibetan pantheon.

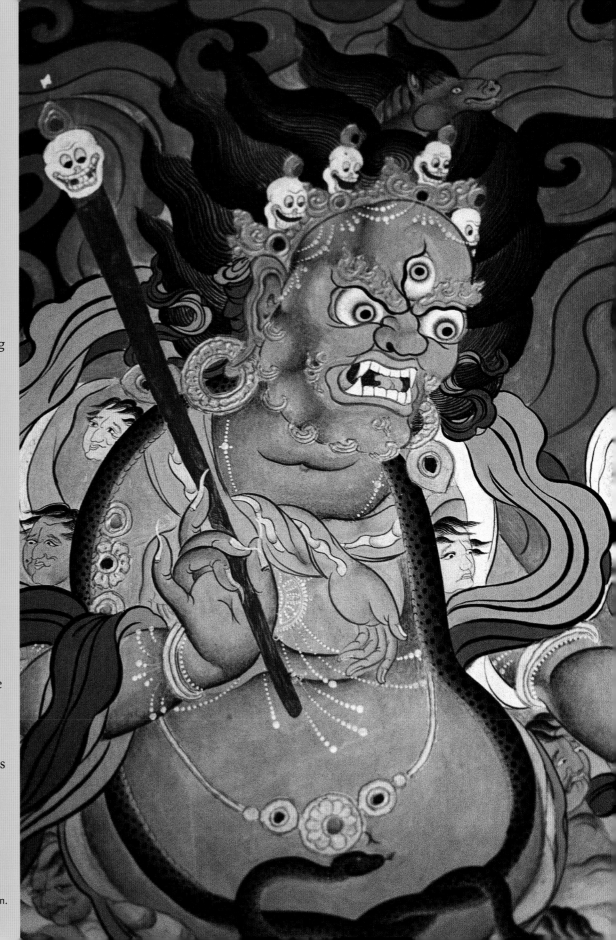

In India images of deities appear in the most unexpected places and in the most disconcerting forms. At Deshnoke in Rajasthan, the temple of Karni Mata, an avatar of Durga, houses hundreds of rats because that is the shape taken by her son when he was thrown into hell. At Ujjain, a major Hindu pilgrimage centre, pints of alcohol are poured onto a block of stone which is only vaguely roughed out to suggest the form of a deity. In the Tamil Nadu countryside, villagers make offerings of milk and honey to giant termites' nests, inhabited by cobras. On the border between Gujarat and Rajasthan, the Bhils set out dozens of clay statues of saddled horses. Everywhere, depictions of gods blend with cults that go back to the dawn of time.

LEFT
A Hindu ceremony, c. 1910.
RIGHT
At Puri in Orissa, one of the most sacred pilgrimage sites in India, the god Jagannath and his family are represented by crudely painted blocks of wood.

THE BLESSING
OF WATER

Vidhya takes off her sandals, first one, then the other, on the steps of the ghat. When the brown waters of the Hooghly touch the edge of her sari, she shivers, pauses, and then with determination continues her descent. She stops again when the cold water reaches her thighs, then goes on until only her breast emerges from the river. Sharp pebbles in the silt hurt her feet. But that does not matter: Vidhya is happy. Above her head, tens of thousands of feet pound the Howrah bridge on their way into Kolkata, for this is the time when people are hired for work. On the ghat, dogs and goats frolic in the dawn light. *Sadhus* are folding up the blankets in which they had wrapped themselves for the night, and adjust their loincloths and togas, which are orange – the colour for ascetics.

Men are doing yoga, slowly breathing in the early morning air. Others rub their teeth with neem twigs to clean them. Women go down to the river with a pile of washing in a bowl, carefully balanced on their head. Near Vidhya an old man, stripped to the waist, is also standing in the murky water up to his waist. Like him, she clasps her hands on her breast, closes her eyes, and immerses herself completely three times in the Hooghly. '*Ram, Ram, Ram*', her lips murmur the name of God. '*Jay Ganga Maiki, jay*' – 'Glory to you, Mother Ganges': her lips form the *mantra* of Ganga, the prayer to the mother-river of India.

In Kolkata the Ganges has nearly reached the end of its course, and the Hooghly, with its earthy waters, is one of its lazy meandering streams. Like the curls of Shiva's hair, the river divides into many branches before spilling out into the sea. '*Har, har Ganga*' – 'Blessed is Ganga!', Vidhya whispers. The Ganges is a gift from the ineffably majestic Shiva, who caught the river in his hair when it agreed to come down from heaven to earth. Glory be to the gods, glory be to Ganga, the holy one, glory be to her purifying waters that bring life and carry away

> **"My heart beats her waves at the shore of the world"**
>
> Rabindranath Tagore

the corruption of men! There is no sin so black that Ganga cannot wash it away. 'Mother Ganga', Vidya prays, 'guide the ashes of our dead through your meandering arms, in the folds of their *karma*, after you have carried them across the vast plain of the North. Take our myriad ancestors to Sagar, where you meet the sea, to be released and dissolved in the infinite Ocean. Wash away our sins as you have done since time immemorial for millions of Hindu men and women, in the endless motion of your voyage to the sea.'

Having completed her ritual bath in the sacred waters, Vidhya climbs back up to the ghat. She wrings out her hair as well as her sari and smiles to herself. Her son Rahul has promised her that when she dies he will set out on the long journey to Hardwar to throw her ashes into the bosom of Mother Ganges. Hardwar is the gateway of heaven, where Ganga emerged as a clear, pure cascade through the curls of Shiva on her way from the Himalayas towards the plains, leaving the dwelling-place of the gods for that of the masses of humanity. It is the most beautiful gift a son can give his mother. Rahul's promise has put an end to two of Vidhya's great regrets. The first was that, in spite of her long life – she will be eighty at the end of the year – she has never been able to go to the Khumb Mela, the great festival that takes place every twelve years, when people come from all over India to pray in Allahabad, where Garuda, the man-bird, let fall a drop of precious divine nectar, and where Ganga joins two of her sisters, the Sarasvati and Yamuna rivers. The prospect of her ashes' final journey to Hardwar has also erased the even greater regret, that she was never able to save enough money to go to Varanasi – Kashi, 'the luminous', where the Ganges forms an arc similar to the crescent moon that adorns Shiva's forehead – and there await the peace of death on the shore of the long river.

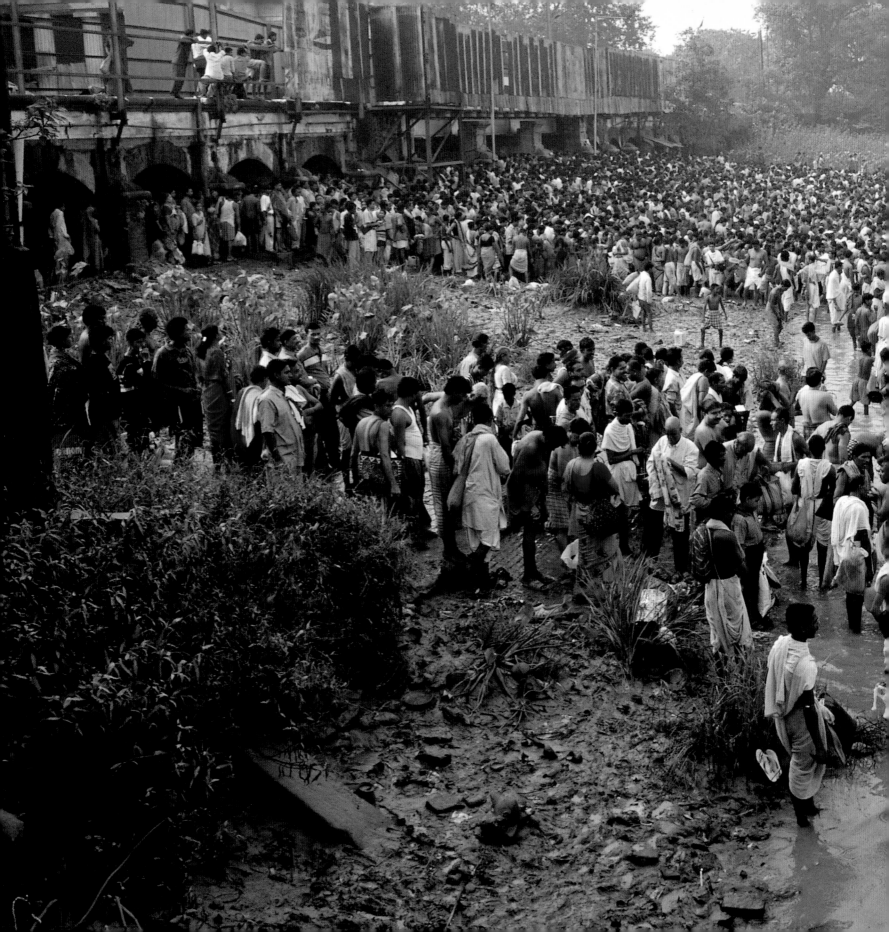

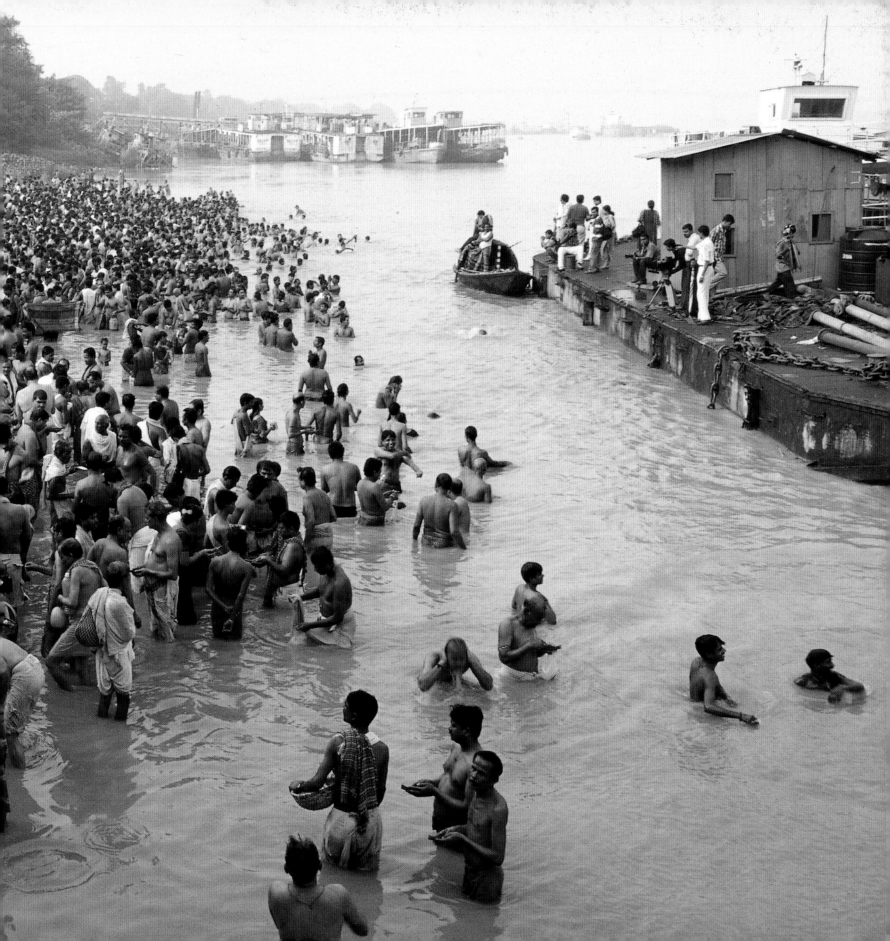

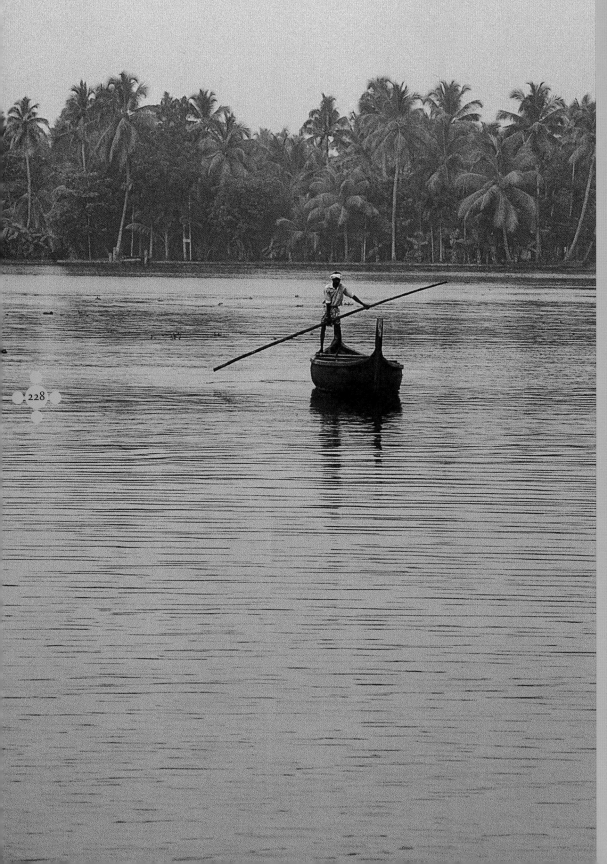

A very, very long time ago, a sage who had acquired great powers swallowed the Ocean in a single gulp to get rid of the demons who inhabited it. The earth was deprived of water – no water to bathe the plains, no water for the rites of purification. But in heaven there was a river called Ganga. For many centuries people entreated her to come down and bring the parched earth back to life. All in vain, for neither the gods nor Ganga could be moved. It was only through King Bhagiratha's harsh asceticism that Brahma, the god of creation, was moved and allowed the river's descent to the earth; and it was thanks to King Bhagiratha's prayers that Shiva, the strongest of the gods, received Ganga the impetuous in the curls of his hair, to prevent the wrath of her waters from devastating the earth. That is how the Ganges rushed down from the sky to the slopes of the Himalayas, and then spread across the plains, bringing life and carrying away all corruption.

PRECEDING PAGES
Giving thanks with thoughts of the dead in the Hooghly, the branch of the Ganges that flows through Kolkata.
LEFT
A lagoon in Kerala.
RIGHT
The Shore Temple at Puri in Orissa.

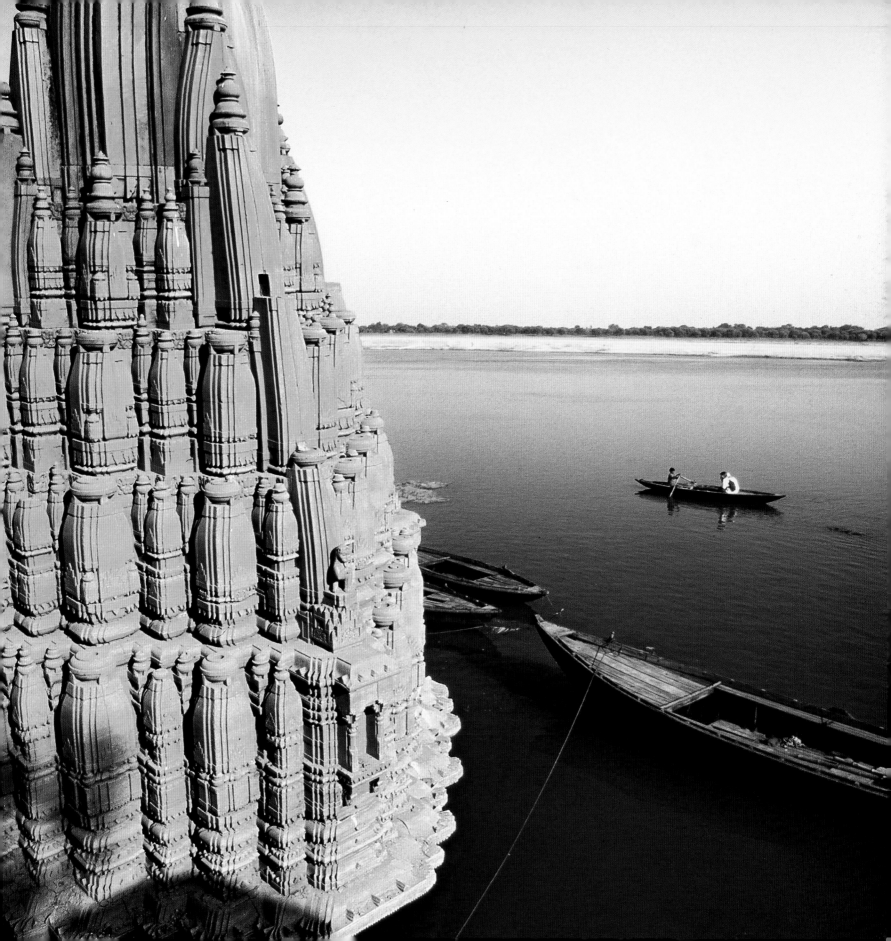

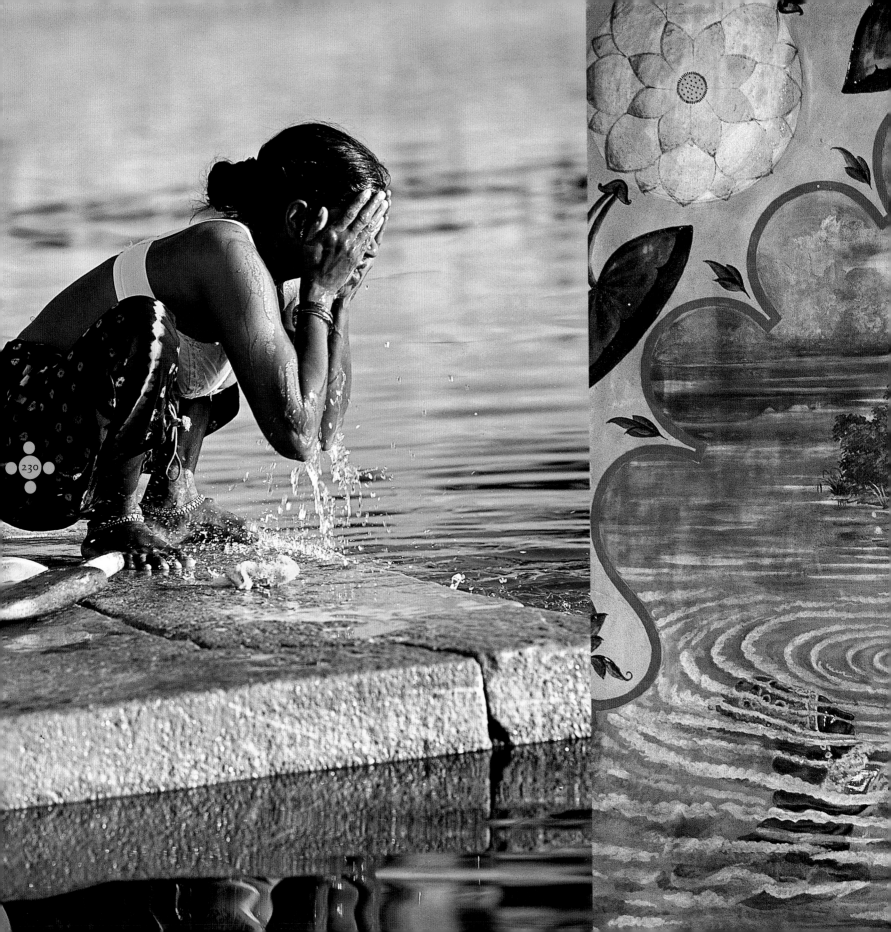

The Solanki, who ruled over the arid lands of Gujarat in the Middle Ages, sponsored the building of numerous monumental step-wells (*vav*) and tanks or pools (*kund*) to meet the needs of villages, supply troops on military campaigns, provide a watering place for passing caravans, or simply be a cool spot in which to rest in the sweltering heat of summer. They were dedicated to Vayu, god of wind and rain. Excavated down to great depths to reach the water table and fitted with steps, they still provide water today: for villagers without running water in this dry land, the *vav* and *kund* are precious gifts from those rulers of the past. At dawn and dusk, the steps leading down to the cool water are transformed into amphitheatres for the washing of clothes and bathing.

FAR LEFT AND RIGHT
The Adalaj Vav step-well in Gujarat was built by a queen in the fifteenth century.
LEFT
Krishna helps a woman fetching water: detail of an early twentieth-century wallpainting in a palace in Rajasthan.

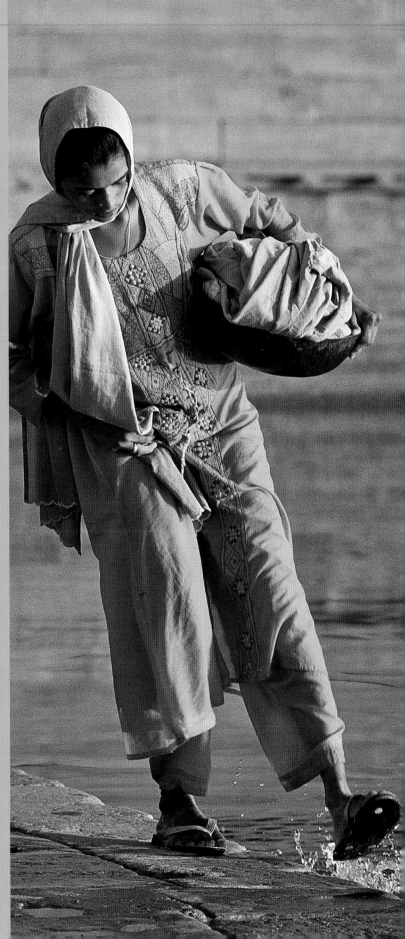

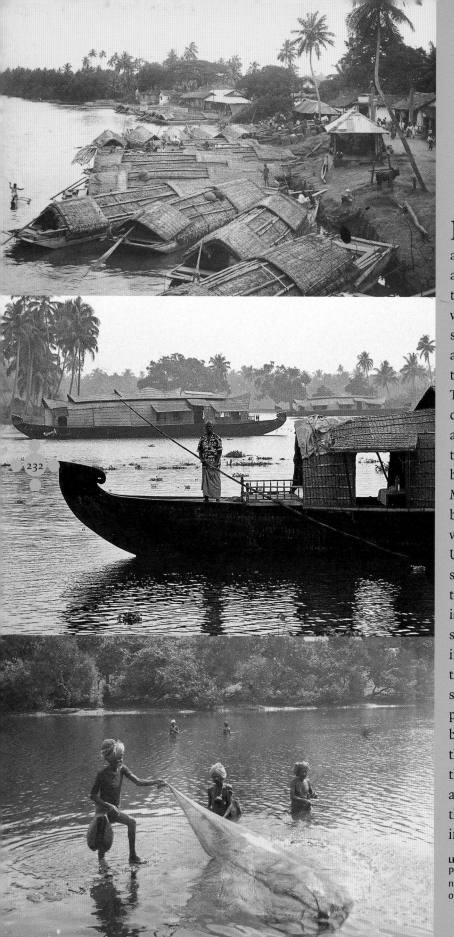

In India, places of pilgrimage are called *tirtha*, 'ford', for they are seen as passages between the celestial and the terrestrial worlds. They are always situated near a lake, a river, a place where rivers meet, or the sea – always near water. This is true of the seven holy cities of Hinduism – Varanasi and Hardwar, on the banks of the Ganges; Ayodhya, ruled by Rama, an avatar of Vishnu; Mathura, where Krishna was born, and Dwarka, where he was proclaimed king; and Ujjain and Kanchipuram, sacred to Shiva. While the temple, the house of the god, is the heart of all these sacred sites, water plays a key role in the rituals that take place there. On the ghats, stone steps lining the banks, pilgrims can purify themselves by bathing before approaching the deity, and they can share the blessing of water with their ancestors by letting it run through their hands, joined in prayer.

LEFT AND RIGHT
Precious, divine, purifying and nourishing, water is at the heart of everyday life in India.

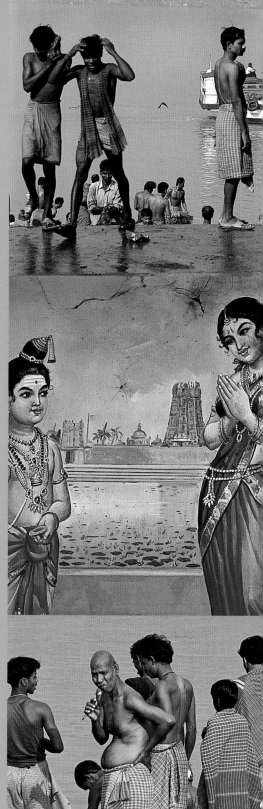

232

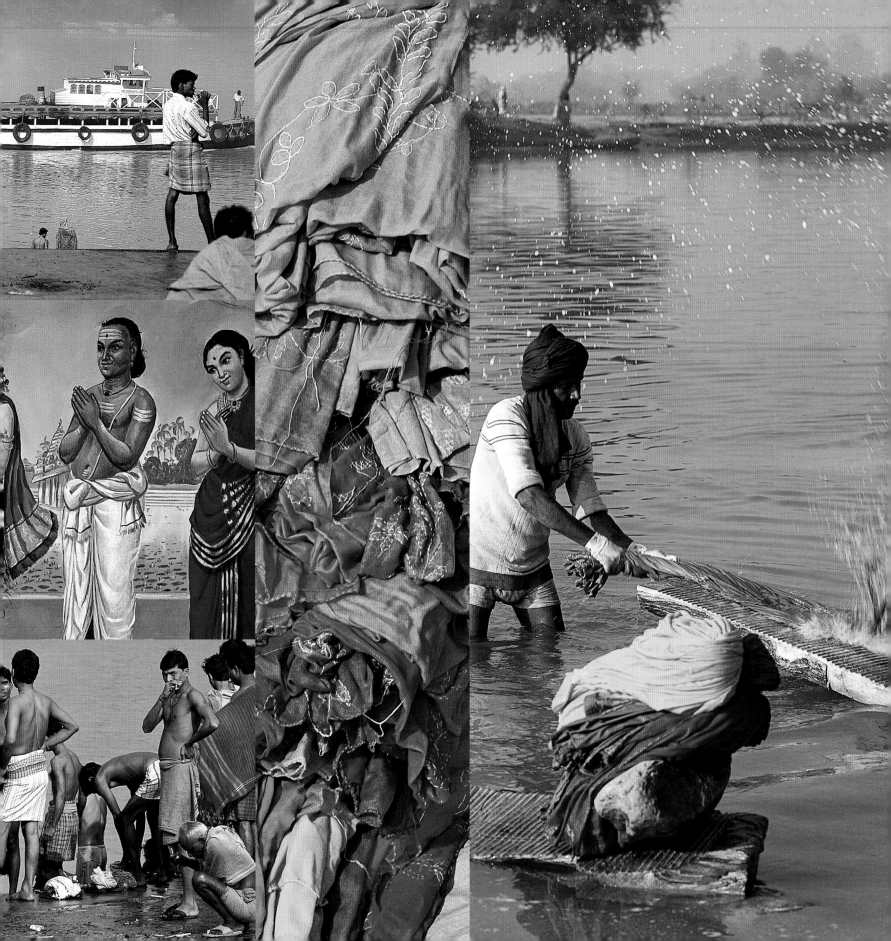

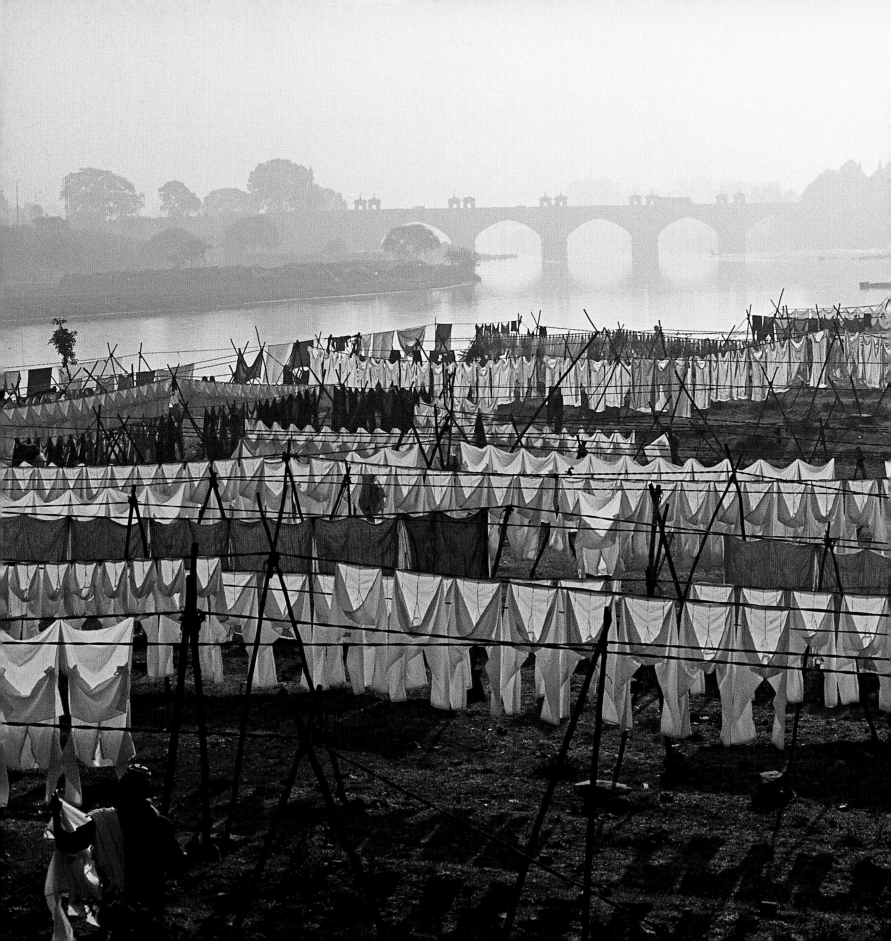

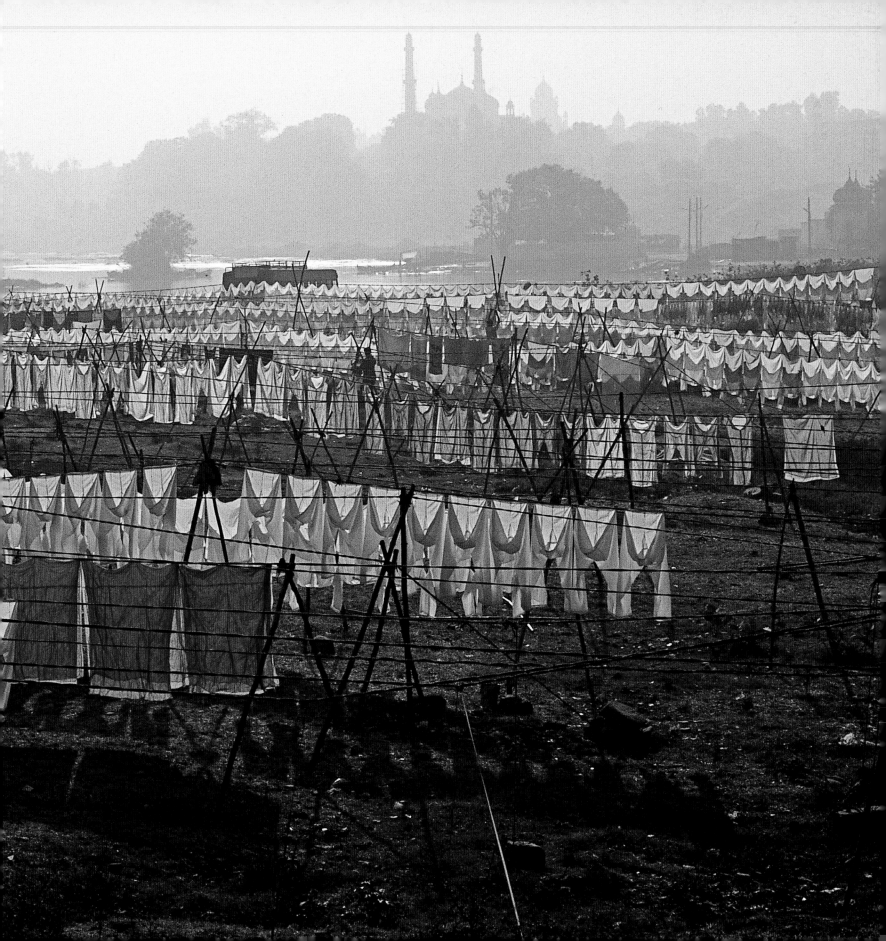

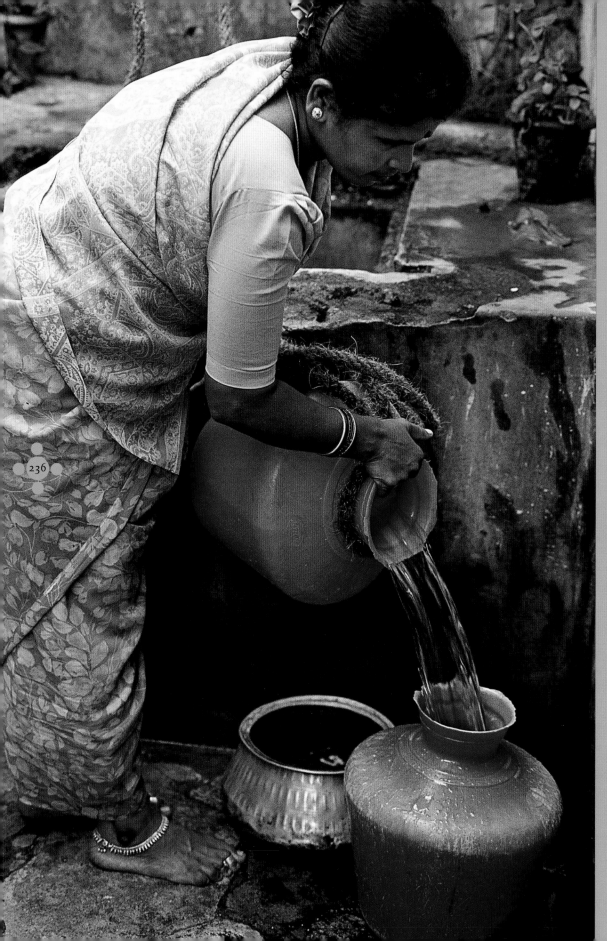

236

Villages with pumps and pipes for running water are very rare. In the desert regions of the North-West and on the Deccan Plateau, the spectre of drought haunts the dry months that precede the arrival of the monsoon rains. Indians value water in all its forms more than anything else. Fetching water is a task carried out by millions of Indian women, who meet daily at communal wells. From the age of seven or eight, little girls are taught the women's task: to fill an enormous clay or metal jar with water, lift it up onto their head, which is protected by a ring of cloth, and bear the precious liquid home while walking like a queen.

PRECEDING PAGES
In Lucknow, the corporation of the *dhobiwallas* or laundrymen has hoisted the colours of the last washing on the river bank.
LEFT AND RIGHT
Women and girls are mistresses of water for daily life.

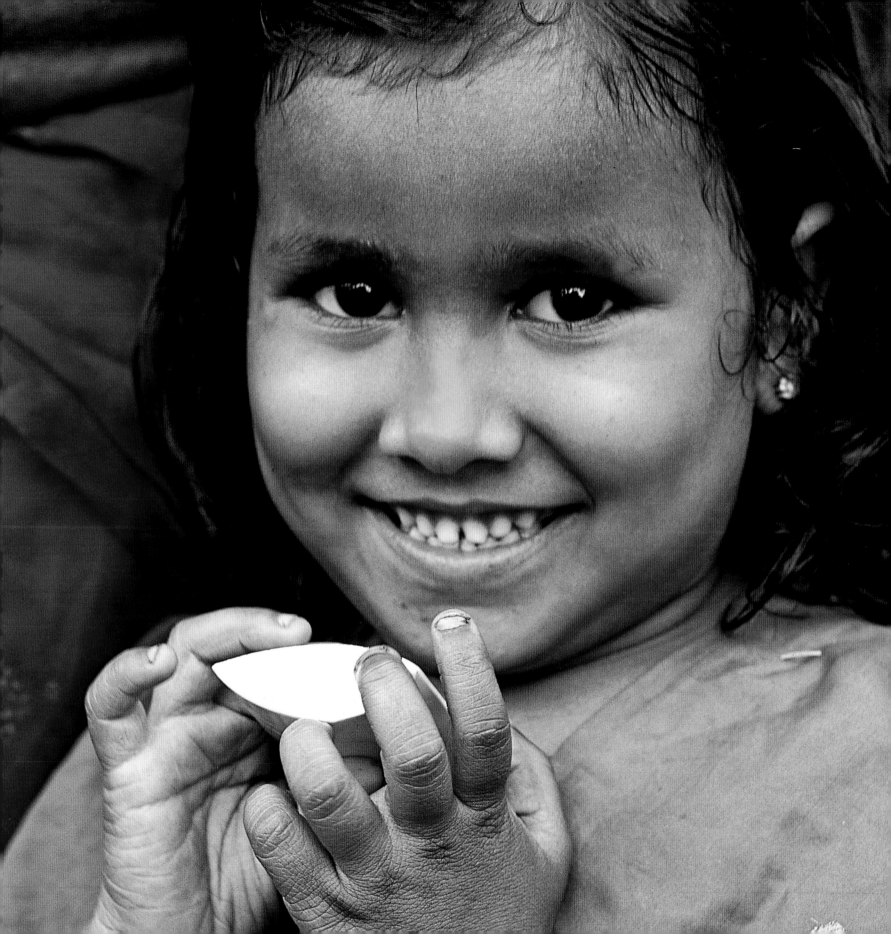

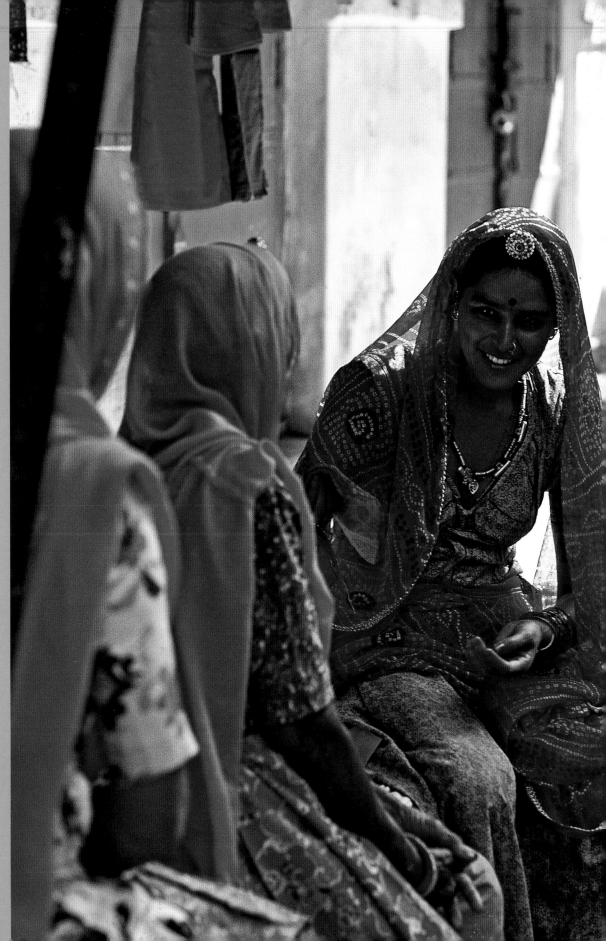

Apart from a few districts built during the period of British rule, most towns in India are agglomerations of villages, *basti*, where the everyday life of the countryside is reproduced in the turmoil of the city. Women queue for water at places that are only open for a few hours every day. With the exception of some new towns built in the 1960s, Indian cities have grown and are still growing like human beehives. Nothing governs or checks the growth of the honeycombs. Most of their infrastructure dates back to the British, more than half a century ago. Water, electricity and telephone lines follow capricious, unpredictable, mysterious routes. Breakdowns are common: swarms of plumbers and electricians, who patch up rather than repair the tangles of pipes and wires, rule as masters over the urban chaos.

LEFT AND RIGHT
At the water supply point in the Tiretta district of Kolkata.

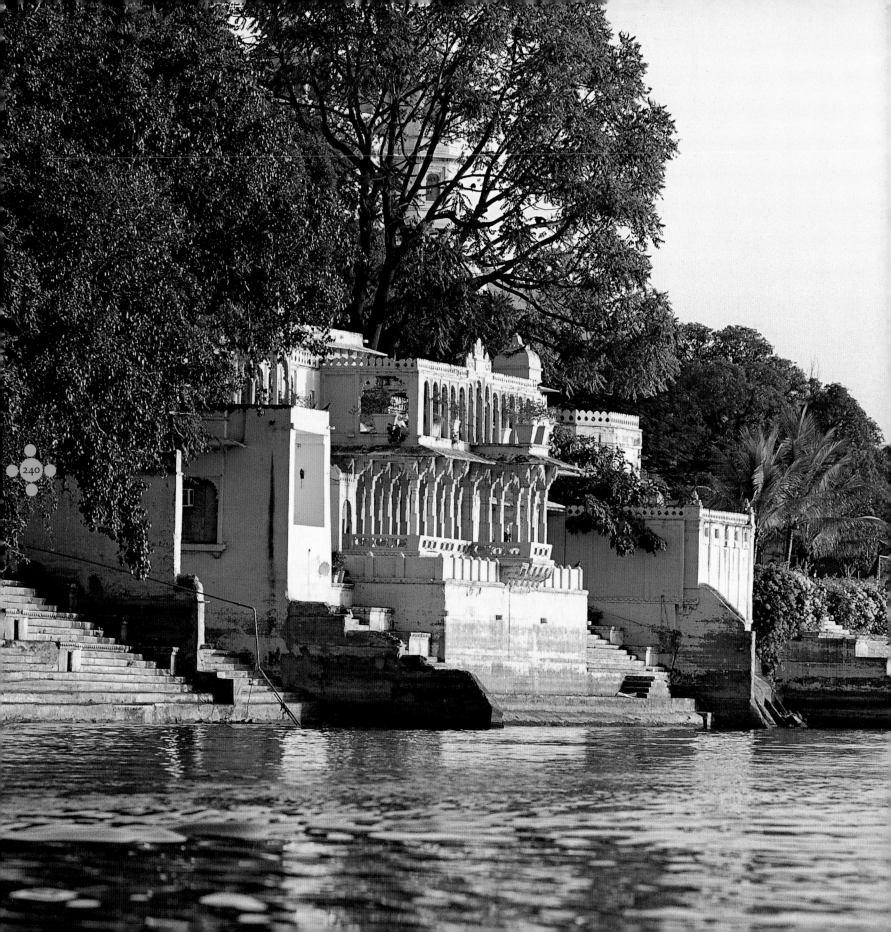

An ancient custom required that every rajah in India should build a palace in Varanasi, the holy city. They came on pilgrimage, did the rounds of the great temples, and amiably prostrated themselves before the images of the gods. But they also came to have fun, because the city was celebrated for its musicians, dancers and courtesans. Then, if they managed to make it in time, they came here to die. Because from here the road to paradise is the shortest.

Alain Daniélou, *L'Inde traditionnelle* (Traditional India)

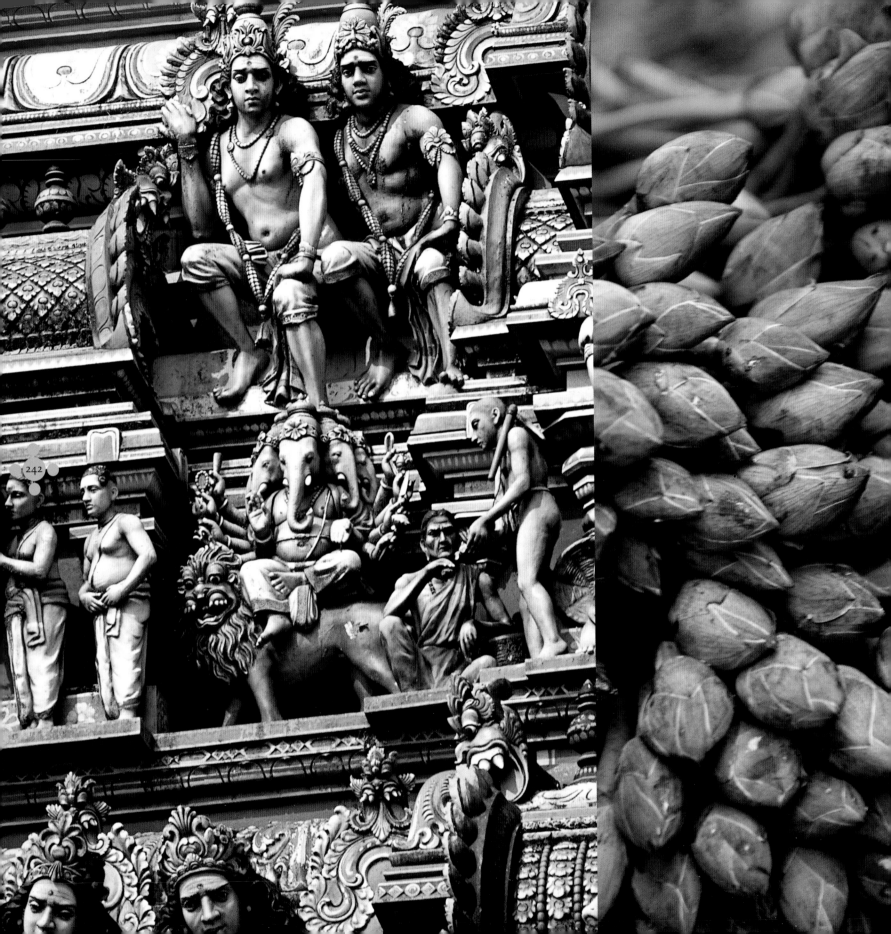

The Ganges is the greatest river in India, and the ultimate sacred river. Indians worship it along the whole of its course, from its source at Gangotri in the Himalayas to its mouth, but some spots are more holy than others. Varanasi is the place where most pilgrims congregate. At Prayag, near Allahabad, the Ganges and the Yamuna, another holy river, converge, and are joined by the mysterious Sarasvati that is believed to flow underground to join them. The site is also known as Triveni or 'Triple River'. According to legend, when the demons, expelled from heaven, fought with the gods for possession of the liquor of immortality, a drop escaped from the clay pot and fell to earth at Prayag. Every twelve years – in memory of the twelve-day battle for the divine liquid – millions of pilgrims flock there to bathe in these most sacred waters.

LEFT
Gods of India on the porch of a temple in Tamil Nadu. • Lotus buds, daughters of water and symbols of purity.
RIGHT
The sacred tank of a small temple in the suburbs of Chennai (Madras).

FABULOUS PALACES

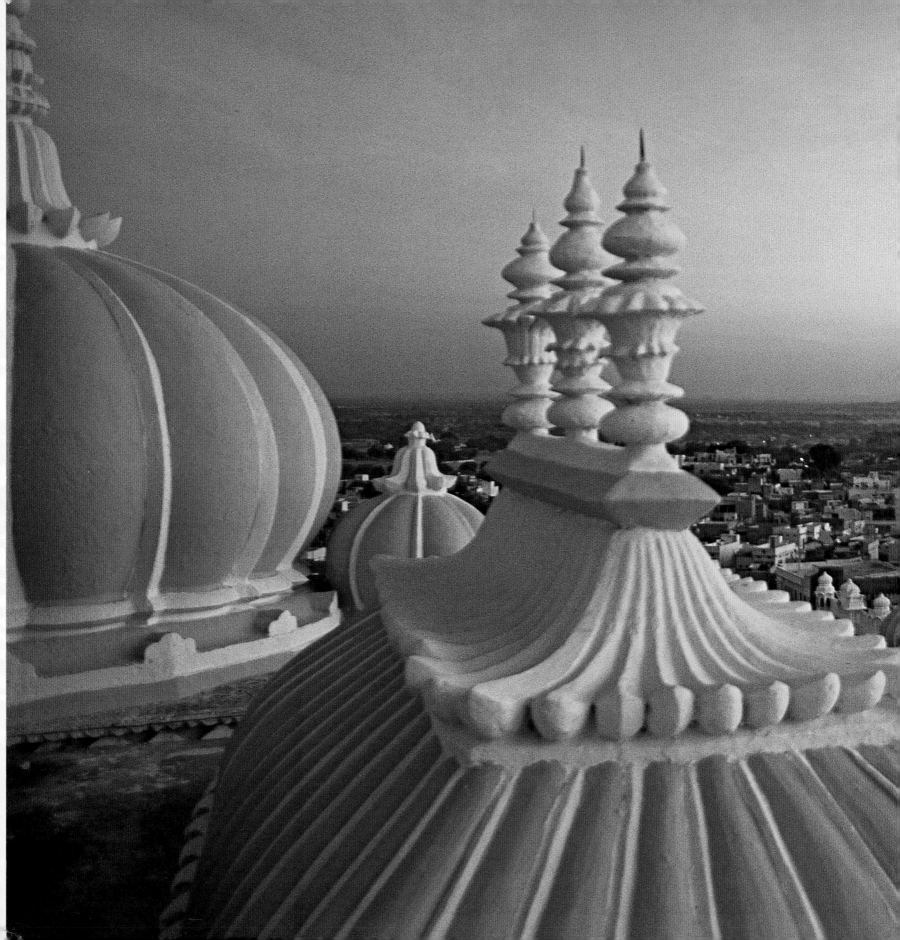

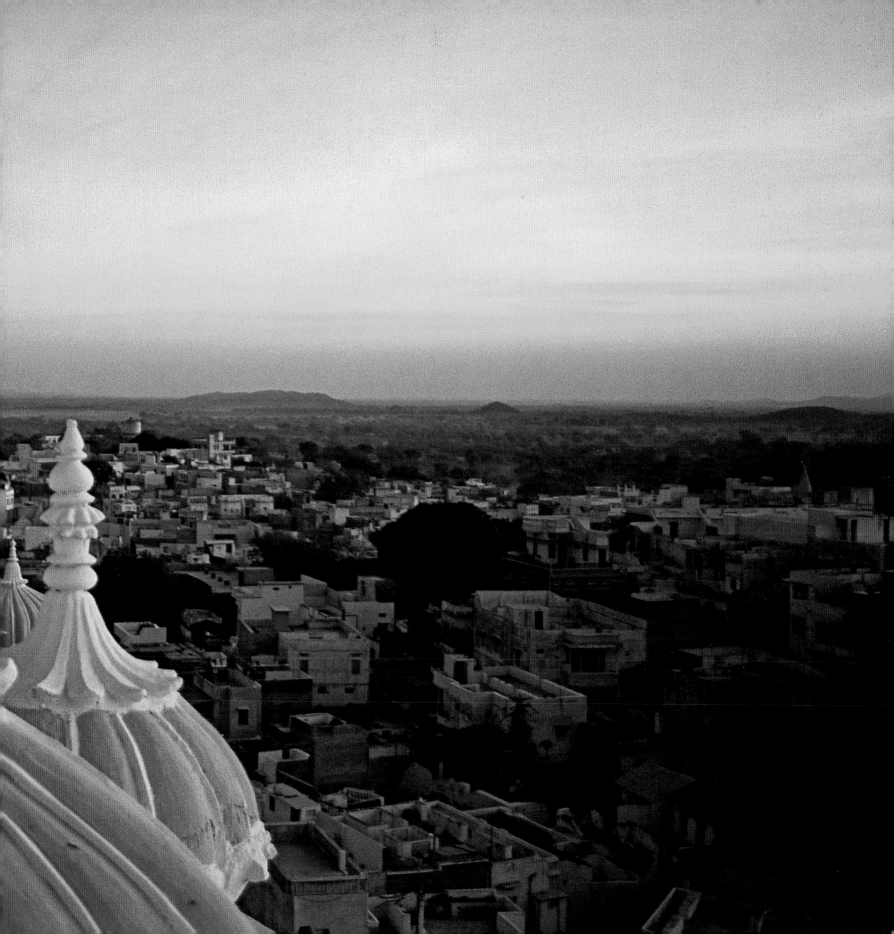

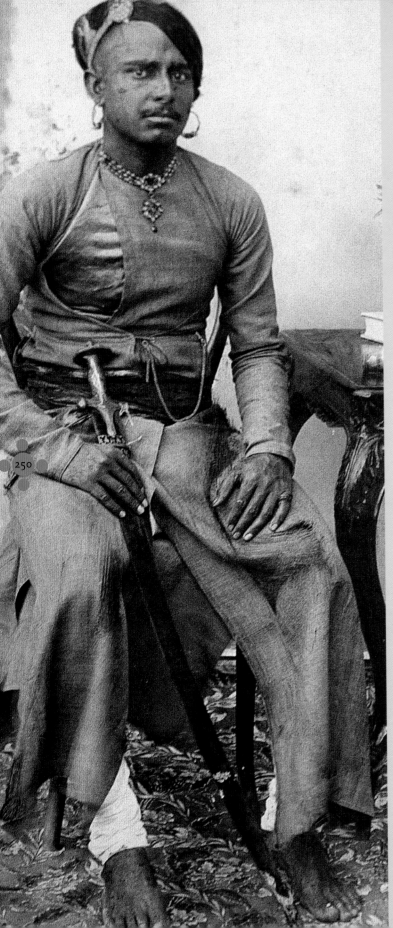

The Rajputs, 'sons of kings', are descended from the military aristocracy of medieval India, whose unfailing heroism and unbending honour are still sung by bards and storytellers in the desert of Rajasthan, 'the land of kings'. Between the twelfth and the fifteenth century, the Rajputs defended Hindu civilization against the threat of the Turkic Muslim dynasties that ruled in Delhi. Junagadh, Kumbalgarh, Chitor and Gwalior are the impregnable fortresses built by clan chiefs, self-styled kings, to halt the sultans' expansion northward. They endured formidable sieges; when the outcome was hopeless, Rajput honour demanded the great sacrifice of the *jauhar*: the warriors went out to fight the final battle, and the women, children and old people set fire to themselves on pyres in the fortress.

PRECEDING PAGES
Onion domes of the palace of Deogarh at daybreak.
LEFT
Portrait of a fierce ancestor in the dining room of a palace transformed into something out of a dream.
RIGHT
Screened windows of the Palace of the Winds in Jaipur. • A man wearing a turban in Rajput style.

250

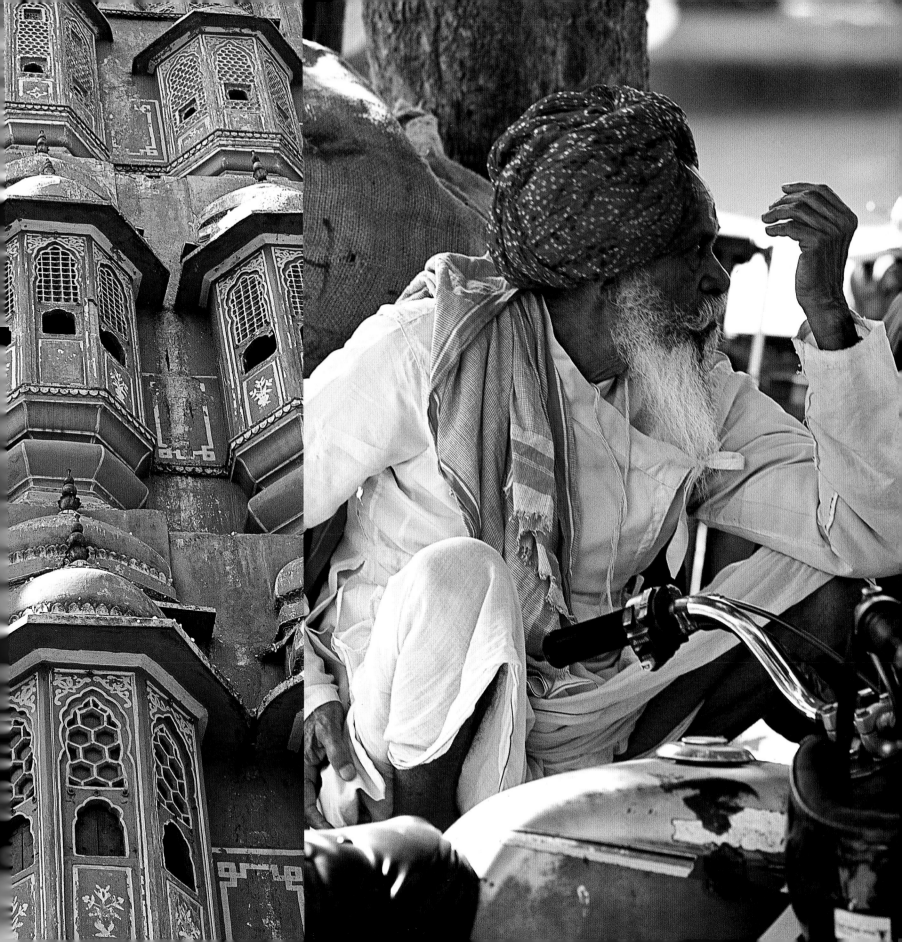

This dome that seems to float upward like a hot-air balloon, these sparkles, this gigantic floating monument. There is nothing more to say, except perhaps this inscription, added later by the Emperor Aurangzeb in a neighbouring garden: 'If there be a paradise on earth, it is here, it is here, it is here!'

Nicolas Bouvier, 'En Topolino sur la route d'Agra' (On the Road to Agra in a Topolino)

RIGHT
The Taj Mahal, a white marble mausoleum erected by the great Mughal Emperor Shah Jahan in memory of his wife.

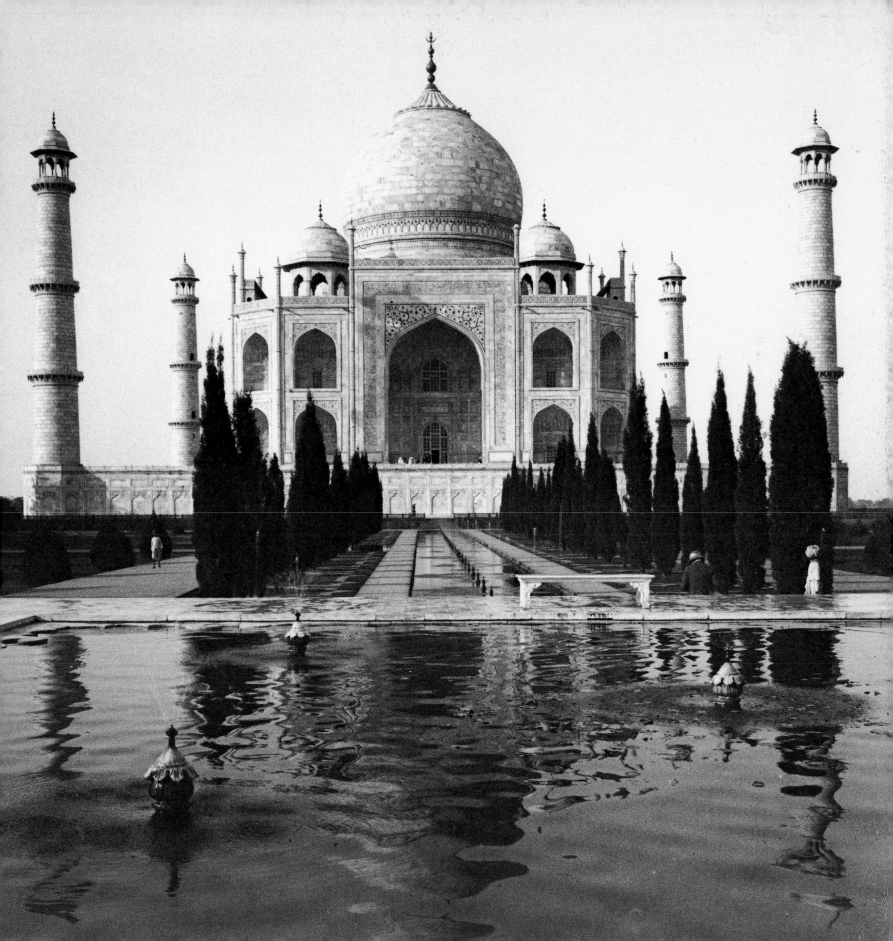

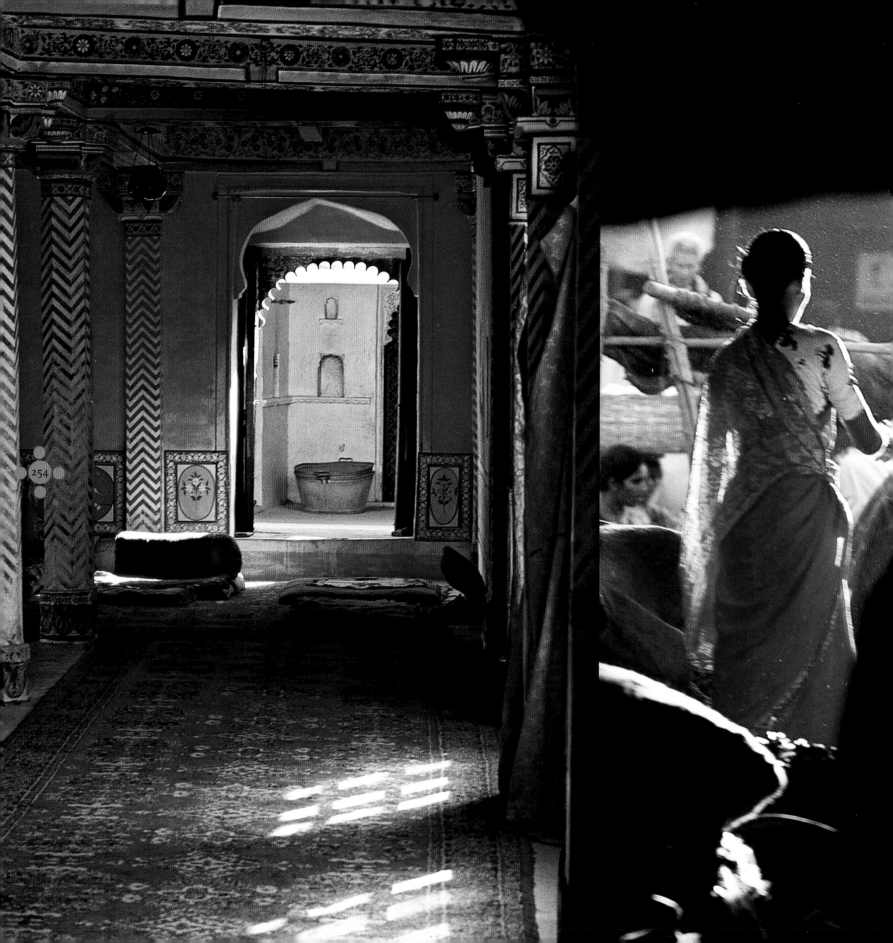

Living in the shadow of the military exploits of their husbands, to whom they had in some cases been married since childhood, Rajput women had not only to submit to the rules imposed on high-caste Indian women, but to live shut away in the *zenana*, the separate quarters for women in the palace compound. No one was to see the prince's wives, and they only knew as much of the world as they could see through screened palace windows. When the court moved from place to place, they were allowed to emerge only with their head and torso covered by an *odhni*. These rules governing the separation of the sexes, known as *purdah*, were taken over by the Indian warrior aristocracy from the Muslim traditions of the Delhi Sultans.

LEFT
Old Rajput palaces are labyrinths of courtyards and apartments, of which the innermost ones were reserved for the women.
RIGHT
Domes, inspired by Muslim architecture, are a hallmark of Rajput palaces.

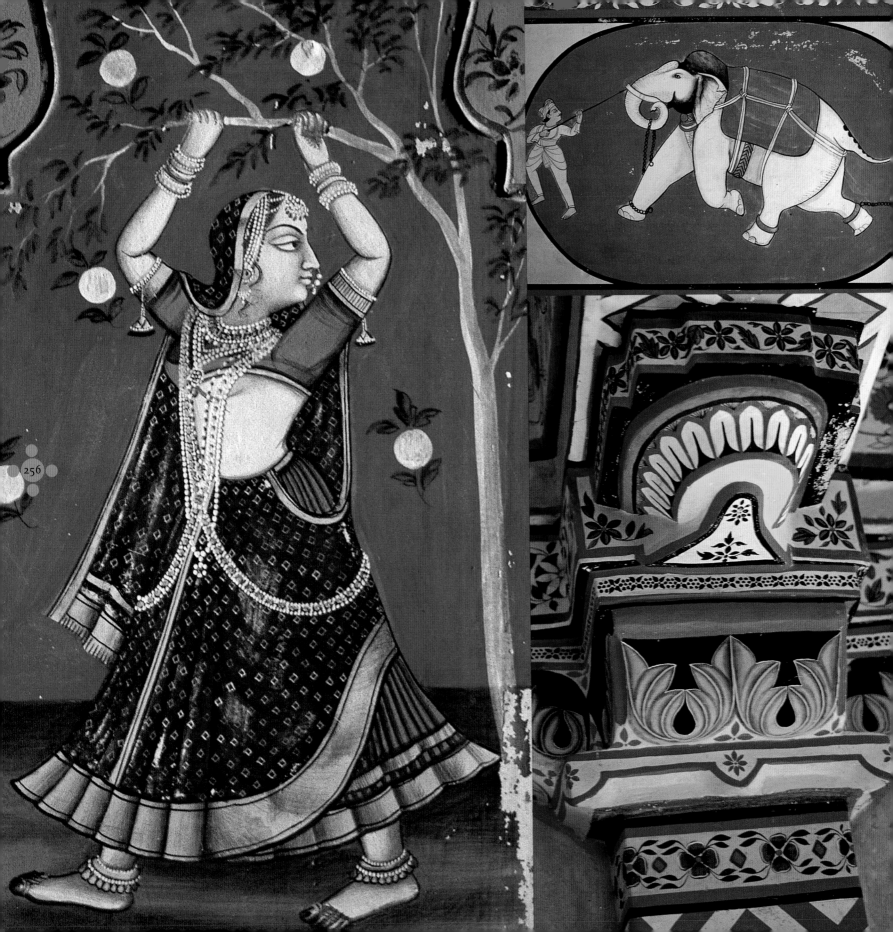

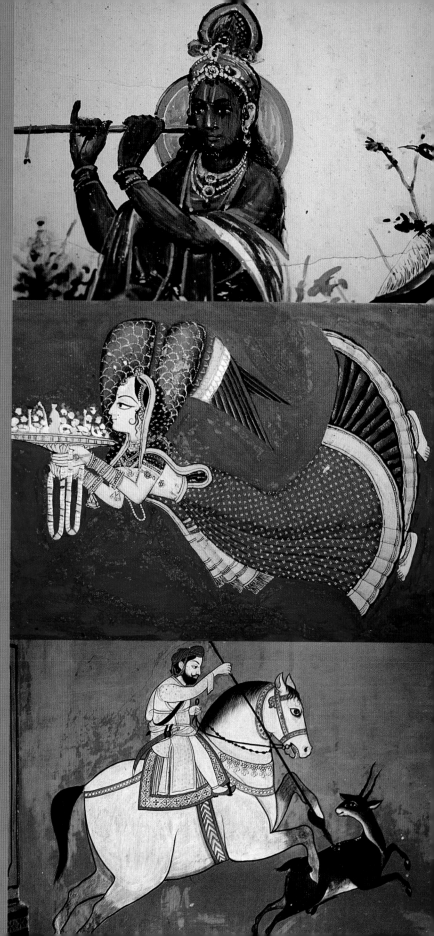

The din of battle was followed by peace when the Rajputs entered into an alliance with the Mughals, whose rule from the sixteenth century onwards gradually extended over the whole of India. Following the example of their powerful allies, warriors turned into patrons of the arts, and rivalries were settled not by the sword but by the splendour of the various princely courts. The old, austere fortresses were abandoned in favour of sumptuous palaces and hanging gardens, embellished with fountains and lakes, made possible by ingenious hydraulic systems. Painters were brought together to decorate the royal palaces even in their remotest corners with depictions of the Rajputs' great military exploits, scenes of the ruler's life – hunting, receptions and festivities – and stories of the lives of the gods.

LEFT AND RIGHT
The owners of Rajput palaces commissioned brilliantly coloured paintings to decorate the walls.

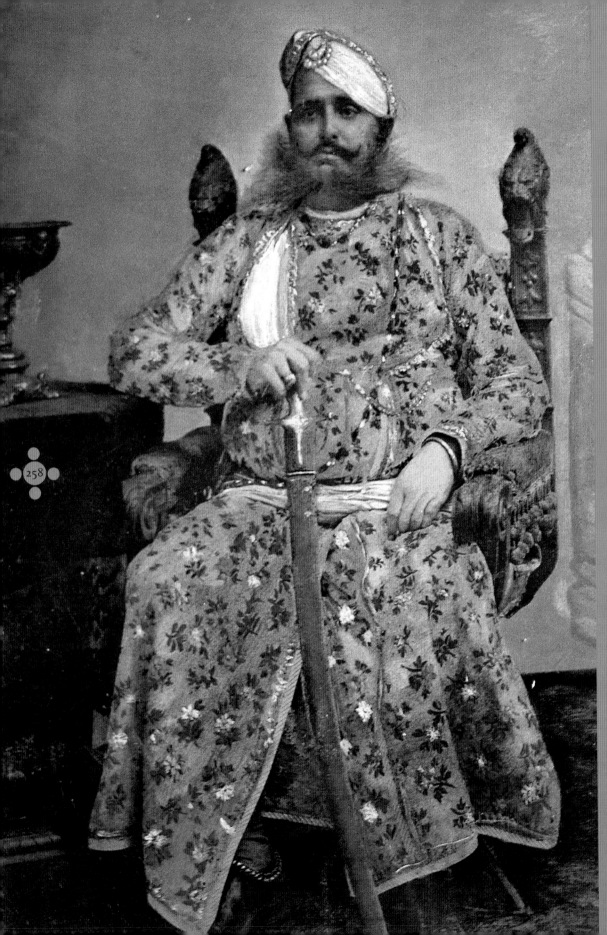

Of the great Mughals who succeeded one another on the throne of India, Akbar (1556–1605) was the most open-minded. He was a Muslim, but he was interested in all the religions that flourished in India, and received the wisest and holiest representatives of each at his court. He succeeded in pacifying the Rajputs, preferring *rapprochement* and alliance by marriage to military conquest. Fighting now on the emperor's behalf, the warrior clans accumulated booty and rewards, gold and precious stones, and gradually built up the fabulous treasures of the maharajahs, who drew on their wealth to embellish their palaces. The art of the period reflects these royal alliances, blending Persian-inspired painting from the Mughals with the exuberance of Hindu sculpture from the Rajputs.

LEFT
A Rajput ancestor wears a *kurta*, a coat decorated with floral motifs, inspired by Mughal dress.
RIGHT
Columns with carved wooden capitals in Hindu style. • Detail of a mausoleum with floral ornament in Persian style.

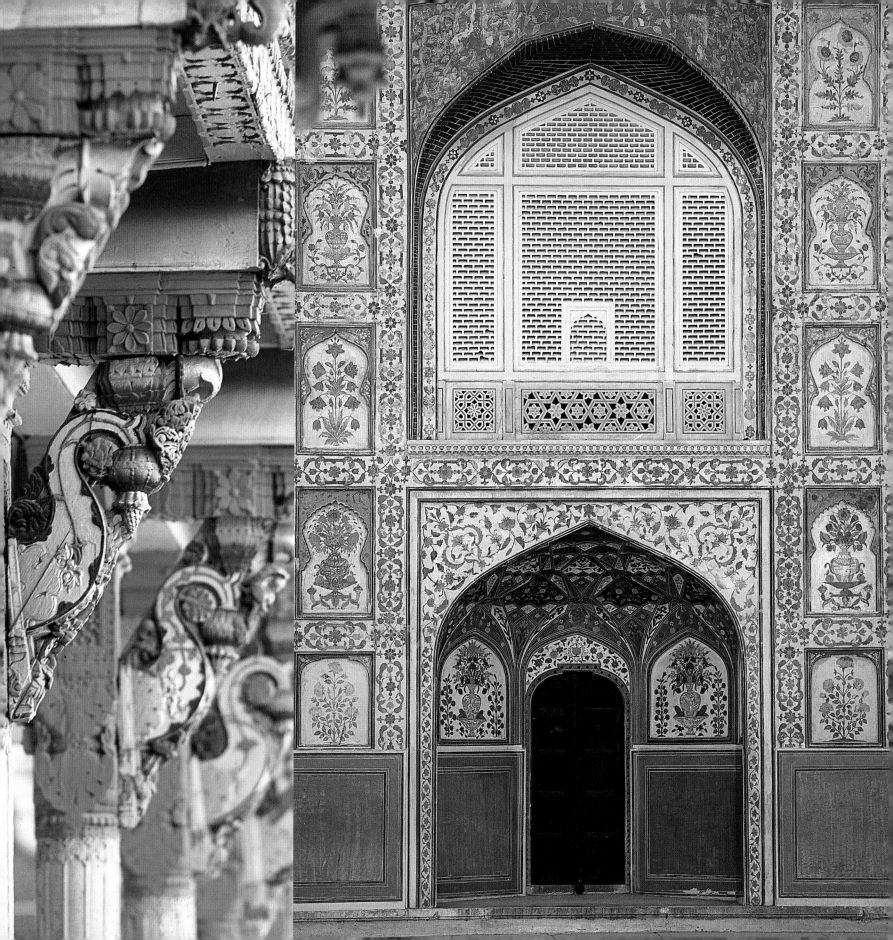

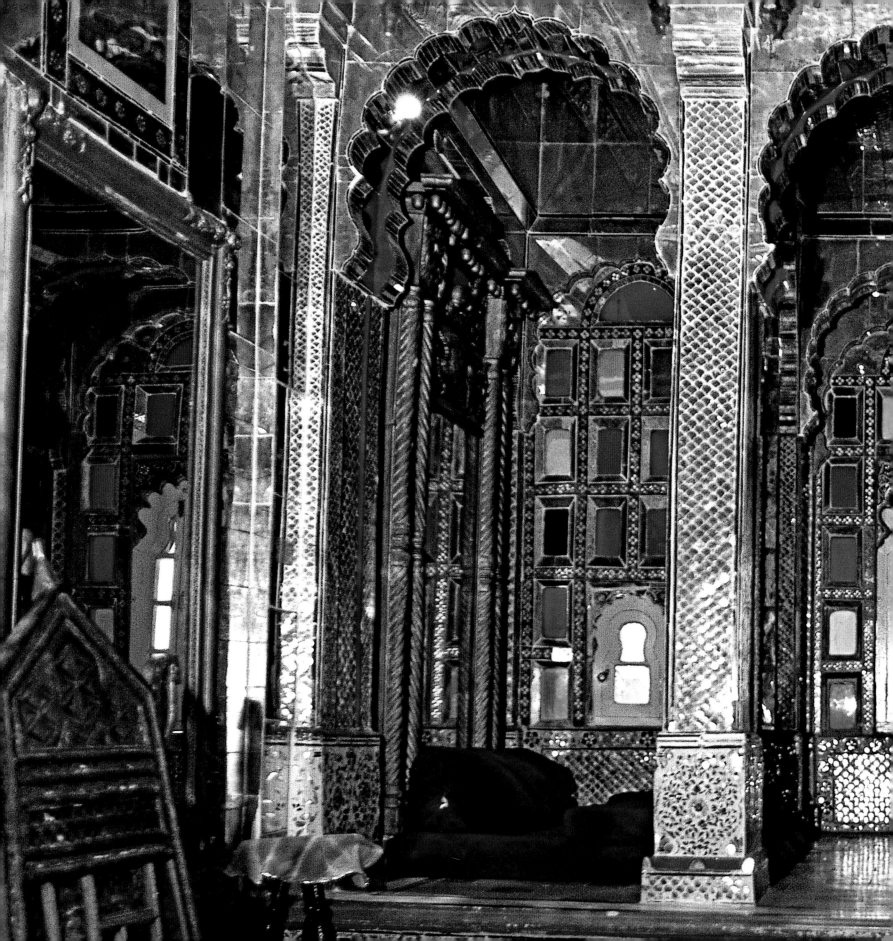

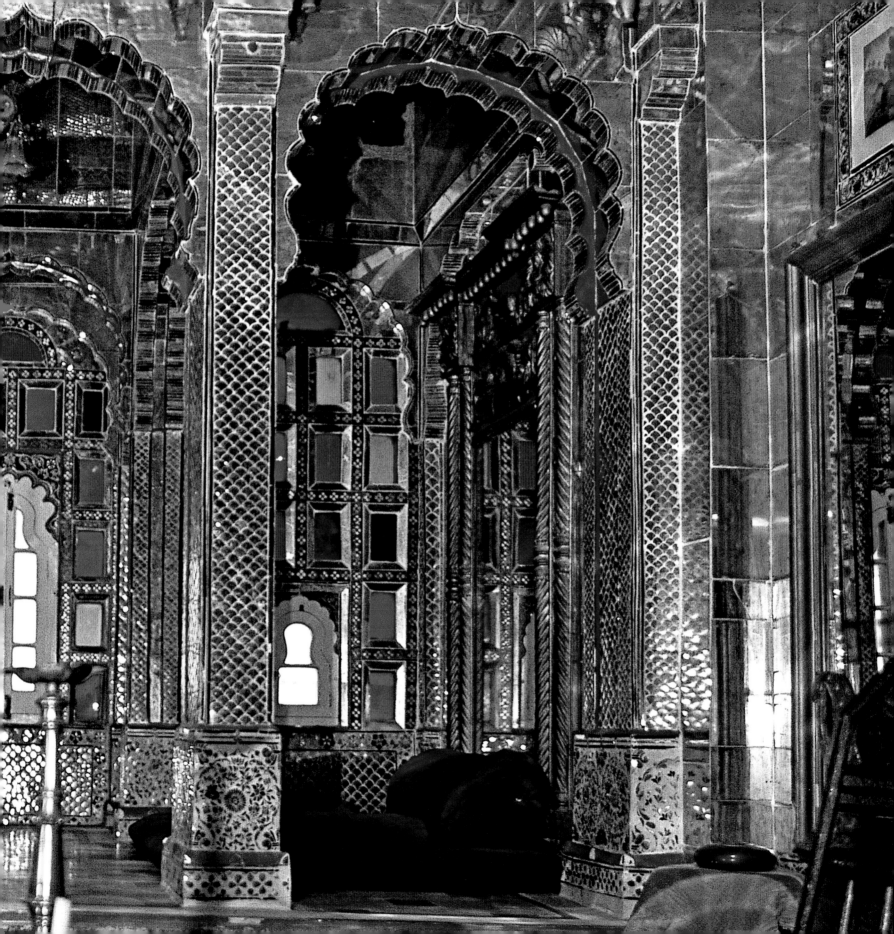

262

The Rajputs modelled their palaces on those of the Mughal emperors. In the outer courts, magnificent royal audiences or durbars took place around the *diwan-i-am*, the hall of public audience, where ambassadors were received and justice was dispensed, and the *diwan-i-khas*, the hall of private audience, where the sovereign received his ministers and dignitaries. The floors, paved with marble, were covered with carpets; giant fans hung under the arcades; oil lamps were set in mirrored niches, which multiplied the lights like so many stars. A narrow passage, well guarded, led to the private apartments and the *zenana*, where the prince visited his wives. In these private regions, the wallpaintings depicted erotic scenes, in a manner that was sometimes tender and sometimes crude.

PRECEDING PAGES
The audience hall as 'Shish Mahal', or palace of mirrors.
LEFT
A painting both erotic and bucolic in the private apartments.
RIGHT
Infinite variations on floral motifs.

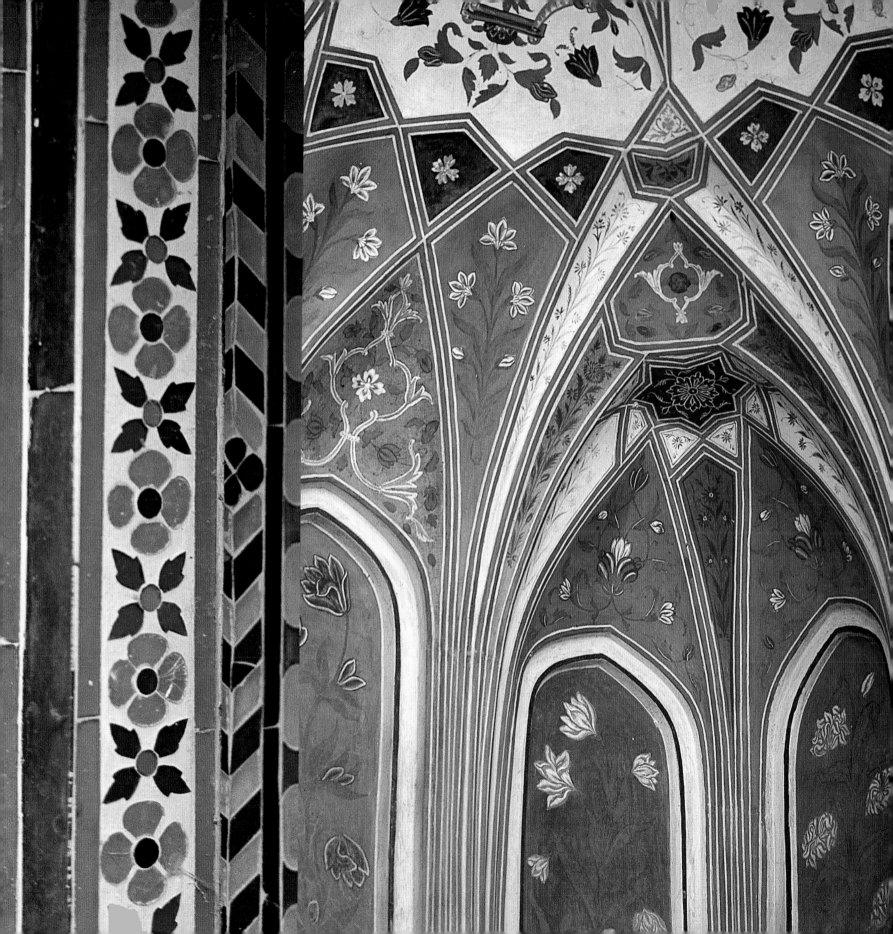

264

The Sisodia clan were the last of the Rajputs to agree to an alliance with the Mughals. When their princes left Chitor, the fortress that was both witness to and symbol of their resistance, they traded it for a city of grace and elegance, Udaipur. The 'town of Udai' is a perfect setting for the turquoise waters of Lake Pichola. Its palaces, of marble and granite, are exquisitely delicate. Sumptuous rooms within them have been furnished to welcome tourists today into the fairy-tale India of the maharajahs.

LEFT
Carvings and arabesques on the white façades of Udaipur.
The old photographs show, clockwise from top left, the Taj Mahal, *c.* 1912; the great gateway of the Taj Mahal, *c.* 1916; and Parsees in Mumbai (then Bombay) in 1908.
RIGHT, ABOVE
A servant, *c.* 1910.
RIGHT, BELOW
The Little Imambara, a miniature Taj Mahal, built in 1839 by the nawabs of Lucknow, extravagantly generous sovereigns, who dedicated their wealth and life to art, poetry and gastronomy.

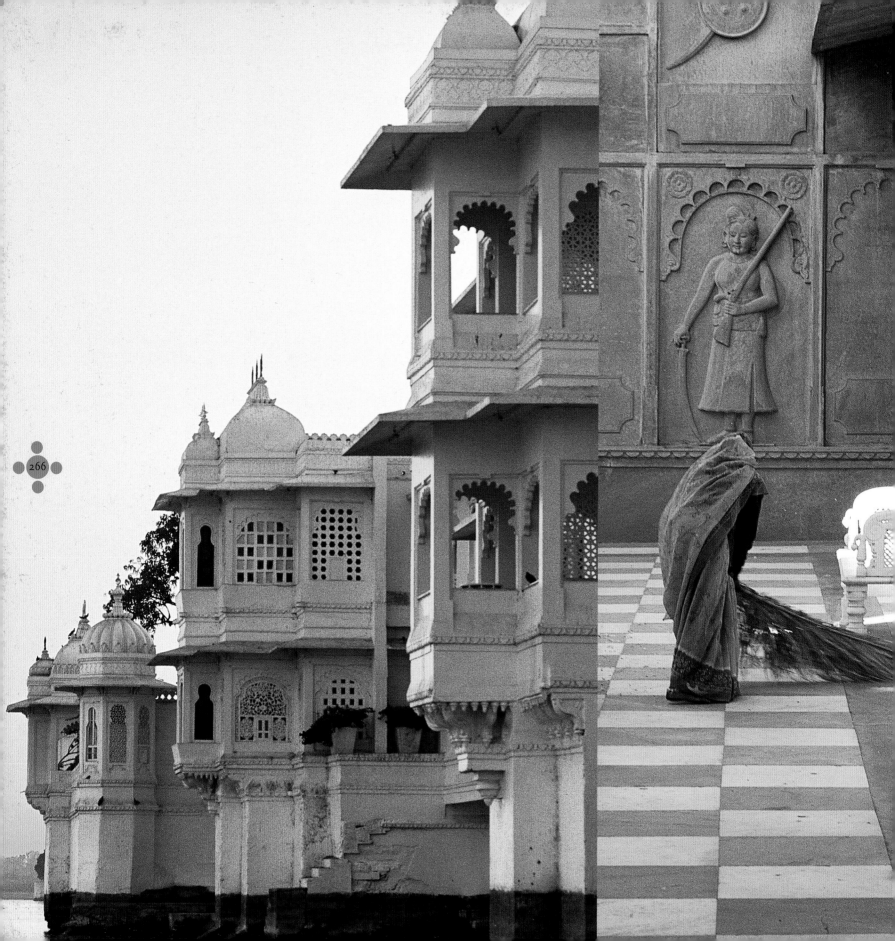

A horse, a sword, and a wife to perpetuate their lineage – the desert storytellers of Rajasthan would have it that these three things constituted the entire wealth of the mustachioed early Rajput warriors. In the past, boys were directed towards the martial arts from a very early age. Between the ages of three and six they were taught archery, riding and swordsmanship, and they learned a strict code of conduct based entirely on honour and courage. At the age of ten or twelve they took part in their first battles, and were prepared to die for the Rajput cause. The descendants of this fierce aristocracy, honoured for their ancestors' exploits but now concerned with politics and business, form a caste that is highly respected in India.

LEFT
Balconies of the Jag Niwas or Lake Palace of Udaipur, overlooking Lake Pichola. · Reliefs and sculptured benches in a courtyard of the palace at Dungarpur.

RIGHT
Being the son of a king did not bring a smile to the face of this young ancestor of a Rajput family.

OVERLEAF
The plain of Amber, in the heart of Rajasthan.

WORKS QUOTED

p. 22 Guido Gozzano, *Verso la cuna del mondo; Lettere dall'India (1912–1913)*, Treves, Milan, 1917

p. 31 Tarun J. Tejpal, *The Alchemy of Desire*, Pan Macmillan, London, 2005. Copyright © Tarun J. Tejpal, 2005

p. 45 Allen Ginsberg, *Indian Journals*. Copyright © 1970 by Allen Ginsberg. Used by permission of Grove/Atlantic, Inc.

p. 77 Mircea Eliade, *India*, Editura 'Cugetarea', Bucharest, 1934

p. 88 Rudyard Kipling, *The Jungle Book*, The Century Co., New York, 1899

p. 105 Tarun J. Tejpal, *The Alchemy of Desire*, Pan Macmillan, London, 2005. Copyright © Tarun J. Tejpal, 2005

p. 110 Rohinton Mistry, *Tales from Firozsha Baag*, Faber and Faber, London, 1987

p. 141 Sarah Dars, *Nuit blanche à Madras: les enquêtes du brahmane Doc*, Picquier Poche, Arles, 2000

p. 146 *The British Magazine*, September 1828

p. 155 Charles Müller, *Cinq mois aux Indes*, H. Floury Editeur, Paris, 1924

p. 174 Robert Chauvelot, *Mysterious India*, Berger-Levrault, Paris, 1924

p. 185 Siddharth Dhanvant Shanghvi, *The Last Song of Dusk*, Orion, London, 2004

p. 201 Catherine Clément, 'Le Mahabharata', in *Internationale de l'Imaginaire*, no. 2, June 1985

p. 204 Alberto Moravia, *Un'idea dell'India*, Bompiani, Milan, 1962

p. 241 Alain Daniélou and Raymond Burnier, *L'Inde traditionnelle*, Fayard, Paris, 2002

p. 252 Nicolas Bouvier, 'En Topolino sur la route d'Agra', in *Le goût des villes de l'Inde*, Mercure de France, Paris, 2005

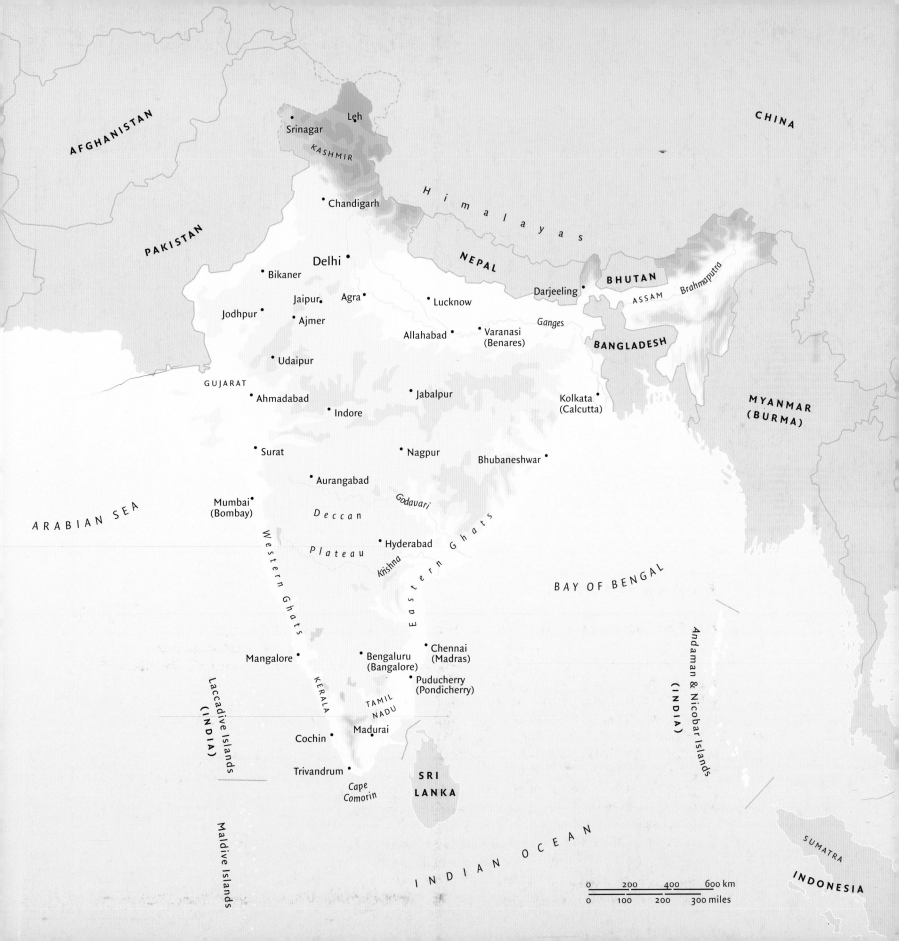